ELIZ SPARHAWK-JONES
THE ARTIST WHO LIVED TWICE

BARBARA LEHMAN SMITH

Outskirts Press, Inc.
Denver, Colorado

The opinions expressed in this manuscript are solely the opinions of the author and do not represent the opinions or thoughts of the publisher. The author has represented and warranted full ownership and/or legal right to publish all the materials in this book.

Elizabeth Sparhawk-Jones
The Artist Who Lived Twice
All Rights Reserved.
Copyright © 2010 Barbara Lehman Smith
v2.0

Book jacket design by Joe McCourt, Bark at the Moon Studios

Author Photo: Evan Cohen Photography, Inc.

Front cover artwork, left: Elizabeth Sparhawk-Jones, *In Rittenhouse Square, c. 1905,* Oil on canvas 32x32-in., Courtesy of Private Collector.

Front Cover artwork, right: Elizabeth Sparhawk-Jones, *Untitled,* c. 1960, Oil on canvas, 45 x 31 ½, Courtesy of Private Collector.

Back cover artwork: Elizabeth Sparhawk-Jones, American, 1885-1968, *Shoe Shop,* c. 1911, Oil on canvas, 39 x 33 1/4 in., William Owen and Erna Sawyer Goodman Collection, 1939.393, The Art Institute of Chicago.

This book may not be reproduced, transmitted, or stored in whole or in part by any means, including graphic, electronic, or mechanical without the express written consent of the publisher except in the case of brief quotations embodied in critical articles and reviews.

Outskirts Press, Inc.
http://www.outskirtspress.com

Paperback ISBN: 978-1-4327-5990-2
Hardback ISBN: 978-1-4327-6003-8

Library of Congress Control Number: 2010928445

Outskirts Press and the "OP" logo are trademarks belonging to Outskirts Press, Inc.

PRINTED IN THE UNITED STATES OF AMERICA

*With love for Chris,
Adam, Carter, and Kelly*

TABLE OF CONTENTS

Prologue .. ix

Part I

I. New York City, April 26, 1964 1

Chapter 1: Saving Souls ... 7

Chapter 2: The Minister's Daughter 29

II. April 26, 1964 ... 41

Chapter 3: The Academy 47

Chapter 4: "The Find of the Year" 63

Chapter 5: Ghosts .. 77

Chapter 6: Burying the Sun 93

Part II

III. April 26, 1964 .. 111

Chapter 7: "Sparhawk" .. 117

Chapter 8: Against a Phantom Sky 133

Chapter 9: Caryatides .. 151

IV. April 26, 1964 .. 167

Chapter 10: The Mystery of Marsden 173

Chapter 11: "A Phenomenon in the World of Paint" 187

Chapter 12: Paris.. 203
V. April 26, 1964... 213
Epilogue.. 215
Acknowledgements.. 221
The Paintings of Elizabeth Sparhawk-Jones... 225
Bibliography.. 227
Selected Bibliography..................................... 229
Index... 233

PROLOGUE

People ask me why I chose Elizabeth Sparhawk-Jones as the subject of a story that has taken me the better part of ten years to complete. "I didn't choose her," I reply, "she chose me."

Once upon a time I didn't believe in ghosts—those puffs of mist banging around someone's house, making raspy noises and scrambling cable channels—but as it turns out, I do perform their handiwork.

A particularly strong-willed spirit with bobbed hair, a hearty laugh, and bright lipstick made her presence known to me in carefully crafted (some may say sneaky) ways to lure me to do her beckoning. It began for me some years ago when I started working in Trimbush, a historic house on the grounds of the hospital where I was employed in the public relations department.

A brown-shingled, rambling home built in the 1920s, Trimbush had in its heyday housed a series of poets and writers as part of the Johns Hopkins lectureship in Baltimore. Bayard and Margaret Turnbull, who owned the home, hosted Robert Frost, W. H. Auden, Walter de la Mare, and Archibald MacLeish. My literary first love, F. Scott Fitzgerald, was a friend of Margaret Turnbull; he had rented another home

on the tract of land and frequently visited Trimbush. He finished editing *Tender Is the Night* just a few hundred yards from where I wrote the medical center's press releases forty years later. The connection was heady.

Trimbush, renamed La Paix Center by the hospital that had bought the land, now housed the public relations, marketing, and development departments. And, despite a few local protests and a failed campaign to declare the house officially historic in Maryland and thus off-limits to destroy, the house was about to be torn down for redevelopment options. Its charm notwithstanding, the house—along with its walls that had been lovingly painted with seven coats of paints for luminosity—had become a death trap. Frequent gas leaks, temperamental water and heat systems, and four-legged visitors suggested we work elsewhere.

That said, I loved working at La Paix and loathed the move to a sterile environment. The poor construction men who participated in the destruction actually believed my feature-story ploy and posed for photographs in front of the ravaged home. Instead of celebrity glory, the photograph of their proud smiles was defaced with the words LA PAIX KILLERS, enlarged to 8x10, and tacked in my new office for the rest of my years working there.

Enter stage left the spirit of Elizabeth Sparhawk-Jones, a stranger to me, but, as I would discover, she was Margaret Turnbull's only sister—and dead since 1968. In a strange but fortuitous circumstance, the demolition men mixed up items meant for the incinerator with my new office, causing them to save, and effectively transfer, four boxes of her mementos

into my possession. Brittle newspaper clippings of art reviews more than one hundred years old, handwritten notes and self-admonishments, class work and struggles of a young artist filled the pages of several scrapbooks.

My hands became stained from the ash of the papers as I tried to read everything about this ingénue of the art world. She was so promising, so golden . . . what happened? My initial research yielded nothing (Sparhawk-Jones didn't exactly trip off the tongue like Cassatt, Beaux, or O'Keeffe). The grip I felt drawing me into her story was real. It was Elizabeth's heavy hand, and she was somewhere marveling at my gullible ways.

"She's such a romantic," I imagined she said about me when she discovered how I'd mooned over Fitzgerald. She was right, of course; she seemed to know what got to me. Like the receipt for art pencils sent from Canton Junction, my tiny Massachusetts town 400 miles away, left behind in the boxes, or when I found out Elizabeth is buried about 3 miles from my home. Or the destiny of the scrapbooks themselves.

A visiting fellow of literature at a writing seminar once addressed me from the podium about this. "Sometimes a coincidence is just a coincidence," he sighed. "It doesn't mean anything." He said the word *anything* with such lightness that its mere vapidity seemed to make it float to the ceiling of the auditorium and hang there. Stunned into muteness, I wished to float away too. But then I clearly heard Miss Elizabeth, in all her sardonic glory, say, "And sometimes it does."

As I pieced together Elizabeth's life, I was swept into a wonderland of sorts, complete with its own eccentric charac-

ters: American master painter and teacher William Merritt Chase with his Wile E. Coyote mustache and ever-present showman cane; the sexy, mysterious Morton Schamberg, who died well before his time; painter and friend Marsden Hartley, whose competitive drive didn't lessen even if his opponent was dead; actor and patron Claude Rains, who collected Sparhawk-Jones's art while his wives confided in the artist; and the love of her life, the enigmatic Pulitzer Prize–winning poet Edwin Arlington Robinson, as complicated a man as he was a poet. There were even cameo appearances by Scott Fitzgerald and a string of other fascinating characters.

But in truth, it was the unevenness of her life that attracted me, the tragedies versus the successes: Elizabeth's breakdowns, the unrequited love affairs, the gypsy lifestyle she and her mother eventually shared, the manipulative relationships, and the paradox of Elizabeth herself. Four years before her death, Elizabeth told an interviewer, "I was always a lonely person." A surprising confession coming from an artist usually described as having robust humor and a confident rapier wit, and whose works hung in the some the world's finest museums.

In fits and starts, I traveled and searched for clues, tracing her life from childhood through her adult years. In Philadelphia, I spent days at the Pennsylvania Academy of the Fine Arts, where, as a student, Miss Elizabeth Sparhawk-Jones had won its highest-possible award. In Maine, I fell in love with the moody, dark-haired Robinson and wished he'd written poetry about me like he'd penned for Elizabeth. In New Hampshire at the MacDowell Colony, I sat inside the stone studio where Elizabeth most often worked but heard

her spirit singing loudest in the open fields overlooking Mount Monadnock. In Baltimore, I met a few times separately with her two nieces, talked with the historian from her father's former church, and visited his grave, which sits alongside that of his wife and two daughters in the northern Baltimore countryside.

In Connecticut, Florida, Paris, and elsewhere, I found pieces of her story and met many modern-day additions to this wonderland cast. There was Carlie from North Carolina, who shared my affinity for the macabre humor of Elizabeth's later work shown in paintings like *Housewives on Holiday*, which offered an unusual twist to the classic theme of bathers in a landscape; then, in 2009, I fortuitously met its private collector. In the jewel-toned watercolor painting, naked women dance, arms swinging in abandon, in a pool littered with refuse and rocks on the edge of a desolate cliff. Other admirers wrote to me to rhapsodize over Elizabeth's impressionistic *Shoe Shop* or *Shop Girls*, which they had seen at the Art Institute of Chicago. Academics and biographers contacted me to ask questions about Elizabeth's relationship to Robinson, Alice Kent Stoddard, Andrew Turnbull, and others. With each exchange, I'd always come away with another fragment of her story. Discovering the Sparhawk-Jones Smithsonian interview of 1964 turned out to be the key to telling Elizabeth's story and, best of all, brought the incomparable Ruth Gurin Bowman into my life. Still a firecracker of spirit in her eighties, Ruth generously shared her knowledge gained from decades of experience as an art insider along with her memories of Elizabeth.

On the paper trail, I felt a particular thrill reading notes

that William Merritt Chase had written Elizabeth about her talent and in reading between the lines of Marsden Hartley's insincere coddling throughout his five-year correspondence with her. In magazines like *American Artist*, I read extraordinary reviews like the one written in 1944, which went, in part, "Elizabeth Sparhawk-Jones is something of a phenomenon in the world of paint. In her occasional exhibitions . . . she is revealed as a remarkably original, not to say eccentric, painter and person. . . . Her brush answers inner urges, it is a subconscious voice, a yearning voice that strives to translate deep meanings into the language of paint." In 2008, I found her riveting work, *In Rittenhouse Square*, nestled in the heart of the Manoogian Collection, one of America's most prestigious art collections of American impressionism.

Like most manhunts, my search was not linear. Elizabeth's spirit age to me was a teenager upon my discovery of her. From there, my search brought her into her thirties and forties, then back to her twenties (the breakdown years), and then to her final years (another breakdown) and sitting alone in the parks of Paris. Ironically, her childhood years came last, but unlike watching the end of a movie first, this only made her beginnings more poignant. Her voice changed in my head through this process. I heard the young girl begging her parents to allow her to travel abroad to study and to love whomever she chose, the hearty laugh and wicked charm of the full-blown artist and social magnet, and the strident, sometimes nonsensical ramblings of an elderly Elizabeth being interviewed by a mere mortal curator. But in her earliest years, I didn't hear her at all. I simply saw her, a baby girl with those brilliant knowing eyes.

The trail was hot, then cold, then forgotten for a time. But then I'd hear her voice again urging me to get back to work. *Find me*, she seemed to taunt, *Maybe you'll learn something you need to know.* Not satisfied by my publishing a long piece on her in a regional magazine, her nagging voice in my head only seemed to worsen. In my weak moments, I tried to dissuade her from her choice of me. "I'm not an artist. I don't know a plein air painting from a portrait," I whined.

What I didn't admit aloud was that artists intimidated me. These were mystical creatures, always seeing beyond the apparent, responding to inner urges, and creating art for its own sake. To me, writing followed a more logical pattern: beginning, middle, end. THE END. To each argument of my deficiencies, she only shot back, "I don't want you to paint me, you ninny. Just write about me."

The "Miss Jones" I met in the scrapbooks was a girl who knew that the spectacular was within her reach. From what I'd already learned, its toll seemed to be higher than she ever could have imagined. The mystery of Elizabeth's legacy—with its shadow of unhappiness—intrigued me. How could the art world so easily forget a woman of her vast accomplishments? Was it because she suffered a breakdown or perhaps because she survived it? What else didn't I know?

And so I surrendered: *Lead me where you will.*

PART I

I. NEW YORK CITY, APRIL 26, 1964
INTERVIEW of ELIZABETH SPARHAWK-JONES
Conducted by RUTH GURIN for the
Archives of American Art, Smithsonian Institution

Elizabeth Sparhawk-Jones sat upright in her chair, waiting while the woman from the Smithsonian set up the tape recorder between them. At seventy-nine, the artist was about to give an interview about her life. Well, perhaps not about her *life* so much as the career spanning it. They might talk about her current show at the James Graham Gallery and the review in the new issue of *Art News* that called her works of "poetic nature" and her brushwork "turbulent and expressionistic." They would surely talk about her years studying at the Pennsylvania Academy of the Fine Arts with its celebrated teachers, and of all her awards, and perhaps about the small fortune commanded for her works then. Maybe too about being called "the find of the year" or "the girl assured of a golden future" by New York art critics at the turn of the century, or that one article that said her "talent rivaled the master himself," comparing her with her teacher, William Merritt Chase.

But they almost certainly wouldn't talk about what happened then, when it all stopped. Questions about the turbulence of her life and its consequences would be left unasked,

chances were. She'd never married, so the discussion probably wouldn't touch anywhere near the subject of love. They wouldn't talk about loss, although she'd nearly drowned from it. Nor would the conversation touch upon time spent locked away in darkened hospital rooms—years taken, snatched while in the midst of what she'd thought was the crest of her fame as a painter. Nor would the young woman politely inquire how a damp red rambler rose poetically recalled the death of her beloved. For the best, perhaps, to stick solely to her life as a painter, one who survived—and survives.

Ruth Gurin, New York University curator and interviewer for the Archives of American Art for about a year, didn't like to know too much about her subject before an interview. She always enjoyed the excitement when one thing led to something she didn't expect. Better known within art circles in later years as Ruth Gurin Bowman, her career would become something she called a chain of "fantastic coincidences." In this case and many others, all she knew was she had to interview the artist (or curator, historian, or administrator) before he or she died.

Vivacious herself, Gurin appreciated the sense of liveliness held within Sparhawk-Jones's eyes. As she made sure the recorder was properly placed—she had a habit of glancing down at it during an interview and needed it near to be less conspicuous—she recharged her thoughts about questions she usually asked her subjects: Ask about their take on the art world and how it's changed for them, how they created it, who they knew, where they went to study, who influenced them, how did they find balance perhaps, and any other data she may wring out of them during their conversation. Her favorite

I. NEW YORK CITY, APRIL 26, 1964

word, she liked to say, was *why*.

They sat in the spacious, quiet lobby of the Hotel Allerton, a residential hotel at 57th and Lexington. They began slowly, talking about Sparhawk-Jones's lifelong appreciation of writers, and eventually the conversation turned to William Merritt Chase.

"Chase did a magnificent portrait of my father."

"Oh, really?"

"Oh, yes," Sparhawk-Jones said, "Of course, at the time we might have had [Thomas] Eakins do it and it might have been a greater work, but I had never heard of Eakins, and Chase was teaching there and I knew him. So it was natural to ask him. And he made about fifty portraits that year in Philadelphia."

Known for bringing French impressionism to America among other accomplishments, William Merritt Chase was one of the few artists influential in his own time, inspiring an entire generation of artists. When Sparhawk-Jones knew him, the painter had been a teacher longer than she'd been alive, teaching everywhere from Chicago to the Art Students League of New York and in his own school. Thomas Eakins, perhaps considered the best portrait painter of all time by many critics, was forced in 1886 to resign from teaching for his radical idea of using nude models in a mixed class of men and women.

"Was [Chase] a strong teacher?"

"I don't know that he was so strong but he was very decided in his likes and dislikes. He didn't like anything. The more advanced at the moment liked to imitate Whistler and get a

little smoky and that he loathed—that he *loathed*—because he said they were working under a high north light and they couldn't be seeing anything that they were painting like that, you see. He was a realist, but so was Thomas Anshutz."

"Yes," Gurin agreed. An assistant to Eakins, an innovator who taught artists to study anatomy and closely observe the human body, Anshutz had continued his predecessor's teaching methods of drawing nude models and incorporating animal dissection into anatomy classes.

"What happened to the portrait of your father?"

"My sister has it. She has it hanging in her house. You can see it anytime you want to. In Baltimore. It's a little severe, a little aloof, but it's got his brushwork; the eyes are beautifully done. The eyes are *beautifully* done."

"I'm looking forward to seeing that. That ought to be marvelous. Did you look like him?" Gurin asked.

"I don't think so," Sparhawk-Jones paused. One may argue that in this moment she considered revealing the more powerful commonality between them. But then their pleasant conversation may have turned darker, toward subjects much less pleasant to recall.

"Perhaps," she continued, "more than like my mother."

"What did your father do?"

"He was a clergyman and a very great preacher."

Between them, the recording machine spun on.

The Reverend John Sparhawk Jones, D.D.

CHAPTER 1
SAVING SOULS

Gracing the corner of Baltimore's Park and Lafayette avenues, the Brown Memorial Presbyterian Church was many things to many people. But first and always, it was Isabella's gift, given with the purest of intentions. The widow Brown chose white limestone, like the pyramids of Egypt, for her monument's construction. Practical for its heaviness and yet easy to cut for elaborate carvings, the limestone also was in easy abundance in the northern county in the late 1800s.

Large in its Gothic Revival–style architecture, the church was a worthy testament to its namesake, George Brown. Son of an Irish immigrant, Brown personified the American dream of immigrant kids like him, possessing the freedom to work hard and worship where and as he pleased. The fortune amassed by George Brown by doing the former, mainly in his father's investment firm, created the grand opportunity for the latter.

As the first Presbyterian sanctuary in the country, the church itself had a stake in the success of bringing others to their faith. So far, only an Episcopal church existed in the neighborhood. It would be a few years before the ornate stained windows, created by the artist Louis Comfort Tiffany

himself, would be added or the sanctuary would be enlarged, but Brown Memorial always had a masterful presence. Like its vaulted ceiling that seemed to skyrocket into the heavens, the church (or more aptly, its leadership) saw few limits to continued growth.

And understandably, just twelve years after its 1870 dedication, nothing could mess that up.

But within the church, a secret was budding that would grow and stretch greedily for at least three generations, taking as many lives in various ways. For the church leadership's part, they would have a hand in sacrificing one of their own to its lies. But they wouldn't stop it. In truth, they actually fostered its strength, although this was impossible for them to realize at the time.

For it wasn't the innocuous kind of secret whispered on any given Sunday morning before services began about marriages, new babies or pregnancies, illnesses, or other matters (some arguably bordering on gossip), but the kind that tore through money, sanity, and lives with equal glee and abandon.

In the early spring of 1882, things were still quiet and content at Brown Memorial Presbyterian Church. If some men were seen huddling together at the back of the church, they were probably discussing the six thousand German miners who were protesting wage cuts at the Consolidated coal mines near Frostburg. In a few years, they may be talking about the reporter from London who'd just visited Baltimore; his article about the town likely would be passed around. One passage, especially irritating to the locals, read: "One's

impression of the city depends on which railroad brought you to town." The writer may have been called *a horrible bore, a moron*—and worse if they hadn't been in a holy place—but in truth, they couldn't say he was wrong.

Everyone knew that from the Baltimore & Ohio (B&O) Railroad, you see an ugly, rundown place with not-so-tidy streets where pigs, chickens, and children run freely. But from Pennsylvania Station, a prosperous-looking land awaits: neat streets of large homes, spacious parks brimming with Victorian gardens, and quiet streets inhabited only by those of impeccable lineage.

Perhaps the snooty Brit, in his quest for a salacious lead, missed the better story about Baltimore: the tale about the phenomenal growth of the city, banks and buildings seemingly rising overnight, roads being paved with modern signage where only little more than dirt pathways had been before. This could have been the story. Or he could have told about all the boats bringing foreigners to Maryland every day, immigrants who began working right away if they chose, some risking everything to escape their homelands. For these men and women, Baltimore offered hope for a better life for them and their children.

In 1882, the importance of prosperity was never far from the minds of Dr. Jones's Baltimore flock. The mind-boggling possibilities of new industries and steady city growth—even the transformation of labor from the craftsman, like the cigar maker or piano maker, into the new factory worker— suggested progressive times ahead. Marylanders felt blessed compared with newer settlers, especially because the federal

government had just passed a law to limit immigration.

True, few who sat in Dr. Jones's church had firsthand experience with the violent conflicts of the Irish, Bohemian, African, or German immigrants who still arrived daily looking for new lives full of American opportunity. The members of Dr. Jones's congregation were not shoveling coal into vessel chutes at Locust Point or working in construction camps for the B&O extension for 25 cents a day. Nor were they the oyster dredgers, suffering from painful "oyster hand" from the freezing Chesapeake waters with little or no pay. Perhaps that was precisely why they were here.

If laughter erupted from the men at one overly boisterous version of the day's politics, no disrespect was intended. And most likely it would be quickly hidden by the organ beginning its tune-up—or ended by a few turned heads from wives with fingers to lips, signaling a prompt return to their seats. Services were about to begin.

⌒⌒

By most accounts, if the Reverend John Sparhawk Jones, D.D., had not been a preacher, he would have made an excellent lawyer.

By 1882, he'd been pastor since the church's dedication in 1870. Held on an early December morning with a second service in the evening, the dedication attracted so many people that hundreds had to be turned away. Those who made it into the evening service were especially lucky to witness the interior of the church lit by gaslight, an ethereal magnificence cemented into the Brown Memorial Presbyterian

Church history book.

Selected to take the helm of the new church before he'd even celebrated his thirtieth birthday, Dr. Jones had seen the congregation grow steadily. Years later, he would be memorialized as that rare preacher who—not being much of an orator and, unlike many others, never appealing with grandiosity to the emotions of his congregation—won people on the strength of his arguments and by the power of his convictions. Though he had not yet reached his zenith, at the still young age of forty-one, there was no doubt that Dr. Jones's star was on the rise. Just one year ago, he'd been approached by a much larger New York City church, but he'd been convinced by his Baltimore church family to stay and continue his leadership.

As the son of early Americans with privilege and money, one of his deepest convictions was that money could not buy your way into heaven. *For religion is not gain, in the mercenary sense of the world; it is not worldly success,* he preached.

Though speaking before hundreds, Dr. Jones seemed to meet the gaze of each of his parishioners, challenging them as individuals and Christians, talking about what mattered to them. With his severe center part of wavy white hair, hooded eyes, and lips that naturally turned down, he always fought against looking like a stereotypical fire-and-brimstone preacher; he considered himself more of an intellectual, a man of compassion.

Baltimoreans coaxed to his church by ecstatic friends or family members couldn't be blamed for having second thoughts at first taking in his appearance. There were always

other things to do that seem more pressing than getting a scolding from some dour-looking preacher. Some may have groaned inwardly at the thought of what would certainly be an interminable hour; others probably considered excusing themselves to check if they'd properly marinated the meat for that night's supper. Perhaps even a few industrious women ruefully pushed away thoughts of the cast iron stove, with its bin full of ashes waiting as needy as a new pet, or other jobs they could accomplish instead of the time wasted sitting idle in the hard pew.

But from most accounts, when Dr. Jones spoke, all possible scenarios other than being in his church were at that moment abandoned. The pastor didn't have a strong voice (a pleasant contrast to his looks), so his oratories were not theatrical. He didn't rant, condescend, or try to intimidate as he interpreted the Word to his listeners. He simply appealed to their intellect like a lawyer stating facts to a jury. Speaking plainly and precisely, he chose each word not only to outline his message, but to illuminate it. His voice, clearly audible yet barely more than a whisper, held them, and one easily can imagine the entire congregation leaning ever so slightly forward to catch every innuendo. Often he talked about the power of money, as he wrote for the *Presbyterian Pulpit:*

> It [money] is gain in the highest acception, but not in the lower and sordid. Money is simply a feature of the current order of things; it belongs strictly to this world. No man carries it with him into the next stage of being; he leaves it behind. Hence Apostle Paul argues that it cannot be essential to religion and the deepest needs of man. It must be incidental. It does

not go into soul building.

Dr. Jones always reminded his church of the immigrants and others as they offered the requisite prayers for those less fortunate. Their thoughts during a service couldn't help but focus on their mixed feelings with prosperity; they loved to see the new bank and insurance buildings on South Street or the hundreds of new brick homes, and they even enjoyed the smell of fresh asphalt and all it promised. But was there a spiritual cost for all this progress? Hard work had brought them so far, they believed, and keeping God first in their lives could only help them as they struggled to make the most for their families.

Material things are not important, Dr. Jones reminded them every Sunday; *money will not get you to heaven.* He washed their guilty thoughts away with a slight wave of his hand. He understood their worldly struggle. *Build your soul*, he instructed them. *Build your soul.*

⌒⌒

After fifteen years, all but three spent at the Brown Memorial Presbyterian Church, the Reverend John Sparhawk Jones, D.D., had earned a reputation as the most charismatic preacher in Baltimore. More and more people came each week, from farther away and even from different faiths. Perhaps most surprisingly, they came back.

He began his ministry as an assistant pastor at First Presbyterian Church in the city of Baltimore. Then the failing eyesight of the pastor, the Reverend John C. Backus, D.D., suddenly required John to begin filling in for him at the

pulpit. More than a hundred years later, the magic of the substitute pastor was memorialized this way by John H. Gardner Jr., D.D., in *The First Presbyterian Church of Baltimore: A Two-Century Chronicle*: "During this time, he [Rev. John Sparhawk Jones of Philadelphia] earned a reputation as the most brilliant and popular preacher in the city, and the church was thronged every Sunday evening with strangers and members of other churches in addition to the regular congregation, so that chairs and benches had to be placed in the aisles."

A few years later, one of First Presbyterian's parishioners (and the widow of one of Maryland's richest men), Isabella McLanahan Brown, decided to build a church to honor her late husband, George Brown, eldest son of Alexander Brown, who founded the investment firm of that name. She then asked Dr. Backus, considered an expert on church building, for advice. She had already given $100,000 to First Presbyterian as well as many other contributions to charities over the years.

The Brown family was definitively a family of *doers*: Alexander Brown began by exporting Irish linens, cotton, and tobacco before realizing that he might as well establish his own banking firm to finance his international business. The Browns were also instrumental in the formation of the B&O Railroad, the first railroad in the United States. Alexander and his son George were two of the original twenty-five citizens meeting at the Browns' Baltimore home to discuss the rail's possibility, along with Samuel Morse, Charles Carroll, and other leading citizens. George became B&O's first treasurer. Upon his father's death in 1834, he also took over the Alexander Brown and Sons firm, which had offices in

Liverpool, New York, Philadelphia, and Baltimore. In 1852, his eldest son, George Stewart Brown, became partner in the family firm.

The widow Isabella Brown gave the substantial sum of $150,000 to erect the Brown Memorial Presbyterian Church, and in 1869, the church cornerstone was laid. By the next year, Dr. Jones had been elected pastor of the initial congregation of sixty, and the church had raised the $5,000 to pay the pastor's annual salary (and an additional $3,000 for other expenses) by auctioning off pew rentals. Though the Brown family was given two free permanent pews and George S. Brown held a position on the first board of trustees, neither gave up membership at First Presbyterian Church.

It's not recorded how many ministers Isabella Brown took into account before selecting Dr. Jones for consideration and election as the church's inaugural pastor. He *was* only twenty-nine. But how many other Princeton Theological Seminary candidates had a Yale alumni father who'd been mayor of Philadelphia and in his spare time also translated theological books into French while writing a few of his own? How many had a Harvard-educated uncle who shepherded two Presbyterian churches? Dr. Jones lived perhaps not on the same financial sphere as Mrs. Brown, one of the richest women on the East Coast, but definitely in the same world of privilege.

With his background of elite education and experience—and, more important perhaps, the stage presence he'd demonstrated over the three years she'd watched him mature—he promised to be a dynamic pastor despite his rel-

atively young age. And like her husband, George, whose first stop was church when he arrived in Baltimore at the age of fifteen from Ireland still in his woolen socks, John Jones had lived a life in which religion was as integral to his upbringing as being an American.

John was taught to appreciate every opportunity created from living on American soil, as his maternal and paternal families had for many generations. When he was eight, he'd seen his father, Joel Jones, elected mayor of Philadelphia. The elder Jones, after graduating from Yale and practicing law for many years, was appointed a commissioner whose job it was to revise the civil code of the state. Later, he became the first president of Girard College, and then spent many years as a judge of the Philadelphia district court.

Besides his work in politics, Joel Jones also became known for his theological outlook, and he wrote books advocating a literal translation of the scriptures. He also translated religious works from the French and edited English writings on prophecy.

Though his father's religious convictions strongly influenced John as a child, it was his father's brother, Joseph Jones, who perhaps inspired him to give his life to ministry. An evangelist, Uncle Joseph studied at Princeton Theological Seminary after graduating from Harvard. After preaching for years at churches in New Jersey, he eventually became pastor at two Presbyterian churches.

Joseph became a second father to John after his father's death in 1861, and for important events, like John's graduation from his uncle's alma mater, Princeton Theological

Seminary, Joseph had been there to support his nephew's achievements. John's mother, nursed by Boston society, also ingrained in him the idea of service to others as the definition of a meaningful life. Though bolstered by his Philadelphia upbringing, John's outlook was pure Yankee fundamentalism, as plain, simple, and life-sustaining as his boiled meats and vegetables.

If Isabella Brown eventually had second thoughts about her choice for the first pastor of Brown Memorial Presbyterian—that glorious testament to her husband of whom a Baltimore historian would gush that "he regarded religion as preeminent above all things and loved his church with all the ardor of his noble nature,"—she never let on, at least publicly. Regardless, it would fall to her son George to maintain the integrity of Isabella's gift.

The spiral downward for Dr. Jones apparently began with the death of his mother. There was an outpouring of concern from his congregation at his loss. Everyone wanted to let him mourn privately while also helping commemorate his mother, the latter desire resulting in the formation of a quickly approved memorial auxiliary in her name.

After thirteen years of pastoral leadership, certain habits continued by virtue of tradition alone. Parishioners usually surrounded Dr. Jones after service, some exchanging pleasantries or asking for prayers, others offering invitations to their homes for dinner. Everyone knew it was an honor to have a man of God in your home, and because Dr. Jones also

was single, each wife likely felt a motherly duty to keep him fed and healthy.

Once the pastor wouldn't have given it a second thought to accept invitations and actually looked forward to the extracurricular fellowship. But these activities had slowed lately. Such intimacy likely proved more of a burden, spontaneous moments of joy hampered by an overlying malaise. In all likelihood, he knew that his relationship with the congregation was vital, and he should accept the invitations. But all the *shoulds* reverberating within his head couldn't slow what was ahead.

In the twenty-first century, John Jones's illness would be named by descendants without apologies. But in 1883, any type of mental instability raised questions of moral failure and even an association with devil possession. Whispers of such a condition damaged the lives of ordinary men, but for a godly man, the repercussions could be shattering. Whatever was happening to Dr. Jones, it could not be confided or confessed. Perhaps that way it would not grow any stronger.

Within months, conceivably in less time, his wry sense of humor likely faded away. Things may have seemed less amusing and more absurd. Depleted of a natural range of emotions all that remained in the depressed man was perhaps a mute despair. How could he continue to convey hope to others when he couldn't overcome this impending sense of desperation? The Church House, the parsonage in the land next to the church, may have offered him a few hours of private refuge. He could stay in his room for hours after the sun had risen, praying for strength, then finally emerging to go

through the motions of the daily routine, bearing the weight of his duties and no more. After supper at the parsonage, or sometimes in lieu of it, he could retreat to his room again with a book or papers in his hand.

After years of having an assured control of his life, its inexplicable loss must have been terrifying.

The Brown Memorial Presbyterian Board of Trustees understood that their pastor bore great pressures; as a religious man, his role naturally was to keep burdens private and ask for divine intervention if necessary. But dramatic changes of mood had never affected his position as pastor until recently. Since his mother's death, perhaps, it seemed that the dark episodes had become more common.

The Brown Memorial Presbyterian Church Board of Trustees—a cluster of good-hearted men, each invested in some way with the success of the Brown church—surely was a little nervous about calling Dr. Jones before them to talk about his behavior, but something had to be done. By all accounts, he'd become so lethargic, so quiet and more pensive than normal, so obviously troubled that more than one parishioner had observed and commented. At first they may have explained his melancholy on the death of his mother the year before, but they couldn't use that excuse much longer. These men understood how quickly small rumblings of instability like these can erupt, eventually turning a whole congregation sour on its leadership. The church could be crippled in an instant. Only fools would think otherwise

There is no record of the meeting between John and the Brown Memorial Presbyterian Church board. Perhaps they

met in the church basement meeting room, calling him in to discuss "church matters," closing the door quietly behind them. Did they call in Dr. Backus, John's mentor, to soften what they had to say?

In the family account, John expected to be dismissed, to be advised to get the proper medical treatment for his melancholy, and to be told that they would pray that he'd be back at the helm sometime soon. As a minister, he was trained to anticipate moods—and sometimes minds. We can imagine John's wariness, which by now had become etched on his face, and see his long fingers running through his thick hair as the men in the room avoided his eyes.

He would be understandably surprised, however, when their suggestion was finally expressed. (Keeping abreast with the late-nineteenth-century medical community, a physician concurred with their decision.)

Years later, their suggestion would become a kind of punch line to the origins of the Jones family tree, and one that granddaughter Eleanor Pope enjoyed paraphrasing: "'Marriage,' they told him. 'Have you thought about getting yourself married?'"

Some Brown Memorial Presbyterian parishioners may have seen the accelerated pace of the courtship between their pastor and a woman seventeen years his junior and whispered with amusement that it was more hurricane-like than whirlwind, but who could blame Dr. Jones? By all accounts, he had endured a difficult year, losing his mother and then be-

ing overwhelmed by the curious listlessness that followed. As churchgoing people, they also knew from scripture that "God works in mysterious ways," and if that didn't describe this sudden race to the altar, then they didn't know what did.

And it also was a happy day for the Brown Presbyterian Church Board of Trustees seeking a wife for Dr. Jones; if they could have collectively jumped for joy when they discovered Harriet Sterett Winchester, they probably would have—and jumped high. Yes, Harriet's family biography and religious convictions were extraordinarily strong, but that paled next to the woman herself. She clearly adored Dr. Jones. (This truth most likely helped later in soothing their residual guilt.)

An arranged marriage reeks of desperation, or, at the least, a loveless business-like union. But the idea of a man and a woman merely being prodded along by well-meaning friends (with a guiding nudge from above) perhaps made the same scenario irresistibly romantic to many, including Harriet herself. With a life already thick with tragedy, hadn't she earned that by now? She'd already spent too many of her twenty-six years around death or its repercussions. She had no memory of her father, who had died before she was three. She'd watched her mother's body, poisoned by tuberculosis, turn and betray her as the sickness progressed. It was a horrible disease creating monsters out of loved ones; necks became freakishly swollen while the chest, arms, and legs could be skeleton-like. Then the thick mucus, which filled the lungs like lava, produced a cough, harsh and constant, only eased by death.

Every girl her age already was married and had babies—fat, cooing bundles in their arms, lazy smiles pushed in carriages; messy faces and sticky fingers to be wiped; husbands to cook for; homes to be kept clean. A life existed somewhere for Harriet that she unfairly had missed, one now suddenly possible.

As the granddaughter of landowner Henry Hill Carroll, Harriet had an influential and wealthy pedigree on her mother's side with a healthy dose of political and religious clout dating back to the legendary Charles Carroll. This Carroll had complained bitterly to authorities in England about religious intolerance in the 1700s; later, he became attorney general of the province of Maryland.

Though born a Winchester, Harriet embodied the essence of her mother's and the Carroll legacy of resilience, a survival quality that she'd need repeatedly over her lifetime. Beginning at age three when she lost her father, Alexander Winchester, and then shortly afterward when her mother, Sarah Carroll Winchester, became stricken with tuberculosis, Harriet adjusted. When Sarah's sickness forced her to leave Clynmalira (or Carroll's Manor), the family's 5,000-acre country estate (where she'd married Alex in 1845), for the necessary medical help and facilities of Baltimore about 30 miles away, she left Harriet at the estate to be raised by extended family. The older Winchester children were self-sufficient and lived on their own.

Growing up in a different home from her two sisters and two brothers—and living without her mother—made Harriet more of an only child than the baby sister of four siblings. By

the time she was eight, both sisters, Fanny and Betty, had married and moved to Chicago. Brothers Samuel and Henry were also married, though they remained in Maryland. Her family at Clynmalira became her cousins, the McCulloughs, whose pristine sense of virtue Harriet absorbed along with the Carroll culture.

As she grew into a regal profile, benefiting from her mother's wide-set eyes, a long dainty nose, and strong chin, Harriet's devout demeanor ripened into a subtle blend of American aristocracy and religious fervor. To marry someone who pledged his life to God and to share in his passion for helping others—this was not merely a worthwhile pursuit, but, she reportedly believed, her calling.

Materializing always at the least opportune times in Harriet's life, only her sisters tried to discourage her from even considering the forlorn existence as the wife of a minister—especially perhaps when they learned of his meager salary. Both Fanny and Betty had earned the decree of marrying well (the social code for wedding someone financially secure), and they apparently were mystified as to why any woman would choose less for herself. Family members describe the sisters as "cruel in their indifference" to Harriet.

But Harriet's sisters' attempted intervention didn't work and likely only irritated her further. They had so little faith, and that was something Harriet stored in abundance—not just in herself and in John, but in God's plan for her life. How dare they try to persuade her to face in a direction other than the one God had chosen?

Leaving Clynmalira for the parsonage at the Brown

Presbyterian Memorial Church proved bittersweet for the new minister's wife. As a parting gift to her cousins, Harriet wrote a poem she titled "Clynmalira, my beloved. Home of my Childhood."

It read:

Goodbye to the life I used to live
And the world I used to know.
And kiss the hills for me just once
Now I am ready to go.

But even Fanny and Betty, as worldly and cynical as they were, would have been surprised by the length of Harriet's marital happiness, though it's doubtful she confided in them. Cruelly short, they'd have had to agree, if it ever existed at all.

Months into her marriage, Harriet already had to sense something troubling her new husband—not *about* him but *within* him. So much was unfamiliar to the new bride: the daily routine of a minister and John's expectations for her as a wife.

With Harriet's characteristic restraint, she left few specifics in accounts of how she witnessed John's final breakdown, except that it happened. Perhaps one morning, as she watched him sip his coffee, it struck her: *He doesn't really see me anymore.* He was somewhere else, locked inside himself. Eventually she realized the glazed expression she mistook for boredom was just a shell, like the frozen smile of a carved

pumpkin. Nothing but hollow.

Soon—for both Harriet and within the church family—the depth of his illness emerged, including its covert history preceding his courtship and marriage. Harriet learned that John, her husband of less than a year, was suffering from some sort of mental breakdown that most likely had been coming for many months.

Dwelling on feelings of anger and betrayal would have been a luxury and a waste of energy she didn't have. Harriet had to face the realities of her new life; what was done was done. Despite the puppet show she'd unwittingly been apart of, she had vowed in front of God and her friends and family that she would love John, even when difficult and challenging to do so. She in all likelihood didn't expect the time to arrive quite so soon in their marriage, or so suddenly. But if she was embarrassed, even worse for her, according to family accounts, was witnessing John's pain. Punished by the illness and then by its every consequence, John had digressed from charismatic healer to voiceless leper.

As much as the Brown Memorial Presbyterian Church family loved him and respected all he'd done for them in his tenure as pastor, his instability and melancholic ways had become alarming and impossible to overlook. The good parishioners' concern could no longer be appeased. Regardless of its root, everyone agreed that he drastically needed help for whatever health problem he had. His collapse disturbed the parish on many levels. But the one question perhaps foremost on their minds was an obvious one to ask a church shepherd: *How can you help us if you cannot save yourself?*

Dr. Backus had been present at the first vote months earlier, but this time Dr. Jones's mentor couldn't have helped if he had wanted to as the final vote was cast to remove John as pastor; the elder clergyman's heart had given out only a few weeks after assisting at the Jones marriage ceremony. It's not known if John was in attendance at the meeting, but the Brown board of trustees agreed unanimously for dismissal. Perhaps as a token of friendship and loyalty to Dr. Jones, however, they left no clues as to the true nature of the pastor's sudden departure: no paperwork, no letters from witnesses.

The only testament to Dr. Jones that remains today is a positive one: a bronze tablet adorned with an angel and a trumpet inscribed lovingly to John Sparhawk Jones, D.D. He'd been their hero for quite awhile, but he'd fallen hard. Time to find another savior; time now for everyone to move on.

After John's dismissal, Harriet took charge, refusing to sign his care away to an insane hospital, where there was a high possibility of inhumane treatment or being locked up indefinitely. They moved from the church manse to find refuge elsewhere—probably her mother's old residence on Franklin Street. It must have been a humbling return for the newlywed, but she also knew that God blessed the humble and meek, and that may have given her some solace. Her pride tumbled away as, it may be argued, it had no place here.

In the midst of the chaotic move and the worry about John's health, Harriet's body began to change in ways she'd never experienced. Even in her prayers, she must have whispered her hopes about what it could mean. But then,

twenty-seven-year-old Harriet Sterett Winchester Jones received her miracle: She was expecting a child, sometime in the fall of 1885.

Like most expectant mothers, Harriet likely imagined countless scenarios about her life and that of the growing life within her over the next long months. One may think that these fantasies—ranging from the darker ones that perhaps included worries of the current diphtheria outbreak—didn't linger on thoughts about the possible repercussions of John's mental illness on their baby.

There would be time for that.

Elizabeth Sparhawk-Jones as a child

CHAPTER 2
THE MINISTER'S DAUGHTER

Heavy with child toward the end of the year, Harriet surely faced the reality about the mounting dangers of diphtheria. The infectious disease was killing at random, adults and children alike, equally affecting the poor and the rich, those who lived in the city and those in more rural areas. No one seemed safe. The township of Frederick had lost 125 people in a year—with four out of ten being children—and was doing some serious study of their sanitary conditions, analyzing the degree of bacteria and germs and such.

With Harriet's family history, an erosion of confidence in a successful pregnancy and birth wouldn't be surprising, especially amidst such health risks. As a child she had undoubtedly withstood hundreds of clucks of sympathy and heavy sighs from those who learned her family situation; they weren't sounds a lucky child heard. Every time she gained something, she also had seen how easily it could be torn away.

But mercifully, on November 8, 1885, Elizabeth Huntington Jones was born—most likely in a customary house call by the local physician—and her mother's worries surely lightened as quickly as the onset of labor. After the

dismal start of the Jones union, was this finally proof of God's hand in their lives, offering hope for a future touched with blessings?

Over the next few years, Elizabeth's growth mirrored her father's recovery as both gradually becoming less dependent on Harriet. John began keeping to a routine that regulated meals, reading time, writing time (he began to draft ideas for a book), and sleep. His strength began to return as the depression became bearable.

In September 1887, just before her twenty-ninth birthday, Harriet gave birth to a second daughter, Margaret Carroll Jones. The antithesis of her fairer older sister, Margaret was a dark-haired baby with a perfectly round face and wide-set dark brown eyes. Harriet loved to dress up the girls in their finery and take them into town for professional photographs.

In one portrait of Elizabeth, marked "aged five years and four months," she sullenly dons a white ruffled collar of a high-necked dress, the puffed shoulders of the dress raised above her like two clouds. Her light brown hair is cut very short, exposing her ears and framing her face in short bangs. In another, taken around the time of the family's move to Philadelphia, her hair had grown long past her shoulders; her face remains serious as she poses, quill pen in hand over studies.

Her eyes, however, are luminous. At every age in every photograph, they dominate with a mix of confidence and playfulness. Many years later, it would be rumored that a Pulitzer Prize–winning poet wrote about those "gray eyes," seeing "a phantom shape against a phantom sky."

But for the young Elizabeth Jones, not yet ten and about to move to a city lush with promise, the phantoms still lie many years ahead.

Sunday mornings on Locust Street in Philadelphia generated a different rhythm than other days of the week. The rustle of corseted dresses, the hastening pace of buffed and shined leather shoes, and the chatter of family and friends greeting each other as they approached Sunday service pumped the air with both urgency and a harmony unique to the Sabbath.

The Calvary Presbyterian Church, with its heaven-grazing spire and gothic face, was undoubtedly the jewel of Locust Street. Built to create a stir, Calvary owed its no-expense-spared grandeur to the ambitions of the "new school" of Presbyterianism. These breakaways, who advocated the then-radical concept of interdenominational aid to the needy, used the creation of the Calvary Presbyterian Church as one means to flout its independence from the older faction after the order's split in 1837. Though long on idealism, the new group fell short on capital, and in 1870 the church again unified, the rift over mission-relief protocol quietly mended.

For Dr. Jones in 1894, the church couldn't help but represent his own independence, for after nearly ten difficult years, he'd earned a second chance to lead a congregation. When Calvary parishioners met their new pastor, the Rev. John Sparhawk Jones, D.D., he wasn't a complete stranger to them because he'd been working there as a "stated sup-

ply," a prepastoral position, for about a year. When this lesser opportunity arose within his hometown, John had to prove himself again; and he'd done that remarkably well in an arguably short time, gaining the trust of a new church board that approved him to become its pastor and take the helm of this magnificent church with all that entailed.

The strain of the past six years had redefined the preacher's face. His dark eyes were deeper, more fluid and warm. Weight loss and possibly age had sculpted his cheekbones an arch higher, and his hair was now chalk white. The darkness he'd endured had aged him certainly faster than he would have liked. But he had survived, and perhaps that fact alone gave him strength.

The blackest years for John were likely the first five of Elizabeth's life, 1885 through 1890, as he left no record of activity for this period. Harriet and John called his depression simply *the illness*, belying its terrible power over him. Winning back the confidence of his wife and family, along with a new congregation, was undoubtedly everything he had wanted, and now it had come to pass. His father and uncle surely smiled down on him now.

Traveling at 35 miles an hour, considered a rapid pace in the late 1800s, the train ride to Philadelphia from Baltimore earlier that year must have exhilarated all of them, if for different reasons. Compared with other cities, Philadelphia was an economy boom town. You could own a home for $25 a week; trains ruled; cigar making was a minor-league industry; and the potential of industrial growth from iron, steel, coal, steam engines, and steamships made everyone dizzy

with optimism. Through its diverse sizes of businesses—from large factories to small family-run companies—the city had survived two depressions better than most other cities. And Pennsylvania Hospital, with its specialty of advanced treatment for the insane, was the nation's first major hospital.

For fun, Philadelphians zealously loved baseball—the city was home to both the American League Athletics and the National League Phillies. Watching a game at Philadelphia Baseball Park at Broad and Huntington was as mandatory to most as Sunday service. Cricket and lawn tennis also were highly popular sports, with Philadelphia clubs competing in the same league as prestigious ones from England.

Then there were the clubs. Everyone seemed to belong to at least one: social clubs, special interest clubs, women's clubs, sport clubs. The social elite belonged to the Philadelphia Assemblies, a mix of German, Jewish, Swedish, Irish, French, Welsh, Scottish, and English upper class. The burgeoning women's movement brought new "women-only" clubs, some political, some educational, some especially for working women. Each club had a different set of criteria, exclusive and inclusive, for members to join. But because of their sheer number, chances were good that if you wanted to be in a club, you could find one.

As group thinking was in, individuality was not. So for Harriet and John, keeping the history of his mental illness and six-year recovery quiet must have been vital to building respect and trust in their new community. As John's status began to grow within the church, he spent less and less time with his family. Gradually, the dinner hour became the ex-

tent of family time, but after the years he'd spent healing and idle, the transition may have been welcome to some degree.

Unlike the "big small-town" atmosphere of Baltimore, Philadelphia was a more complex city, complete with social and cultural layers, intricacies that now erupted in widespread scandals involving corrupt politicians. The tempestuous climate suited the charismatic Dr. Jones, crystallizing the spiritual versus earthly dilemmas he often posed to his church. Soon a new flock sat rapt by the pastor's words, challenged as he argued forcefully for the benefits of change in the political system. As the son of a former mayor of Philadelphia and the nephew of a well-regarded preacher, John had all the gravitas he needed, both within the city and for those inside his church to listen and heed his advice.

As the energies of the Presbyterian faith became increasingly focused on affecting political reform, John soon became the most sought-after clergyman in Philadelphia. The *Evening Bulletin*, a Philadelphia daily newspaper, noted his soaring reputation and reported that he was asked to "preach in every city of importance in the country." Beginning in 1902, he also began writing, soon publishing theological books to an eager audience.

Dr. Jones had found his redemption.

As a gift for her parents as they celebrated their first year in Philadelphia, Elizabeth wrote a poem she called "The Robin's Song."

> High day! High day!
> I'm giddy, I'm gay

Swinging aloft on the top of this tree,
And singing, and singing while blue-bells are ringing
Their bright joyous welcome to spring
I send forth a cheer
Long, loud and clear,
'Tis the voice of a joy-laden soul
Then upward I fly, till, half lost in the sky
Only One ear can follow my song.

A few blocks away from the Calvary church, the Jones family took up residence in the church manse, which also provided some assistance with the cooking, laundry, and cleaning. Groomed at Clynmalira, with its many servants, Harriet certainly appreciated the extra hands. Managing a household for four involved a lot of labor. Just the daily shopping for fresh foods alone could test one's patience—things spoiled so quickly. The neighborhood ice man, with his rubber mat flapping over his shoulder to balance the ice he carried, was a popular figure. If he somehow missed seeing the 5-, 10- or 15-cent-piece card in a window and passed by without delivering fresh ice for the ice box, soon that unlucky household would have big, rotting, sour trouble.

On the outside, all the pieces seemed to finally fall into place for Harriet and John. With his depression under control, John had no physical or emotional dependence on his wife, and that was the way most believed it should be. After all, he was a strong and capable minister, leading the charge in his church and in his city. Once again, faces peered up at him from pew after pew, looking to him to show them the way to

a fuller spiritual life.

Almost since their marriage began, Harriet had been the partner in charge. She did what a wife needed to do for an ill spouse, and now she simply was no longer needed in that capacity. From their first moment in Philadelphia, John took over his own care, understandably believing this was the only way for permanent recovery. Perhaps this was the first turning point for Harriet, when her focus turned from her husband toward her daughters, but soon other factors would come into play, creating a more severe rift within the framework of normal family dynamics.

John and Harriet did agree on their daughters' upbringing, including exposing them to the world, and they took the girls to Europe on an ocean liner. Like most parents of moderate means of their day, they regarded the trip as equal parts enjoyable for the traveling experience and educational for its immersion into European culture.

The Jones girls, though sharing a passionate love of poetry, did not resemble sisters. Margaret, with her huge, soulful eyes, was dark-haired and serious. Elizabeth, the mischievous one, inherited her father's reputed wit and those piercing eyes. Like most girls their age, child's play was rather sedentary. She and Margaret loved reading poetry and writing their own.

Soon Elizabeth's interest in drawing with pencil and charcoal on paper grew into an enthusiasm for more complicated artist techniques and subjects. She imitated the popular genre of sketches, typically the popular romantic or domestic style that portrayed women of different cultures and soci-

etal levels. In various drawings, Elizabeth explored different styles, copied what was in vogue, and soon was rarely without her sketchbook. From drawing a mother and child, a washerwoman with the strap of the clothes-laden satchel balanced on her head, or two ladies in winter with their hands hidden inside thick mufflers, Elizabeth's early work portrayed women with a delicate strength and an inherent pride of their gender.

Harriet recognized her daughter's raw talent and encouraged her, and both parents eventually supported her desire to be an artist, believing everyone should "follow their own bent." Fortunately for Elizabeth, most of Philadelphia society considered an amateur interest in the arts to be charming, an indulgence of the upper class.

The roots of Elizabeth's lifelong practice of finding comfort within church walls began for her as a girl at Calvary Presbyterian Church. The prisms of stained glass would forever attract her artist eye, and though she enjoyed discovering different churches, she considered herself more spiritual than adhering to one religious order. "Painting is how religion possesses itself in me," she'd write many years later, "It is worship for me and very continual."

Most of Elizabeth's early sketches centered on the church, not surprising for a minister's daughter. There was *A Priest in Good Humor*, the pencil drawing she sketched at fourteen of a pleasant-looking man in clergyman dress; *Bright and Early Sunday Morning*, with its courting-age couple walking down the road while the young man in a top hat tries to catch the averted eye of the tiny-waisted woman; *At Church*, a family

portrait of a bonneted mother seated between two solemn young girls; and some others of everyday activities with titles like *Sketching, Thoughts, Thinking What to Write,* and *The Sewer,* which she decorated with a bubble over the head of the subject with the words: "I can't thread my needle." Each she signed with her initials, E.H.J., for Elizabeth Huntington Jones.

Only one sketch exists that could be construed as of her father; it shows a statesmanlike man leading three women on a walk. While the women acknowledge one another, the man walks ahead, aloof and careless of his charges; she atypically left this sketch untitled.

Of all the things to begin to tear apart the union of Harriet and John and tug at the loyalty of their two daughters, perhaps money would be the least expected.

Or maybe not.

For John had made no secret of his low priority for money in the "scheme of things," and Harriet had grown up never having had to be too concerned about being provided for, and despite marriage to a pastor, she really had lacked for little. The family, after all, had taken voyages to Europe; they had all the necessities and perhaps more than a few niceties. All that suddenly changed when John apparently trusted a relative to make some investments for him—and these investments failed badly. By family accounts, they lost everything.

After these financial difficulties surfaced, Harriet reportedly began confiding her worries about her husband's

decisions to her daughters. The seventeen-year gulf between Harriet and John, coupled with his longer absences from the family to spend time at work, may have affected Harriet's judgment, and this in turn probably increased the odds for the girls to listen and side with their mother.

As stunning as the loss of financial security was to them, underneath hid undoubtedly a greater fear: *What if Father's illness returns? Then where would we be?*

II. APRIL 26, 1964
INTERVIEW of ELIZABETH SPARHAWK-JONES
Conducted by RUTH GURIN for the
Archives of American Art, Smithsonian Institution

"But you were an impressionist painter? I mean, you picked up lighter colors than they were teaching in the Academy."

"I'm not sure. I'm not sure," Sparhawk-Jones paused momentarily and then continued her explanation. "There's a great deal lost if one loses too much of the darks. I think the things in the show are a little bit too light. Of course, in Paris I've been working in very high daylight and sunshine in a very large window. I put the canvas over the faucets of the bathtub so I could bend over easily for me because in France they'll do all things to make their guests comfortable." The image of Sparhawk-Jones painting over a bathtub in Paris was a romantic one, and fittingly the conversation followed suit as the painter began to reminisce about her relationship with artist Morton Schamberg.

"And Morton Schamberg was somebody I knew quite well. He was in love with me. It's ridiculous to be personal this way, but it was true during the years that we were students together at the Pennsylvania Academy of Fine Arts."

Sparhawk-Jones surely knew she didn't have to explain

who Schamberg was to Gurin. The American painter and photographer, who was an early follower of cubism and other modern movements, was probably a staple in the current syllabus of art curriculum. His machinelike drawings are considered early precisionist, and though his most famous work, *God*, consisting of plumbing pipes, was a sculpture, it's his only known such work.

With their conversation revolving around the classes Sparhawk-Jones took in her first years at PAFA, from two years of cast drawings, portrait and life classes, and sketch classes, Gurin brought the conversation back to Thomas Anshutz and asked if she had classes with him.

"Yes, because Chase swallowed up the life class and the portrait classes. Anshutz had a sketch class Saturday mornings which was extremely popular. That sketch class was of clothed models, people carrying a satchel or an umbrella or in the rain or all kinds of things. And that was very popular and he had that Saturday mornings. And also I think he had—well, he taught cast drawing and he made that immensely exciting."

"Oh, really?"

"He did everything—everything he did he made exciting. And people dared all sorts of techniques with the charcoal. He was a good teacher."

"And he gave his students complete freedom?"

"Complete."

"Well, that's unusual."

Sparhawk-Jones perhaps wasn't sure if Gurin was com-

menting or questioning her viewpoint, so she expanded her explanation to include the various levels of freedom she'd experienced as an artist over the years.

And that freedom began with her mother. "She was always for everyone following their bent and not for impeding anything in any way that happened. I was drawing when I was seven and eight while she read aloud to us novels . . ."

"How did you know that you should leave school and go paint and nothing else?"

"That's instinctive."

"But didn't your family get angry?"

"Not at all! My mother was very glad to have it happen."

"She was proud of you?"

"That's what she wanted. She put nothing between me and that."

"That's very good."

"And Morton Schamberg also. His father was the same way . . . he said to me, 'My father has faith in me.'"

Gurin decided to talk more about what Sparhawk-Jones thought about Schamberg's motivations as an artist as she continued to bring him into the conversation.

"When Schamberg was at the Pennsylvania Academy, what possessed him to go into abstraction?"

"Because it had already begun."

"Well, we are taught that he is one of the founders of the modern art movement in the country."

Sparhawk-Jones doesn't hesitate to contradict the popular thinking. "Well, I know. I know he was *had*," she said, and then continued with her reasoning.

"I tell you Morton Schamberg was a natural born worshipper. It isn't everybody that is. He was a worshipper in love and he was a worshipper in his work of whatever he turned his mind to. The thing had begun and it was all through. And he was very avant-garde; he was always for the last thing."

He couldn't help but become fresh again in her mind with all this talk about him. She easily recalling the handsome man of twenty-one that he was when they met during her first year at the Academy—a man with a smile that caused a lot of damage, it would turn out.

Gurin pushed her questioning further.

"Do you think he was inventive at all? I mean, do you think he had new ideas? His ideas were new and different from anybody else's," Gurin paused perhaps to offer any small out for Sparhawk-Jones and all her absolutes, "—some of them?"

For a moment, Sparhawk-Jones at least pretended to consider this possibility about a man she'd said had once loved her.

"Well, I hadn't thought so," she disagreed, arguably blurring the line between personal and professional judgment. "I hadn't thought so."

Elizabeth as a student at the Pennsylvania Academy of the Fine Arts

CHAPTER 3
THE ACADEMY

When Elizabeth talked about it later, probably trying to understand how her concentration had been weakened by a boy even a sliver, she often referred to those rebel strands of golden hair on his head.

Love wasn't considered, not seriously. At times in her life she may have wished to go back to her first days as a student at the Pennsylvania Academy of the Fine Arts and change what had happened. But the life-altering complications that began with those distracting golden locks springing from the marcel wave on Morton Schamberg's head were doubled by the hypnotizing effect of a thread of a mustache that scrunched up when he smiled at her. It was just as gold as his hair.

With the arrival of the new century, the myriad of possibilities awaiting Philadelphians in the modern world were enough to make anyone giddy. City residents already had unsurpassed availability of transportation, shopping, schools, homes, sports and their venues, and the growing strength of the industrial job market.

At the heart of this sophisticated culture, on par only with New York City, was the Pennsylvania Academy of the Fine Arts (PAFA), a teaching facility that consistently pumped an influx of the new and the best of the art world into mainstream infamy. One of the more famous alumni (in the 1860s) was native Philadelphian Mary Cassatt, although the teachings of the time—learning to draw from plaster casts of antique statues and imitating old master paintings—were vastly different from the impressionist style she'd later adopt. (In 1875, she left to study art in Paris and did not return to Philadelphia for twenty-three years.)

In 1902, as the school approached its centennial, PAFA again dominated in its tradition of being on the forefront of art techniques thanks to an innovative managing director, Harrison S. Morris, who'd led the institution since 1892. Morris understood that PAFA applicants had other viable choices for art training within the States—not to mention their ability to now travel to Europe with relative ease—so he fought to maintain a top-notch faculty, which included painter Thomas Anshutz, known for being the modest assistant to the "radical" Thomas Eakins, who was fired for using nude models in a mixed class of men and women; painter Hugh Breckenridge, who for eighteen years operated a summer school with Anshutz; William Merritt Chase, whose joy for art and teaching was legendary; and Cecilia Beaux. Beaux, the first female full-time teacher, was a Philadelphian who had studied in Paris and, like good friend Chase, was active in the jury process of exhibits and fully involved within the New York art world. One of the nation's leading society portrait painters and often compared with John Singer

Sargent, Beaux in later years painted Theodore Roosevelt and his wife and children while they were still in the White House.

So in the fall of 1902, Elizabeth entered one of the best contemporary art schools in the country in a class of forty other students. By nature, a woman choosing to be a professional artist meant something quite different than choosing the traditional educational route (as her sister Margaret would).

For Elizabeth, the Academy became a sacred place, as pure as any church or religious sanctuary. If painting was for her a spiritual calling, as she would say, then PAFA was a place where these private revelations came to her as brush met canvas. It was also where she'd spend some of the happiest times of her life, having freedoms within these walls that didn't exist in society.

Professor Chase, who took the train once a week from New York to the Academy to give critiques, immediately became a favorite; with his high enthusiasm for painting, he made anything seem possible—even for a woman. It wasn't just his charisma or his reputation or even the amazing brushwork of his paintings that was so admired—it was his outlook. Chase believed that women artists were on the same level as the men artists and treated them as such. As his contemporary Cecilia Beaux had proven, women were capable of winning the highest awards (as she had at the 1899 Carnegie Institute with a gold medal), even when in a field with men. His attitude was that women were not any better or worse than the men, but capable of producing works of equal talent.

Though Elizabeth and her fellow female students learned in some separate classes from the men, Chase's way of teaching did not make them feel separate.

Years later, Elizabeth described how Chase energized a room with his flamboyant personality. "He comes into the classroom, where the women work from life. It's a circular room so we can all be around the model. He always comes in with very clipped speech, 'Good morning, ladies.' It was just like an electric arrow had shot into the room when he said those words, 'Good morning, ladies.' We are all a little afraid of him because he is so much . . . I don't know. His whiskers are going up and palette on his thumb and his gold stick, all the paraphernalia."

In 1905, Harriet commissioned William Merritt Chase to paint a portrait of her husband. Now that they had a little money put away again, Mrs. Jones was thrilled to have the resources to pay the $1,000 fee commanded by the legendary artist. More than a little nervous about John's appearance for the portrait, she rescheduled the sitting twice, once because John had a cold and another time because he had a bad haircut and she decided he needed a few weeks to let it grow in.

When the painting was finally delivered, Dr. and Mrs. Jones sent the artist a note of gratitude, to which Chase responded:

My dear Dr. Jones,

I am much gratified to receive your letter of yesterday. It pleases me to give so much pleasure, I hope the picture will continue to give both you and your

friends the pleasure intended in the work.

With great respect,
I remain,
Yours very sincerely,
Wm. M. Chase

The portrait of Dr. Jones received praise from a wider audience than just his family. In a Philadelphia paper in the spring of 1905, under the heading "Our Greatest Portrait Painters," a reviewer wrote:

> One of the best recent specimens of American portraiture is William M. Chase's portrait of the well-known Philadelphia clergyman, the Rev. Dr. Sparhawk Jones, whose daughter is herself among the most promising of the younger American artists. This portrait has been deservedly admired by the connoisseurs.
>
> "Behind the brushwork in this head," says Ernest Knaufft, "is a knowledge of the 'planes' of the face equal to a surgeon's knowledge of the muscles of the face. It is only after years of practice in the study of painting that the human eye is able to discern all of the many planes in a rugged countenance like this."

In 1905, the school commissioned Elizabeth to create a decorative painting for the girls' lunch room, an honor based on a recent award she received for composition. By November, the three panels of work, which she titled *The Market*, were ready to hang. With an obvious display of Professor Chase's influence of painterly realism on her work, the Dutch-looking subjects of the painting resembled the work of seventeenth-century realist Frans Hals, a painter Elizabeth had come to

admire after exposure from Chase.

A note the manager of the Academy wrote to her upon receiving the panels she saved in a scrapbook she'd begun keeping read:

> Dear Miss Jones:
>
> I have your note of the day before yesterday and the panels have just come in.
>
> I cannot thank you enough for them. They are even better than I expected, and I expected much from you.
>
> Won't you please come in and see me when you are at the Academy and we will talk about putting them in place just the way you would like them.

Artists arguably receive small liberties others in society do not, a slightly wider berth for living outside the social norm. As she matured, Elizabeth's strong presence, intelligence, and wit drew people to her, and she most valued friendships with those equally confident. The other kind of girls she called *the clinging vines,* and they didn't interest her. She had no time for babysitting. Elizabeth paid attention to details, looked people in the eye, and appreciated others' insights as well as her own opinions. Her direct style made others likely feel stronger, wittier, and more gifted themselves, and throughout her life this trait attracted many of the famous and successful to her side. A family member would later joke about the pull of Elizabeth's charisma: "If there was a celebrity within two miles of Elizabeth, he would find her."

One of Elizabeth's first friendships at PAFA was with the

Connecticut-born painter Alice Kent Stoddard. Both ministers' daughters and the same age, Elizabeth and Alice became dear friends, sharing life-drawing classes together from 1905 to 1907. But it was Alice's stunning portrayal *of* Elizabeth that showcased both women in different ways and forever cemented their connection. Produced after their graduation and while a fellow resident, Alice's award-winning portrait, *Elizabeth Sparhawk-Jones*, projects strength and, perhaps only in afterthought, a hint of what's ahead.

In the painting (which remains in PAFA's permanent collection), Stoddard captured the ethereal beauty of Elizabeth's spirit and of her professional character —her confidence defined with the arch of an eyebrow, the delicate tilt of the head, the clasping of hands, the slightly unkempt hair. In the portrait, Elizabeth looks serenely off to her left. She is thinking, not dreaming. Her piercing eyes show no hint of drifting upward to the world of everyday thoughts or fantasies.

In later years, Elizabeth discussed the sitting, which she recalled happening somewhat on a whim. In the studio one day, Alice asked to paint a portrait of her, and in three hours, the painting was done. "A lovely thing," Elizabeth said at the time, a sentiment that never diminished. The Academy eventually bought the portrait—which in 1911 also won the Mary Smith Prize for best portrait by a resident woman artist—for $100.

Another important female friendship for Elizabeth in her student years was with the sculptor Emily Clayton Bishop. From a small town in Maryland, Bishop had already graduated from the Maryland Institute College of Art, where she'd

enrolled at sixteen, by the time she came to PAFA in 1905. One admirer of her work was none other than Professor Chase, who reportedly found her style "so full of force and originality" that he brought it to show his New York classes of students.

Within her growing circle of friends at the Academy, someone new caught—and held—Elizabeth's attention around 1905, and she began spending more time with him. Morton Livingston Schamberg, who at twenty-four was four years older than she, had completed a four-year college before entering the Academy on a scholarship. A few years earlier, Morton had made his first trip abroad with Professor Chase and his class to England and then to Holland, where he saw firsthand the work of master painter Frans Hals, whom Elizabeth had imitated in her painting for the Academy's lunchroom.

A constant companion of Morton's was Charles Sheeler, a Philadelphia-born painter who'd attended the Philadelphia School of Industrial Art before coming to PAFA; he worked in the same building as Morton and shared his friend's passion for the avant-garde art movement. Unlike Morton, who loved to argue his viewpoints, Charles's natural shyness made him more the type to sit back and soak in the atmosphere of an animated discussion than to participate, though his fervor ran just as deep.

A woman friend in the group teased the two men for their inseparability, calling them the "shami shees," an expression of the time that meant there was no telling where one began and the other ended. But Elizabeth came to admire Charles

Sheeler's talent and thought of him as the more gifted of the two men. In later years, she'd say that although "Sheeler was more sensitive and remarkably delicate in his painting," she concluded that "Schamberg was more important to him than he was to Schamberg."

On many evenings, Elizabeth and Morton (and more often than not joined by Charles) sat in front of a fire where they'd talk and argue about all that was happening in the changing art world. According to Elizabeth, Morton Schamberg was always full of new ideas, though she believed he spent too much time trying to make her a "radical," which being a modern painter was considered at the time. And that was not who she was, she believed, at least not then. But through all the discussions and passionate testimony from Morton, the foundation of the modern movement of painting seeped into Elizabeth's consciousness. Many years later, she'd even credit him with being her first teacher of what was modern.

Both students also shared a deep respect for Professor Chase and loved to talk about him, his preferred styles of painting, and how important he thought it was to try different genres. The latest news was that *An English Cod*, a still life in oil Chase displayed in the 1904 Academy annual, had recently been purchased by the Corcoran Gallery of Art in Washington, D.C., for the exorbitant price of $2,000.

Morton undoubtedly appreciated how Elizabeth never backed down from her opinion on an issue even if it differed from his. Using coquettish ways was just not her style. But

by many accounts, Elizabeth's witty candor could border on the caustic. Once, according to Elizabeth herself, Morton took her to Charles's artist studio, which was higher up in the same building as his own, and she blithely quipped, "The higher the altitude, the finer the flowers," indicating her preference for his friend's talent over his. When he didn't seem to understand her comment, Elizabeth added a further dig: "*Very* fancy." According to Elizabeth, Morton still didn't have a reaction. More likely, he ignored her words or thought them innocent. After all, why would she use cutting words or try to instigate a fight with him?

An unsettling but plausible reason may have been found within the Joneses' home, where Elizabeth certainly felt the negative undercurrent about her spending so much time with Morton. The Joneses knew that Elizabeth shared a class with the young man, but it seemed like more than that. Dr. and Mrs. Jones perhaps ignored or discouraged Morton's presence in their older daughter's life—despite the fact of being American born and the son of an affluent family—primarily because he was Jewish. In the twenty-four years Morton Schamberg had lived, the number of Jews in Philadelphia had grown from 5,000 to 100,000, becoming the largest immigrant group to settle in the city. But the Joneses, a prominent Presbyterian family, however tolerant they were of other faiths, approving a young Jewish man as a suitor for their daughter? Not likely.

In May 1906, Elizabeth and Morton attended a costume party at the annual May dance of the Art Fellowship Association.

Japanese lanterns hung from the ceiling, and red and yellow bunting decorations accented the international theme, with graduates dressing to represent different nations. Morton dressed as a Dutch boy, costumed from clothes he brought back from Holland.

The city paper, under the headline "Gayest of Scenes at Art Students' Dance," reported a raucous good time, with the highlight of the evening being a well-known gentleman who dressed as Madame Butterfly but concealed his identity, passing the entire evening as a girl until the last moments. They added:

> Several times merrymakers insisted upon having the "Academy Fling," the dance dear to the heart of the art student. The second time confetti was thrown over those who took part, as joining hands, they hopped, skipped, and danced around the room, giving the effect of carnival days.

A few days later, Elizabeth won the Academy's first Charles Toppan Prize and its award of $400 for *Home Life*, a study of a woman reading on a sofa. Writing about the award, the Philadelphia art reviewer for the *Public Ledger* predicted it as a stepping stone to the greater competition of the Cresson that lie ahead:

> A very strong group of work by Elizabeth H. Jones hangs in the transept, being easily the winner of the first honors in the Cresson scholarship competition. The girl is very talented. The strength and boldness displayed is exceptional. Elizabeth H. Jones may be remembered as the designer of an elaborate fresco

for the students' lunchrooms in the Academy . . . In her present study of a girl reading she has managed the long straight line of the sofa with admirable skill, tactfully persuading it to run back into obscurity, and has handled her color with facility.

Predicting Elizabeth as the upcoming winner of the Cresson scholarship, the reviewer set the stage for the pressure and attention this prestigious award received at the Academy's annual "prize day." Only in existence since 1902, the year Elizabeth entered the Academy, it was created when PAFA was left an endowment of half a million dollars by the parents of a recently deceased professor in memory of their son. The William Emlen Cresson Memorial Traveling Scholarship, which enabled the first honor recipients to travel and study in Europe for two years, quickly became the most important award a student could receive.

Even before this review, words like *strong, exceptional, boldness*, and *talented* were tossed into descriptions of Elizabeth's work as freely as the flurry of carnival confetti at the artists' dance. She had to know she was a favorite for the Cresson; and although there existed lesser awards of money to travel for a shorter periods (in last year's awards, Elizabeth's friends Alice Kent Stoddard and Emily Bishop both won $500 for summer travel to Europe), anything less surely paled in comparison with the woman's first honor of $2,000.

The Cresson Memorial Traveling Scholarship presumably meant different things to each potential recipient, but undeniably the award offered many more countless intangibles than just the two years of foreign study. There were myriad

possibilities, from being exposed to the latest techniques, to traveling on a whim just to see the latest experiment with color, to discussing techniques with other more learned artists over coffee in Paris, to simply living by one's own rhythm as an artist.

The chance to study expenses paid in Europe was a rare opportunity. In her scrapbook, Elizabeth wrote a favorite quote by Walt Whitman that likely expressed her hopes: *He only wins who goes far enough.* Winning the Cresson, she knew, was how she'd get there.

But in late May 1906, when the announcement was made that Elizabeth H. Jones had been named the winner of the woman's top honor, it was meaningless. For Cresson, its $2,000 award, and all its promises had no value if the recipient declined the scholarship—if she refused the two years of travel and study abroad—and this was what Dr. and Mrs. Jones immediately demanded of their daughter.

Elizabeth presumably heard all their arguments as to why, as a lady and the daughter of a minister, she must refuse the award: *It is not proper for a woman (especially a minister's daughter) to travel unescorted through Europe; it is unnecessary for her to advance her art so far from home when she still had so much opportunity in Philadelphia.*

The latest review of the annual exhibition from the *Public Ledger* reported her award and decline without explanation. It read:

> The honors of the display are with Miss Elizabeth H. Jones. She was awarded first honor in the Cresson competition, though she declined the scholarship. Her composition won the first Toppan prize in a finely brushed, well-conceived design—a young woman reading. In balance, in the ready interpretation of various problems, in its light and shade and in its comprehension, rather than the command, of color, the work is admirable. Ready skill in composition marks her competitive work and one study in the nude of a back is of the very best type of student work.
>
> The quality and charm of her work makes her future secure, if it is taken up in a strictly professional spirit.

Elizabeth was crushed. Years later she apparently confided her belief as to the real reason her parents didn't allow her to travel to Europe: Morton also would be there, and that was enough reason to forbid the trip. If she spoke about it then with her parents, she didn't say, but most likely she hadn't dared. Even into her eighties, the loss remained a complicated and painful burden. By family accounts, she remained wistful to the end, imagining countless possibilities of a journey fought for and earned yet denied to her.

Religious bias and marriage partners never to be considered were strong reasons for Harriet and John to nix Elizabeth's dream of travel to Europe, but perhaps there was another factor besides Morton's unsuitability. By staying in Philadelphia, Elizabeth remained available as a companion for her lonely and increasingly overbearing mother. It would be a pattern that would recur often and a dynamic that appar-

ently Elizabeth, the dutiful daughter, never acknowledged.

After the Cresson, Elizabeth's feelings for Morton couldn't help but be changed. As much as she knew logically that it wasn't his fault that her parents used their relationship against her, a part of her forever held him accountable, all the while trying to diminish his importance in her life.

Morton Schamberg arrived in Paris in the summer of 1906 after spending a brief period painting seascapes in Gloucester, Massachusetts, with Charles Sheeler and some other Academy friends. Working in Spain, Holland, and France, Morton's primary residence became Paris, where he began to develop interest in other new styles he wanted to pursue. When in Philadelphia, he shared a studio with Charles on Chestnut Street, but he likely didn't try to contact Elizabeth. He surely knew it would be pointless.

And the next time Elizabeth spent time with one of the "shami shees," the other would be dead.

The Porch, c. 1907, by Elizabeth Sparhawk-Jones, Oil on canvas, 30 ¼ x 30 ¼, Courtesy of Private Collector

CHAPTER 4
"THE FIND OF THE YEAR"

The loss of the Cresson scholarship left Elizabeth not only looking at a long few months trapped in the hot city with her parents, but quite possibly stuck careerwise. Studying the paths of various artists, success seemed far more likely if time was spent studying in Europe; this apprenticeship was an experience impossible to replicate and one that Elizabeth forever regretted missing.

By his charming omission (as he'd repeatedly encouraged overseas study countless times), Professor Chase, he with the long-corded spectacles and the wild smiling mustache, blithely ignored his young protégée's current situation, writing a cheery congratulatory note to her on May 28, 1906, that read:

My dear Miss Jones,

I was pleased to receive yours of the 24th . . . You are fully entitled to all that my teaching has done for you. Not a word of recommendation was needed from me. I am pleased to know that you'll be with me again next season. I think there is something to be done for you in the way of drawing. Wishing you

a very pleasant summer.
I remain,

Very sincerely,
Wm. M. Chase

His reputed joy for painting apparent, Chase likely sought to renew any crushed hopes of his student and point her in the only effective direction: ahead. Though his words sounded optimistic, they glossed over potential damage done that no additional Academy classes—even *his*—could remedy. What could truly substitute for witnessing firsthand all that was current in the art world? Morton and Charles had already left for their summer in Europe. Even Elizabeth's friend and fellow minister's daughter Alice Kent Stoddard, who again had won the Cresson scholarship of $500 for summer travel, had gone abroad (though she had decided to tour with her sister instead of traveling with the group).

With minions of students from three different teaching venues, along with his eight children (and their mother) needing his attention, Chase taking the time to write Elizabeth an encouraging note was definitely appreciated. It was a kindness she would never forget, and one she would repay in loyalty to Chase whatever the cost.

But despite the pep talk from Professor Chase, Elizabeth likely prepared for a long, very *unpleasant* summer.

During the rest of the year and through 1907, Elizabeth again began to work steadily on her painting. Anger and lingering resentment perhaps fueled her to push herself harder and longer than before. Others may gain an advantage

through European study, but that didn't mean there weren't ways to compensate. By the end of the year, her dedication paid off with a significant honor by the *New York Times*.

In a November review of the Academy's 1907 Fellowship Exhibition headlined "Younger Painters to the Fore" with a subheading of "Miss Jones's 'The Porch,'" the *New York Times* art critic wrote glowingly about Elizabeth's entry:

> In the present exhibition the ablest exponent of this modern method of handling one's subject is found in Miss Elizabeth Jones, whose picture "The Porch" showing several ladies seated in the sunlight and shadow of a colonial porch, was the most unforgettable canvas in the show. Miss Jones is a pupil of Breckenridge, whose virtues of sunlight and air she exhibits to a degree rivaling the master himself. By reason of the fine rendering of values and the intelligent understanding of perspective planes, the canvas has depth and space, and everything holds its proper place in the composition. In its beautiful chords of clean, fresh color—a luminous violet in the shadows and a vibrant gold in the sunlight—in its freedom of execution, and in its unfettered fear of the palette it reveals a new and refreshing personality that will surely make itself felt in our world of art.
>
> It represents the younger generation knocking at the door, threatening the position of the "Masterbuilder," whose canvas, No. 76, hangs nearby. This painting by Mr. Chase, an obvious attempt at rendering light and air, falls quite flat and looks tame

and stilted by comparison with the jubilant performance of Miss Jones.

Elizabeth had poured herself into every inch of *The Porch*, and it showed. Receiving such lengthy praise, detailing the colors (for their readers benefit, the *New York Times* also had printed a 6x6-inch reproduction of the painting to accompany the article) along with the execution, must have been gratifying—despite favorable comparisons over Chase that surely made her uncomfortable. Perhaps as a reward to herself, she made a decision around this time that in many ways signified her maturity as an artist: She decided to officially change her name.

Adding Sparhawk (in honor of her father's mother) with a hyphen to her last name, the young girl born Elizabeth Huntington Jones, the student artist Elizabeth H. Jones, became Elizabeth Sparhawk-Jones. (Margaret at this time was registered at Bryn Mawr College under Sparhawk-Jones, perhaps for better recognition as the preacher's daughter, but the use was temporary.)

In later years, Elizabeth would quip that the change was simply because "Jones is not much of a name." But changing her name also symbolized a kind of marriage to herself, to her career as a painter; she wasn't waiting around to affix some man's name to hers. In most paintings she signed sparingly, initials only, E.S.J.

In January 1908, the first newspaper reported the style change with a subheadline that omitted the hyphen but nonetheless had good news, announcing: "Miss Sparhawk Jones Wins." The article, which detailed the 103rd Annual

Exposition of the Pennsylvania Academy, highlighted her accolades for winning the Mary Smith Prize, a $100 purse, for *Roller Skates*. Under the simple heading, "Miss Sparhawk-Jones' Work", another critic wrote:

> Among the many newcomers who have "arrived," Miss Elizabeth Sparhawk-Jones is one of the most notable. She is a daughter of Dr. John Sparhawk Jones, the well-known Presbyterian clergyman of this city. Although still quite young, she has developed a style of her own. She has two canvases in the exhibition, "Roller Skates" and "Nurse Maids," both delightfully fresh in coloring, evidencing surprising skill in her handling of light.

After the show, *Roller Skates* sold for a whopping $500 to physician with a Chestnut Hill address. To place this price in context, Wanamaker's department store was selling men's dress pants for $10, and the workers from the Philadelphia transit company were fighting for a wage increase to 25 cents an hour.

At twenty-two, Elizabeth seemed to be fulfilling many of those earlier prophecies written about the girl whose "quality and charm of her work makes her future secure if it is taken up in a strictly professional manner." What the writer meant by the second half of the sentence isn't quite clear. What was a "strictly professional manner"? To remain single? Forego having children? Or perhaps just the lesson already learned from golden-haired distractions.

Elizabeth's next challenge lay five months ahead in April 1908 at the 12th International Art Exhibit at the Carnegie Institute in Pittsburgh, Pennsylvania. The American Salon—as it was otherwise known—was a prestigious event reputed to be the only true international exhibit in the United States because about half of the show's painters came from foreign countries. Unlike other competitions, works were exhibited whether or not they had been previously shown.

Art critic and writer William Henry French breathlessly reported after the private "press view" that the "standard is higher than ever." He even compared the Carnegie exhibit favorably with the Royal Academy of Arts in London, which accepted only English art, and the Paris Salon, which invited foreign painters but only those with new productions, and he coyly hinted that many "authorities" agreed with him. Of the year's highlighted artist Winslow Homer, who exhibited twenty-two of his works, French deemed these a "remarkable and wonderful display" and named Homer "unquestionably the master American marine and landscape painter as Sargent is the greatest portrait painter."

French's remarkable eye for talent is clear, but he also seemed to have an ear for tuning in to the undercurrent of an event, and on this press night, he caught the buzz around a painting titled *In a City Square*. He wrote, "As the visitors passed before the paintings almost every one had a choice as to the prize winners, but their curiosity is not to be gratified until this afternoon, when they are announced at the Founder's Day exercises...." Based on the synergy around the paintings, French confidently titled the paragraph about the artist of *In a City Square* as the "'Find' of the Year." He continued:

"THE FIND OF THE YEAR" 69

In this exhibit is a painting by a Pennsylvania woman, who is looked upon as the "find" of the year as an artist. Elizabeth Sparhawk-Jones of Philadelphia is the artist and her "In a City Square" is full of sunshine. She received the Mary Smith prize at the Pennsylvania Academy of [the] Fine Arts this year, the first she has ever exhibited. This American artist follows very much after the school of Anders L. Zorn the Swedish artist. [French was referring to Zorn's penchant for genre scenes of his rural Sweden.]

Though French did not even hint at any growing unrest in this 1908 review, attitudes had begun changing in the American art world about the ways some artists approached the painting process. One of the most forward-thinking groups, energized into being when paintings of three of the men (George Luks, William Glackens, and John Sloan) were rejected in 1907 for exhibit by the National Academy of Design in New York, came to be known as "The Eight" and was led by Robert Henri, a student of William Merritt Chase.

Called variously urban realists, new realists, New York realists, or, more negatively at the time, founders of the Ashcan School, these men depicted real-life subjects, even the grittier sides, rather than painting the aesthetically pleasing scenes of nature or fashionable portraiture. A successful exhibit they held in 1908 at New York's Macbeth Gallery would be a forerunner of the iconoclastic Armory Show still five years away.

Even some teachers who had encouraged their stu-

dents to explore Europe's latest trends soured when novel techniques like urban realism or other more abstract styles were brought home. Chase, for one, had never been a fan of European masters like Matisse, Cézanne, or the sculptor Rodin, and when the last came to New York for a showing at photographer/art dealer Alfred Stieglitz's gallery on Fifth Avenue, 291, he reportedly "warned his students not to go and see the 'junk shown.'" In the ensuing few years, Chase's former student Robert Henri would be the first, but not the last, to officially break away from the Chase School of Art in New York, another sign of changes ahead.

Around the summer of 1908, according to family accounts and sketches in Elizabeth's scrapbooks, the Jones sisters, accompanied by a few friends, set sail for Europe. It would have been a fitting time for renewal and celebration after Elizabeth's recent professional successes. (And if Elizabeth wondered about seeing Morton Schamberg abroad, she didn't have to be concerned, as he was in the States for the summer.)

The trip was equally deserved for Margaret, who had just graduated from Bryn Mawr College, an elite women's college about 11 miles west of Philadelphia known for its vigorous academic program. She had combined an English major with two years of Latin study and then two years of French. The youngest member of her class, Margaret hadn't been terribly happy there, attributing some of this to her being "immature." In later years, she wrote that her "personal and intellectual development was far more influenced by my home environment, my love of reading, and . . ."—appropriately—"my many visits to Europe."

On this trip, the girls stopped in Paris, with its museums and galleries. They likely mingled with their European and American counterparts, like school friend Emily Bishop, who had just set up a studio there. They also went to London, where a young minister named Reverend R. J. Campbell seemed to catch Elizabeth's attention. She sketched different versions of the dark, square-jawed young clergyman with wide-set eyes and long lashes. His features were the polar opposite of the finely sculpted ones of blond Morton Schamberg—and apparently a very pleasing distraction. By the time they left London, Elizabeth had completed more than twenty varying-sized portraits of Rev. Campbell. Most showed him full face, baring his compassion and spirituality through his eyes.

As Schamberg crossed the Atlantic in the fall of 1908 to return to Paris and Italy, Elizabeth began her last year at the Academy with a nighttime life-drawing class. Her final year would be one of her brightest professionally, heralding in both national exposure and acclaim.

At the fall exhibition of the Fellowship of the Academy, Elizabeth exhibited a painting titled *Baby Coaches*, which didn't win anything and only received a lukewarm review (though she saved it). It likely didn't bother her. As she knew by now, in the subjective and often fickle world of art, the spring's American Salon was where it counted. This year Elizabeth submitted two paintings, *In Rittenhouse Square* and *The Veil Counter*, which were shipped for her to Pittsburgh along with her photograph for the catalogue.

For the Carnegie Institute's 13th annual international

event held in late April 1909, the words of French writer Honoré de Balzac seemed to have motivated her: "Inspiration is the opportunity of genius," she wrote in her scrapbook above the first mementos saved from this event.

Despite touting its "24,000 offices in America" at the top of its cable, Western Union lost by two days time to a Pittsburgh newspaper in delivering Elizabeth Sparhawk-Jones the tremendous news of her honorable mention win for *In Rittenhouse Square*. For on April 29, the *Inquirer* announced in big, bold letters: "Philadelphian's Painting Praised at Pittsburg Show."

Undoubtedly a more creative writer, perhaps one not so drawn to alliteration, could have whipped up a more apropos and dynamic headline to match the extent of her feat, such as: "Sparhawk-Jones Wins: The Only Woman to Win Anything—and the Only American to Win an Honorable Mention."

With the selection of her oil *In Rittenhouse Square*, she had joined such company as Boston's Edmund Tarbell, awarded medal of the first class; George Sauter of London, recognized for second place; and Bruce Crane of New York for third. While the *Inquirer* obligingly noted its native daughter's work being praised, national magazines suddenly began courting the young Philadelphia sensation with a wider lens of appreciation.

In May 1909, the national magazine *Harper's Weekly* published copies of the works that "won distinction" in a spread of the exhibit and placed *In Rittenhouse Square* next to

"THE FIND OF THE YEAR" 73

Crane's *November Hills* and Tarbell's *Girl Crocheting*.

The Studio, a national magazine for artists, called Elizabeth's painting of nursemaids and children enjoying the city park on a winter day "a clever, spirited little picture," and another national publication, *The Craftsman*, said it "showed a most delightful outdoors with figures." As a bonus to her first national exposure, she sold the second painting she exhibited, *The Veil Counter*, for $200.

A note written April 30 and delivered to her with a return address of 1626 Chestnut Street likely gave Elizabeth a few moments pause (or panic) until she saw it was from Charles Sheeler and not his sometime roommate. He wrote:

> Dear Miss Jones,
>
> I have just read in the paper of the honor conferred on you by the Carnegie Institute. Please accept my very heartiest congratulations.
>
> C. R. Sheeler

The Art Institute of Chicago, similar to the Pennsylvania Academy in that it was a museum and a school, also took note of her recent success and requested a loan of both Carnegie-shown paintings for their autumn exhibition. This would be the first time the Institute noticed the emerging talent, but their eventual purchase of two of her later works began a relationship that exists today.

In 1909, however, Elizabeth couldn't comply with all of the Institute's requests, as she'd already sold *The Veil Counter*. She did send *In Rittenhouse Square*, where the work coinci-

dentally shared the wall with a small painting done by her friend Charles Sheeler. As of 2010, *In Rittenhouse Square* remains in good company within the Manoogian Collection, which also houses other American impressionist works, including those by Childe Hassam, William Merritt Chase, Mary Cassatt, and John Singer Sargent.

The cost of fame was not lost on Elizabeth, and by view of her scrapbooks, she kept herself quite grounded despite the escalating fame and success. Giving space to her detractors as well as the well-wishers within her pages, she included biting comments, such as these published in the *Pittsburg Bulletin* about her:

> Elizabeth's Sparhawk-Jones's "In Rittenhouse Square" is representative of a class that has latterly become popular, but it is no more distinctive than Arnesby Brown's "The Gate." Both are commonplace, whatever must be said of their technical excellence.

The fickle critic also didn't like George Sauter's work, and while expressing admiration for Edmund Tarbell's winning painting found it be "curiously like last year's first honor."

Scrolling from the right corner down the page next to some reviews, Elizabeth added this quotation from Walt Whitman in her neat cursive:

> Have you learned lessons only of those who admired you, and were tender with you, and stood aside for you? Have you not learned the great lessons from

those who rejected you and braced themselves against you? Or who treated you with contempt, or disputed the passage with you? Have you had no practice to receive opponents when they come?

There's no doubt Elizabeth was prepared for opponents with pens whose words may be swords; she anticipated the sacrifices and of course had already made some. But her true opponent, one who *would* reject her, treat her work with utter contempt, and dispute the further passage of her life quietly waited within, still giving her a few years breadth.

Elizabeth with her sister Margaret

CHAPTER 5

GHOSTS

Flush from her triumph at the American Salon in late April 1909, Elizabeth celebrated her graduation from the Schools of the Pennsylvania Academy of the Fine Arts three weeks later. It had been one of the most successful seasons in the history of the schools, according to newspaper accounts of Instruction Committee Chairman Dr. John Packard's speech given during the schools' ninety-ninth commencement, in which he noted, "the work of the students had grown exponentially in its importance and magnitude."

At the closing ceremonies held in the Temple Gallery, Packard awarded the scholarships and prizes, among them a $25 prize to "Elizabeth H. Jones" for showing "the most poetic or best abstract or idealistic point of view as decided by the instructor." Friends Alice Kent Stoddard (who also won the Charles Toppan Prize) and Alice V. Corson had won partial Cresson scholarships. After the ceremony, the graduates joined members of the fellowship of the Pennsylvania Academy for an evening tea.

Henry J. Thouron, benefactor of the first prize Elizabeth ever received at the Academy, sent her a note to compliment her on this final honor as an Academy student. These

seven years had served her well, and the starry-eyed seventeen-year-old painter who'd entered those doors was now a woman of twenty-four and an international-award winner. On this spring graduation night, the spectacular likely seemed more than just within her reach, but, as the papers predicted, "assured."

Physically, she looked the part now, too. Maturity had defined the soft plumpness of her face, leaving her facial features more angular; her neck appearing thinner and longer. If she was painting, strands of her long hair fringed her face, escaping from the untidy chignon at the nape of her neck. Carrying her petite frame with grace, Elizabeth appreciated the undercurrent of movement and easily stole most photographs taken during that time simply by the sway of her hip or the lift of her chin.

Her graduation from PAFA didn't mean Elizabeth's connection to the school had ended; it had merely changed form. Though Professor Chase had discontinued his teaching assignment (and she'd likely miss the regular opportunity to see him), a relationship with PAFA was for Elizabeth, like most students, a lifelong commitment. As soon as January 1910, three paintings by Elizabeth contributed to the PAFA winter exhibition: *In Rittenhouse Square*, *Passing*, and *At the Zoo*.

A few months later, representatives of the "Fifth Annual Exhibition of Selected Paintings by American Artists" (organized by the Albright Art Gallery at the Buffalo Fine Arts Academy in New York, and Missouri's Saint Louis Art Museum) asked Elizabeth to contribute to its collection of

paintings by American artists—an exhibition that would tour the country from May through September 1910. She agreed, lending them *In Rittenhouse Square* and *Passing*.

A vacation was due. In August, Elizabeth and Margaret traveled north with their parents for a summer holiday amid the lakes and mountains of Vermont. With the time demands of Elizabeth's painting, Margaret's recent graduation from the University of Pennsylvania with a master's degree in history, and the arduous work involved with the church, the Jones family, like countless others, surely anticipated a lighter schedule away from the routine: lazy days balancing play and restoration under the shadow of the Green Mountains. Yet three weeks into the trip, any sense of tranquility they'd found suddenly shattered.

With so many years spent worried about the health of Dr. Jones's mind, it was his heart, after all, that betrayed him. The sixty-nine-year-old patriarch suffered an apparent heart attack toward the end of their vacation and died. The abrupt nature of his death necessitated the family making hasty arrangements to return his body to Philadelphia for the memorial service, and then to Baltimore for burial.

The world must have turned surreal overnight for the Jones women. It certainly did for the larger Calvary Presbyterian Church family, where the reaction to their pastor's death reportedly sent shock waves of grief throughout Philadelphia and beyond. With the emotional headline, "Many Weep at Funeral of Dr. J. Sparhawk Jones," the *Evening Bulletin* on August 22, 1910, reported on the event:

The unexpected new of Dr. Jones' death has caused a

shock in religious circles generally in this city. He was apparently in good health when he left three weeks ago with his wife and daughters to spend his vacation in Vermont. The body was brought to Philadelphia yesterday and taken to his home, 1814 Pine Street, where a brief private service was held this morning prior to the service in the church. The services were exceedingly simple. There was no sermon . . .

Seventeen years had passed since the doors of the Calvary Church on Locust Street first opened for Dr. John Sparhawk Jones and his young family. In that time, the city's skyline had grown magnificently jagged, more and more cars filled the streets as politicians promised new construction to widen and increase roads, and the number of Philadelphians themselves increased at the greatest rate in the city's history.

The minister who'd fallen from grace in Baltimore and came to Philadelphia for a new start had done better than merely survive; he prospered (if only in the strictest sense, Harriet may have added). Writing three books (*Seeing Darkly*, 1904; *Invisible Things*, 1907; *Saved by Hope*, published posthumously in 1911) in seven years, he overcame his frenetic compulsion by giving in to it, eventually profiting from his locked-door days spent working. His depression disappeared from public view, hiding under a safe shelter of solitude and wisdom. He may not have necessarily chosen a family life if he'd not been so directed, but he had tried to do well by Harriet and their daughters. Trips to Europe, strong leadership, the providing of a moral compass like his father and his uncle before him—he had always believed these counted for something.

Although the newspaper reported the absence of many dignitaries and parishioners caught unaware of the minister's death because of summer holidays, a number of impressive participants and guests filled the pews at the service, including the president of Lincoln University, an assistant to the president of Pennsylvania Railroad, two judges, a stated clerk of the Presbyterian General Assembly, a secretary of the Presbyterian City Missions, a newspaper editor, a representative from the Brown Memorial Church in Baltimore, and many clergymen and elders from various churches throughout the region.

From the memorial service in Philadelphia, the family and their close friends headed to Maryland, boarding the 12:13 p.m. train at Broad Street Station to travel to Baltimore County. John's body was laid to rest in a small cemetery behind the Immanuel Episcopal Church not far from Harriet's childhood home of Clynmalira in the town of Glencoe. The stone church and its grounds, which encompassed 11 acres of quiet Maryland countryside, sat atop a hill accessed by a narrow, winding road through tall woods.

Created with donations from families like Harriet's relatives, the McCulloughs, (who also donated land for the church itself), the cemetery was established in 1886 with the promise that it was to be "non-sectarian, with no regard to race, religion or the circumstances of death. All will be given 'safe lodging and holy rest' including any person taking his/her own life." This was an important inclusion as some cemeteries would not accept interment of suicides. (Living up to this promise, the church cemetery in 1906 had accepted Henry Perky, the inventor of shredded wheat, who drowned

in his bathtub most likely accidentally, but it was rumored to be a suicide. His burial place at Immanuel has become a local legend as it's whispered that Perky shows himself on warm summer nights.)

John Sparhawk Jones's coffin-shaped monument was very large and appropriately grand, displaying a raised crucifix and listing his various pastoral assignments. Tombstones of Alexander Winchester, Harriet's father, along with a few generations of McCulloughs, resided nearby. At the foot of Dr. Jones's gravesite, a large space of land remained for the rest of the Jones family.

⌒

Dr. Jones's weakness—that of trusting the untrustworthy with his finances and losing his fortune—became his unfortunate legacy, at least for the short term as Harriet oversaw their move from the Pine Street manse. No longer an official part of the Calvary family, she needed to find a suitable new home for herself and her daughters. Fulfilling the marriage predictions of Harriet's two older sisters, John had left his wife of twenty-six years with a near-worthless estate.

Crumbled in a widow's stupor of grief very likely compounded by guilt about the way she reacted to her disappointment with John's part in financial losses, Harriet did an about-face, zealously wearing the traditional black mourning dress. Turning toward her daughters for emotional and financial support like never before, Harriet apparently wasted no time in urging Elizabeth to paint—and *sell*—and Margaret to find steady employment. In short time, Margaret accom-

plished just that, finding a job teaching at Miss Irwin's School in Philadelphia.

The widow's immediate relocation of her family to 1613 Chestnut Street was just that: a physical shift of belongings to a meaningless address. Within months, they would move again, this time to Spruce Street for another rental. It was the start of many such moves for Elizabeth and her mother, beginning a transient pattern that would last the rest of both their lives. For Margaret, the move would be short-lived. Within a few years, she would leave Philadelphia behind for a new untethered life in Baltimore.

In the fall of 1910, the Worcester Art Museum in Massachusetts wrote Elizabeth asking for the loan of a painting for an exhibition. In his letter, the museum director hailed Elizabeth as "an artist of rare promise." Despite the flattery, Elizabeth replied without further explanation that she "can't comply at this time."

In October 1910, Philadelphia celebrated as the Athletics baseball team won the World Series. During this period, Elizabeth agreed to an exhibition at the Corcoran Gallery of Art in Washington, D.C., a decision that proved financially beneficial. After the show, she earned $250 for the sale of *Comrades*, enough to pay for six months of rent. The buyer of the painting, a Charles Van Cise Wheeler, who lived on 16th Street in D.C., apparently became smitten with his new work and curious about its creator. A few months after making the purchase in February 1911, Wheeler wrote Elizabeth and asked if she'd consider visiting him in the nation's capital. There is no record of her reply.

Early in 1911, Elizabeth contributed two works, *Turning Home* and *In Apron Strings*, to the Academy's winter exhibition. But her friend Alice Kent Stoddard created the biggest splash at the event with her oil portrait, *Elizabeth Sparhawk-Jones*. After presenting her with the Mary Smith Prize given to a resident woman artist, the Academy quickly bought the painting for its permanent collection.

That summer, Miss Eliza Otto, whom Elizabeth described to Emily Bishop as "a dear, dear friend and benefactress," took Harriet, Elizabeth, and Margaret on a vacation to Marblehead, Massachusetts. Miss Otto, who could double for Queen Victoria and seemed naturally as regal, was a friend of Harriet's Maryland cousins, the McCulloughs, and she had known Harriet since her childhood. Surfacing now (probably because of Harriet's recent loss), the elderly woman generously shared her beach home with the Jones women.

It was an overdue respite for them. At first it may have been bittersweet—the first vacation without John—but Elizabeth, who had brought a camera, saved a photograph that recorded at least one moment of happiness: It showed dear Miss Otto and her guests gathered around her in a garden. The hostess displays a contented smile, Harriet—in her ubiquitous black—even risks a tight grin, but it's Elizabeth and Margaret, caught midlaugh, who ignite the picture.

The Academy's 1912 annual winter exhibition set the stage for a comeback year of sorts for Elizabeth. Winning the Mary Smith Prize, an award of $100 given to a resident wom-

an artist, for *In the Spring*, Elizabeth then sold the work to her favorite former instructor William Merritt Chase for $350; she also sold two other exhibited works to an art collector in New York. Chase, who sometimes purchased an artist's work to bolster his or her confidence, brought Elizabeth's work home into a collection that included works by notable artists like Jonas Lie, Howard Chandler Christy, Salvatore Guarino, Charles Hawthorne, and others.

In the Spring earned excellent reviews, including this tribute by a critic from the *New York Sun*. It would be one of the last reviewers who could call any Sparhawk-Jones work *not* of a poetic mood, and his appraisal perhaps shows the last snapshot of her early style.

> Miss Sparhawk Jones reveals a personal way of seeing and presenting aspects of everyday life. Her nurses and children fairly tingle with reality, presented in a broad, forthright manner. You won't go to her for poetic moods, for the semitones of subjectivity. Her palette sings with the triumphant C major of life, as Robert Browning somewhere phrased it . . . "In the Spring" is distinctly the magnum opus of the young painter. . . . The title is ingenious, for the flora—multicolored as the coat of Joseph—is not that of the out-of-doors, but that of a lavish array of millinery to delight the feminine fancy and deplete the masculine pocketbook. . . . The entire canvas is undershot and overshot with intense, warm and vivid color laid on with impressionistic strokes as bold as the sword of Jeanne Darc [sic]. . . . "In the Spring" is far in advance even of her prize-winning picture of 1908.

Only one month after that success, in March 1912, Elizabeth and Margaret endured a painful loss with the sudden death of their good friend Emily Clayton Bishop. The promising sculptor, who had won two Cresson scholarships and many commissions, including one at the Academy of Music in Philadelphia, died suddenly of an undiagnosed heart ailment.

Her father, now Emily. Lives taken so quickly with no chance to say goodbye; Elizabeth and Margaret each wrote passionate testimonials about Emily for the service booklet given at the memorial service. The art world also recognized the loss of Bishop's talent; at the 1915 Panama-Pacific International Exhibition in San Francisco, sixteen of her works were exhibited as a memorial to the young girl whose work Chase had once extolled as "so full of force and originality."

At the end of March, a reporter for the Sunday edition of Philadelphia's *Public Ledger* called on professional artists to dramatize a story about the changing nature of women's fashion. The headline candidly asked: "Is Modern Dress Ugly or Lovely? By Famous Artists."

Elizabeth joined William Merritt Chase, Cecilia Beaux, Wilhelm Funk, and other artists in a full-page story about the "artistic value of the present styles of women's dress," which was becoming more figure conscious. Views ranged from Beaux's, who said that "the effect of the natural line of the body, not held closely, but gracefully suggested, give the styles their beauty . . . " to Funk's blunt subhead of "Why Short Skirts Are Ugly," to Chase, who said, "I do not think

there is anything vulgar in the present styles. But we must remember . . . a style that is most becoming to a certain figure is ugly on another type of woman." Elizabeth suggested:

> The dress of today can be wonderful and dazzling in its color combinations of line and color. The most deliciously sophisticated thing I know is an extreme, stopping just short of absurdity, like the whir of limb and silk one finds in a portrait by Boldini. But it takes an artist to know when to stop.

She didn't put this article with her other newspaper clippings in her scrapbooks, but instead saved the entire newspaper section with some other mementos. Perhaps it was too frivolous a piece for her to include in her scrapbooks alongside her reviews and thoughts, but she couldn't ignore the prestigious company she shared within the article. Now twenty-seven, Elizabeth had won a place among the best, declared with all the boldness of its "famous artists" headline.

A few months later and for the second time in her career, the International Exhibition at the Carnegie Institute gave Elizabeth a needed boost at its 16th American Salon in May. Joining the current crop of A-list artists such as Robert Henri, Mary Cassatt, Childe Hassam, and Cecilia Beaux, Elizabeth exhibited a large (38x48-inch) oil on canvas titled *Shop Girls*. With her customary vigorous brushwork and vivid colors, she showed women working in the relatively new world of the department store. In her column for the *Spectator*, art critic Adele Fay Williams expressed excitement at seeing some changes in art development at the show. Williams wrote:

> Not for many, many moons has there been so apt an

apotheosis of certain phases of art. Phases that no longer concern themselves with bald facts, but with their own views, moods, and impressions of concrete things. . . . Never has there been a greater number of poetic interpretations, or subjective meditations on canvas, as compared with strictly realistic treatment.

In her review, Williams also described Henri's painting of a "witch-like girl in black, subtle and fascinating, making less display of virtuosity than in other studies." Williams detailed Cassatt's portrait as a "brooding, brown girl with a fan, powerful in treatment." For Hassam's work, she expressed pleasure with his "vivid and glowing" *Reflected Sunlight,* as she did an impressionistic piece by Claude Monet. Cecilia Beaux's *Portraits of Summer* Williams brusquely termed "characteristic." Other contributors of note included London native John Lavery, who had won a medal at Carnegie Institute in 1896. William Merritt Chase and Edmund Tarbell were among those who helped compose the Jury of Awards.

The Friends of American Art purchased Elizabeth's *Shop Girls* to hang in the permanent collection at the Art Institute of Chicago. In her article, Williams raved:

> *Shop Girls* by Elizabeth Sparhawk Jones is a splendidly spontaneous study, easily managed, brilliant in color, modern in treatment. It embodies more than the hint of existing conditions. It is absolutely different in conception from a study of a department store . . . in last year's exhibition.

But Williams's article had only hinted at the magnitude and speed in which things were changing in the art

world. It could be heard in the energetic conversations of some younger artists and in the strained tones of yet others; it could be seen in Henri's strikingly different work and in more modern experiments like these. Elizabeth appreciated styles like Henri's, but she also believed that art was not really separate from life, as he liked to debate. From her time spent with Morton Schamberg, she knew what being modern meant, and she consciously chose not to go there (unlike some artists who would express "shock" at the coming changes). Paintings like *Shop Girls*, which depicted life in the city and the social forces behind it, would be categorized broadly in later years as "urban realism." It also would be compared by art critic and writer Michael Preston Worley in later years with Degas's compositional methods with his theme of women "depicted without pretension, engaged in their labor." But in 1912, Elizabeth's work was not close to—or trying to imitate—the Ashcan School of some of her peers or anyone else; rather, it represented her own vision of impressionism with all its influences.

Though intrigued by the new artistic viewpoints, she kept those thoughts to herself and within the pages of her scrapbooks. No need, perhaps, to upset anyone with mention of her admiration for the vision of new artists. But this raw style was foreign territory. In many ways, the works seemed created entirely to evoke the emotion of the viewer, a storytelling ploy she'd been taught by Chase to abhor. In contrast, her strength lay in the impressionistic paintings she produced of shining moments simply caught on canvas, studies of women reading, children on roller skates, of a city alight with ethereal beauty.

After she returned to Philadelphia, she sent *In the Spring*, loaned by Chase, to the Worcester Art Museum, to fulfill her earlier commitment to them. She had no plans to travel anytime soon. Perhaps the long train rides had begun to tire her, exhaustion overcoming her patience for the requisite protocol of polite society. Maybe she was still grieving for two people she'd loved and suddenly lost. Or possibly she was waiting to see the fallout from the upcoming Armory Show to be held in New York City. Whatever the cause of her withdrawal, it wasn't like her.

Elizabeth Sparhawk-Jones, c. 1910, by Alice Kent Stoddard, Oil on canvas, 27x20 1/16, Courtesy of the Pennsylvania Academy of the Fine Arts, Philadelphia. Henry D. Gilpin Fund

CHAPTER 6
BURYING THE SUN

Margaret had met someone.

Now twenty-six, the English teacher may have wondered if she'd ever find a suitable man to marry. But she found her match in Bayard Turnbull, a handsome and accomplished architect from Baltimore, who, it seems, was very much worth the wait. With an undergraduate degree from Johns Hopkins University, graduate degrees from the School of Architecture at New York's Columbia University and then from the Ecole des Beaux Arts in Paris, the thirty-four-year-old had been busy earning the necessary credentials to open his own firm and now appeared ready to settle down where Turnbulls had settled for a few generations: in northern Baltimore County. Bayard, who would specialize in designing private homes for affluent clientele, lived on La Paix, a 26-acre estate of rolling hills in Towson, with his parents.

With his mother, Frances, a poet, and his father, Lawrence, an attorney, Bayard understood the nuances and value of the written word. This must have been a highly appealing combination for Margaret, whose passion for literature and writing would eventually propel her into the orbit of some literary giants. With Bayard having his own architectural firm and

being part of the wealthy Turnbull family of landowners, Margaret also had found financial security again, something she'd lost even before her father's death. Like Margaret, Bayard held traditional views based on his refined upbringing while also being culturally sophisticated.

Also like his future bride, Bayard was no stranger to tragedy. When he was eight, his brother Percy Graeme died unexpectedly, leaving the four other siblings and his parents devastated. Four years later, in 1891, Lawrence and Frances Turnbull approached Johns Hopkins University with an offer to fund visits by prominent scholars and poets in their son's honor. Originally called a "traveling scholarship," the memorial eventually would become an inherited privilege of Bayard and Margaret, along with the La Paix land itself.

Although Margaret taught school in the Philadelphia area, she had met Bayard through Elizabeth's friendship with his sister Grace Turnbull, a classmate from the Academy. After PAFA, Grace focused on sculpture, graduating from the Maryland Institute College of Art's Rinehart School of Sculpture in 1911. Elizabeth thought Grace immensely talented, and the feeling was mutual. But apparently the strongest common denominator for both pairs of Jones-and-Turnbull relationships was their similar family lives. As Grace Turnbull once said in Baltimore's *Sun* in an interview about her early life, "Home was a place where law, order and tradition reigned supreme."

The supreme being of the Jones family at this time was undoubtedly Mother Harriet—and when Bayard proposed to Margaret, she tested this status by inexplicably refusing

to give her blessing. To Margaret's added dismay, the widow also coaxed Elizabeth to support her side of the divide, and Elizabeth did. It was a huge betrayal for two sisters who had been extremely close (the rift between the sisters eventually healed but was never forgotten). Despite Harriet having "tremendous remorse" at her treatment of John before his death, she nonetheless fought to stop Margaret's union with Bayard, risking even more family bitterness.

Perhaps Harriet feared losing a source of income that Margaret provided to her, or maybe she thought exclusively of Margaret and all the years of her elite education potentially thrown away on wife- and motherhood. But most likely, as other occasions would play out, Harriet dug in her heels because she could—she was accustomed to being in control of the Jones family, and she wouldn't give it up without a fight.

It was a losing battle. Margaret clearly understood her mother's modus operandi and weighed its negligible leverage on her. Bayard Turnbull was an accomplished architect; he could provide extraordinarily well for her, and his family had established roots in Baltimore and in Maryland. If Dr. Jones had been alive, he would have been hard pressed not to approve of this conservative young man, and it's likely his younger daughter knew this in her heart.

Margaret's decision to continue with her wedding plans despite Harriet's refusal to bless the occasion probably astounded Elizabeth at first. This difference in personality between the sisters—where Margaret drew the line limiting her mother's control over her life and Elizabeth could not—

set the stage for the second act of their lives. Whether or not Elizabeth's growing weariness played a factor, her mother's strong influence on her life had only just begun. Margaret, unlike Elizabeth in her relationship with Morton Schamberg, was a grown woman, too old to be "forbidden" to follow her heart and marry the man she loved and have the family she always wanted.

In later years, Elizabeth would say that her sister as wife and mother "has everything." But, she would add, Margaret's talent in the literary realm had been just as strong as hers with art; however, "she didn't have the passion to do it. She barked up the idea of writing, she took that on, but [it didn't happen for her]."

Not surprisingly, Margaret didn't see it that way. In 1970, she wrote about her choice to leave the full-time career of an academic for a married life: "I found fulfillment enough with my family and my house, and I have always loved and appreciated my freedom, and tried to make good use of it."

In late fall of 1912, the Academy's Jury of Awards asked Elizabeth to serve on the 1913 winter exhibition's panel. The secretary and manager of the Academy, John E. D. Trask, sent an admiring letter:

> Personally, I am especially anxious that you will assist us with an early acceptance and I would be glad for your reply at your earliest convenient time. You are no stranger to the work which we are trying to do here at the Academy. Please help us to do it well.

Your name on the Jury will add prestige to the show. Do let us have your acceptance.

As part of the awards process, Elizabeth and the rest of the Artists Jury spent one day each in Boston, New York, and Philadelphia to select the works for submission. At the show, Elizabeth would exhibit impressionistic-style paintings, *The Sketchers* and *By the Fountain*, along with her recent Carnegie success, *Shop Girls*, though none was eligible for award.

As the Academy readied for its 108th Annual Exhibition on February 8, Robert Henri and the other organizers of the International Exhibition of Modern Art prepared their show to be held nine days later at New York City's 69th Regiment Armory. Much later, Elizabeth would write in a resume completed for a museum that she had been asked to participate in the Armory Show by Henri but declined. The request is possible but cannot be verified. Whether or not she was asked, the reasons for not being included are many: her work was not indicative of this new, extreme show; her loyalty to Chase prevented her from conspiring with Henri; and she already was involved with the PAFA show. These two radically different shows underscored the schizophrenia of the 1913 art world: one conservative in scope and "Chase ordained"; the other wildly provoking and flouting traditional dictums.

For Elizabeth, like many artists, the landmark 1913 Armory Show forever changed what was familiar by its new vision and the techniques that had developed in Europe. The focus for artists had changed from "what we see" to "how we see." The exhibition of about 1,300 works of American and European artists—including Elizabeth's former beau Morton

Schamberg alongside Pablo Picasso, Henri Matisse, and Marcel Duchamp—was intended to show the developments in European art since the Romantic period.

As Elizabeth's recently exhibited oil painting *By the Fountain* illustrated, her characteristic broad stroke in its depiction of mothers with children showed technical brilliance but was not representative of any modern movement. Elizabeth apparently began to sense that her brushstroke—however golden—was alone not enough. As she would say about her style in retrospect: "It's merely the daily denizen of an acrobat."

At the relatively young age of twenty-eight, she could no longer ignore the fact that as an artist, her approach might be becoming passé. Unlike female elders Mary Cassatt and Cecilia Beaux, Elizabeth was too young to even consider resting on her past style and its achievements. (In addition, she had the financial pressure of supporting her widowed mother.)

The new styles presented at the Armory Show shocked the majority of its nonartist viewers. Despite its title, one of the most famous paintings at the show, Marcel Duchamp's "Nude Descending a Staircase" offered nothing quite titillating in its cubist experiment of multiple perspectives. (When former president Theodore Roosevelt wrote a negative column about the show and its "extremists" and especially Duchamp for this work, the painter's fame paradoxically skyrocketed.)

Nonetheless, the organizers had designed the event to be educational, though the press and public took a very nonaca-

demic viewpoint. "Pathological," cried the *New York Times*. And the more than 70,000 people who saw the show in New York (and then in a smaller version in Chicago) apparently agreed, most being more stunned than appreciative. To his credit, William Merritt Chase reportedly tried to put on a good pretense of tolerance for the new works, even seeing the show seven times.

Modern art had come to America, ready or not.

Harper's Bazaar magazine in the summer of 1913 ran an article titled "Why the Girl Art Student Fails." Somewhat prophetically, at the same time, Elizabeth, though technically neither girl nor student, was doing more than failing—she was crashing.

She certainly had endured a chain of tumultuous events in 1913: the Armory Show; Margaret's marriage to Bayard and her move to Baltimore; and, incredibly, financial loss again. According to family accounts, sometime during this period, the Joneses' savings account dried up for a second time due to mismanagement by a distant relative.

As Elizabeth's malaise thickened, her father's history must have come to mind, and the years he'd lost from his incapacitation. Finally, it became insurmountable. She would call it a "nervous breakdown" or more often just "the illness"; but it had been coming for a while, and despair eventually overwhelmed her. Later she would recall the exhaustion: feeling overtired from the work and all the demands placed on her.

The illness she shared with her father was now split wide, releasing its spirits of lethargy and pain. The force of the depression was paralyzing. Effectively retreating from her life, she apparently stopped painting, focusing on her art only long enough to occasionally destroy or set fire to a painting. She threw away her palettes, brushes, and tools. Like most in a melancholic state trying to blunt the anguish of being awake, she slept often, finding her way back to bed after only hours spent awake.

It was an uncertain time in the country, and this presumably intensified Harriet's worries of the future. Would America go to war or not, and what did it all mean? Monarchies, like Austria's, fell in a spray of assassin's bullets. President Woodrow Wilson, benefactor of a bitter Republican campaign, faced strikes and demonstrations about everything from income tax to child labor laws and the unavoidable war debate. It was a confusing and frightening time, especially for a widow with a mentally ill daughter.

Harriet must have been alarmed, and understandably so, about what was happening to her daughter. But this time she was much better prepared. It had been more than a quarter century since she'd had to suddenly deal with John's illness at Brown Memorial. Fortunately, times had changed since then, though it was still a matter best handled quietly and privately, if possible. People now believed a hospital did a better job at helping to revive the insane (a common-day term for those experiencing mental health problems) and coax them back to health sooner than being cared for at home. Because she didn't have help, Harriet likely felt that she would not be the best caregiver for her daughter; she needed professionals this

time, and she didn't have to look too far from home to find them.

Times had changed since the Pennsylvania Hospital for the Insane, and others like it, chained the most serious mental patients to unheated basement cells or asked for money from townspeople who gathered on the sidewalk to watch patients exercise outside (reportedly a backhanded attempt to discourage viewing that failed).

Thanks to Benjamin Rush, one of the signers of Declaration of Independence, the Pennsylvania hospital was one of the first facilities to advocate the theory that mental illness was a disease of the mind and not a possession by demons. It also was the first mental facility to be associated with a general hospital, whose founders included no less than Benjamin Franklin himself. With one of the most esteemed psychiatric programs in the country and within walking distance from her home, it was, in all likelihood, Harriet's choice for Elizabeth. (Family members recall hearing she went to "a hospital in Pennsylvania," but due to closed medical records, this cannot be verified; consequently, the parallel is for framework purposes only.)

If Elizabeth had entered this hospital, she would have been housed in the women's wing at the corner of 44th and Market streets. Under the direction of another psychiatric leader, Dr. Thomas Story Kirkbride, separate facilities had been built for men and women on expansive grounds with libraries, swimming pools, and occupational therapy suites.

A typical hospital of the day also had a center building with a kitchen, store rooms, reception, business and medical offices, living quarters for medical officers, and a chapel.

According to the medical structure common in 1913, Elizabeth would have been classified as "melancholic" and separated within this category by her education level, race, and age. Most head superintendents operated their facility under the assumption that patients get well faster in backgrounds familiar to them. Within each ward, patients again were divided according to behavior, ranging from convalescent to demented and noisy and disturbed. Common drugs used were sedatives and hypnotics, including opium.

~~~

When Elizabeth Sparhawk-Jones disappeared from the art world in 1913, the golden ingénue with the magical brushwork did more than vanish with her—she ceased to exist. Behind the walls of the insane asylum, Elizabeth collapsed, the years ahead of darkened hospital rooms snuffing out years of light.

It was a descent into terror and loneliness from which she would not return unscathed.

~~~

Three years within an insane hospital, even if it was one as progressive as the Pennsylvania Hospital for the Insane, cannot help but transform one's interior composition. An accident victim may replay his helpless *before* moment again and again, seeking to understand how he may have altered

or avoided the incident. Yet regardless of the analysis, in the blur of the *after* moment, he is forever changed. Mental illness is like an accident in slow motion, moving randomly and often savagely, changing its host with each twist and shift of balance within the brain. Some may argue that depression is more like drowning or quicksand, a gasping for life rather than a jolt from it—an image just as true though no less damaging.

Institutional life added another dimension to the scars Elizabeth wore during her three years of confinement: living communally with people from different stations in life (even though hospitals did try to separate by education and financial status, this hardly seems foolproof, especially over such a long period), experiencing the locked-door separation forced upon those like her suffering from "melancholy," and dealing with patients with varying degrees of psychosis.

The "cure" for Elizabeth's depression, as for most melancholics of the day, meant spending days on end in a darkened room; she eventually did share this memory with family members, but little else. Physicians at hospitals like these rarely saw individual patients in the early 1900s, the time frame of Elizabeth's stay, as the doctor-to-patient ratio varied from 1:107 to 1:240. The power belonged to the assistant physician, who ran things within the departments and oversaw the day-to-day care of patients. In closest contact with the patients, the nurses and attendants, with a ratio of 1:9, did the everyday grunt and care work needed by these many men and women. The job description was neverending: cleaning, overseeing food delivery, dealing with patients in varying degrees of mental illness and all that that entails, managing

patients with a seemingly requisite hostility for their caretakers, and making sure patients who could do some work did it.

If Elizabeth received adequate and compassionate care during her time admitted for her depression—and there are no accounts she was treated otherwise—she had a physician she'd likely never met to thank. Clifford Beers, who wrote a groundbreaking autobiography *A Mind That Found Itself* in 1908, detailed his own bout with manic depression and the treatment he received at the Connecticut Hospital for the Insane. Not only did he describe from inside the walls of an asylum all the horrible highs and lows of his condition, but he advocated reforms, including more individualized treatment of patients. Beers condemned the misuse of restraints and abuse toward volatile patients and advocated an entirely new approach: He insisted that the more caring and decent the attitude of the hospital staff, the faster the patient would recover.

Because he was a physician and also a patient, Beers's reform was taken seriously and applied within many psychiatric facilities, saving countless patients from further abuse and assisting in their recovery. (In later accounts written by Beers's family, they reportedly decried his coming forward about his mental illness, saying they were hugely embarrassed he'd written the book; he didn't think about the consequences of his confession on *them*.)

Upon Elizabeth's release around 1916, she moved in with her mother at Harriet's new rental house at 1104 Spruce Street in Philadelphia. The thirty-one-year-old now fo-

cused everything she did on her "health," a priority shift that changed the structure of her days for the rest of her life. She ate well, slept late, and napped every afternoon. In the lessons of the day, she'd likely been taught at the hospital about the strong connection between mental and physical health, and thus feared a setback unless she took care of herself. The treatment plan also catered to her already strong penchant for dependent behavior, indulging her childlike self-centeredness. Family members remember that unlike Margaret, who enjoyed getting some exercise by walking around the La Paix acreage, Elizabeth most often preferred to remain behind to read or rest. Never learning to drive or even caring to work a washing machine, Elizabeth nonetheless admired her sister's deft managing of her family household and the La Paix estate at which she and her mother would become frequent guests.

Between 1916 and 1919, she once again began to exhibit at the Pennsylvania Academy of the Fine Arts, though it's not certain if the few paintings shown in the spring exhibits were new or earlier works. (In later years, she said she did not consider herself active again in the art community until the mid-1920s.)

Elizabeth undoubtedly came out of the asylum a changed person, but the art world had undergone drastic changes as well. For Elizabeth, it was vastly emptier now without the magnetic presence of her mentor William Merritt Chase. The painter's death in late October 1916 had shocked many who'd heard him speak just a few months earlier at the annual dinner of the American Federation of the Arts. Chase, who was sixty-seven, had kept his illness quiet, though he'd

prepared enough to ask another painter to finish the portraits he'd been commissioned to do.

Vibrant images of Chase forever brightened Elizabeth's recollections of her former teacher: his intimidating and intense way in the classroom, his powerful likes and dislikes, those nature-defying whiskers, the ever-present eyeglasses, and that infernal gold stick. *All the paraphernalia he had*, as she liked to say.

But as memorable as his larger-than-life flamboyancy was to her, equally so was his kindness. The note of hope sent after the Cresson scholarship debacle, and later when she won an award—how he reassured her of her own merit when he wrote in his strong hand, "Not a word of recommendation was needed from me." A positive influence on Elizabeth's career (and a likely factor in her future decisions to support struggling artists like Horace Pippin and Marsden Hartley), Chase may have been able to help her now in her journey back from the years away. With his long history of supporting students, he probably would have seen his way into being an integral force in smoothing Elizabeth's transition back to her artist self. For this reason and for thousands more, he undoubtedly would be missed.

A knock of her studio door one fall afternoon in 1918 announced another loss to her, and to the greater American art world, in the senseless "suffering, suffering death" of her first love with that golden marcel wave in his hair, Morton Schamberg.

In 1918, such knocks were not entirely unexpected considering the enormity and pace of the Spanish flu and its rising death toll. During the war, death came in steady waves and affected mainly the military and their families. But this Spanish flu pandemic was a riptide, pulling down healthy adults along with the typical flu's usual victims—the sick, elderly, and young—and killing them swiftly. Ordinary people seen regularly on the street or in shops, the secondary characters of daily life, suddenly gone, relinquished to their beds for days, often just hours before their bodies imploded with the virus. By the time it was done, more than 21 million people worldwide died.

Since Elizabeth had seen him last, Morton Schamberg had grown into a role first shaped by his early school days at the Academy, one drawn to the more modern edge of art, whether as a painter, sculptor, or photographer. Primarily a precisionist, he created works in a style that reflected urban and industrial subjects in a smooth and precise technique. Perhaps not surprising, as he was trained as an architect living in a machine age (and then affected by Francis Picabia's machinist paintings), Schamberg's machine-style paintings merged his longtime love of color with his passion for machines. Arguably influenced by the bitter irony of the Dada art movement, Schamberg recently had created a sculpture titled *God*, an arrangement of lead pipe in the form of a plumbing trap with its base of a miter box; the irreverent piece apparently represented his strong antiwar sentiment. By many accounts, this angst over what he perceived as a chaotic world also paralyzed his ability to work productively and weakened him both emotionally and physically, perhaps

leaving him more vulnerable to disease.

When Elizabeth saw Charles Sheeler at her door, she may have already known that Morton Schamberg was dead, and if she didn't yet, certainly one look at the grave face of her friend belied the horrible news.

Charles brought something for her: a painting of Morton's he thought Elizabeth may want to have. A 14x10-inch oil painting, a reproduction of Piero della Francesca's *Duchess of Urbino* of one of the Este princesses, had been painted for Morton's one-man exhibition about ten years earlier. Elizabeth genuinely admired the intricacy of the painting and accepted the gift from Charles. Years later, she would describe it fondly: "[The subject] has a long nose and pale eyes, and a profile against the delicate, delicate blues; they are perfectly done. And also the costume and the pearls around her neck and the pearls on her bodice. It's a lovely piece of work."

The bequest of the painting, whether instructed by Morton or inspired by Charles, does reveal an inescapable, if subtle, truth: Morton's memento, given as something to remember him by, turned out to be a reproduction of someone else's work.

As if golden-haired Morton *alone*—in death as in life—still wasn't suitable enough for her.

PART II

III. APRIL 26, 1964
INTERVIEW of ELIZABETH SPARHAWK-JONES
Conducted by RUTH GURIN for the
Archives of American Art, Smithsonian Institution

The interview, Gurin felt, was going quite well. *Like two women having tea.* She had just inserted the second tape in the middle of their conversation about the difference between Charles Sheeler and Morton Schamberg.

"But Sheeler was more spooky," Sparhawk-Jones continued, "more spooky, you see him rising from the reeds at sunset with poetry clasped to his heart. But Schamberg was a little more earthy."

Soon the conversation turned to where the artist had shown in her early career.

"I never showed much."

"You didn't?" Gurin asked.

"No, never. At the Carnegie in Pittsburgh and at the Biennial in Washington."

"Oh, yes, at the Corcoran."

"Yes, I was invited in both cases for a certain number of years," Sparhawk-Jones said. "And then I had a nervous

breakdown, I didn't do anything for twelve years."

"Oh," Gurin had not been prepared for any issue regarding the artist's mental health history. She may have read some press release about her absence from the art world, but the artist's comeback must have come some years ago; it didn't seem to affect her reputation now. For her show this month at the Graham Gallery, Marsden Hartley had written that she was "a thinking painter with a rare sense of poetic and romantic incident." Gurin knew Sparhawk-Jones's styles had changed over the course of her career—perhaps that occurred after the breakdown.

"When was that?"

"That was about that time," Sparhawk-Jones considered, "About that time. I was invited many places out of the country. They'd take anything I sent. But I broke down because I was overtired, I had done too much in too short a time. I think I was fifteen when I entered the Academy. I left school to do it."

"How did you know that you should leave school and go paint and nothing else?"

"That's instinctive."

"But didn't your family get angry?"

To which Elizabeth answered emphatically, "Not at all!"

Perhaps because she didn't know how or if to address the delicate subject of a nervous breakdown with a woman twice her age, Gurin returned the subject to the early days of Pennsylvania Academy of the Fine Arts, continuing a theme

she'd asked about earlier in the interview.

"In the days when Schamberg was still alive, did you meet other artists who had not studied at the Academy?"

"No."

"Were you fairly isolated?"

"I wasn't interested in them particularly and I was always a lonely person," Sparhawk-Jones seemed to hesitate at the admission, and then, maybe coaxed into truthfulness by the spinning tape in the recorder, continued. "I don't like to be with a mass of artists. When I went to MacDowell Colony and to Yaddo, both were much more heavily weighted with writers and musicians, and I prefer it. I don't want to be with a lot of rubber brushes. No."

"Well, I think it's probably more stimulating to be with people who work . . . " Gurin agreed before Sparhawk-Jones interrupted.

"It's more stimulating and then it's much more interesting to hear them talk. The musicians particularly are so well versed in the literature of their art and in the methods of playing and they want to talk of themselves all the time. Painters don't, as a matter of fact, are not very vocal."

Later in their conversation, Gurin inquired more about the artist colonies—Yaddo in Saratoga Springs, New York, and the MacDowell Colony in Peterborough, New Hampshire—that Sparhawk-Jones frequented. Gurin couldn't have known the direct correlation between Sparhawk-Jones's breakdown and its antidote: colony life. But the artist did. She vividly

recalled the healing powers of those many summers spent in Peterborough.

"But the MacDowell Colony was the more adult; [it] was the older one and that was started by Mrs. Edward MacDowell. . . . And it was a dream of her husband's because he had a little cabin in the wood and he used to say, 'Oh, if all the people we know could have just bought a farm on the crest of a hill.'"

Along with the more adult atmosphere, Sparhawk-Jones remembered having more freedom than in other colonies. "With Mrs. MacDowell, it was come and go. She used to drive around sometimes and visit the studios. She was lame because she had been made lame through the illness of her husband, Edward MacDowell, the composer, because she was a little thing and he was paralyzed and he used to put his arms around her neck and she used to pull him up by her back, the strength of her back to pull him up higher on the pillows. They couldn't afford a nurse and yet she was starting this thing for artists because it had been his dream. . . . She was a remarkable woman, Elizabethan, magnificent."

The love story between Marian and Edward MacDowell obviously captured the former colonist's imagination with the definition of a more pure love: the beauty of sacrifice, the idea of devotion creating lameness.

"And that was one of the most ideal places you could ever imagine," Sparhawk-Jones said, and then possibly hinting to expand the topic about love, added, "Edwin Arlington Robinson, who is a very great friend of mine, was there all the years that I was there."

III. APRIL 26, 1964

And though the lanky poet had been dead twenty-nine years that month, Sparhawk-Jones speaks about him in the present tense as if he had just stepped away from his rocking chair on the MacDowell porch and would be back for her.

Poet Edwin Arlington Robinson
Lilla Cabot Perry portrait courtesy of Colby College Special Collections

CHAPTER 7
"SPARHAWK"

The MacDowell Colony, a 450-acre artist retreat in Peterborough, New Hampshire, accepted Elizabeth for the first time in 1922. Nine years had passed since her breakdown and six since her release from the hospital; she had been painting but barely producing anything near her previous capacity. Her depression may have been at bay, but simply surviving wasn't enough. Her artistic spirit needed to once again catch fire. And this rural New England oasis of meadows, woods, and streams—a serene setting vastly different from her city studio—offered that elusive possibility.

Composer Edward McDowell had bought the land in 1896 for just that purpose: to rest and work in tranquility. Believing he'd succeeded in "tripling his creativity," he decided a few years later to expand the facilities to a workplace for other artists. After his death, his wife, Marian, became responsible for the two-year-old colony's growth and survival, and it was she who had a knack for finding those artists who'd be truly happy in the colony environment.

Elizabeth's earlier achievements had assisted in getting her into the colony, a place where—officially—talent is the only requirement and the ability to pay is not consid-

ered. Elizabeth walked familiar terrain when she met with Mrs. MacDowell, who had a reputation of being difficult to please. But Elizabeth's experience with appeasing demanding older women clearly proved beneficial; the two hit it off famously. Elizabeth's age and previous accomplishments, both of which Mrs. MacDowell surely considered well seasoned, likely helped cast the painter as a "colony type." As a likely bonus, Elizabeth's humor, cultured upbringing, and ease as conversationalist added to her approval from the mistress of the colony.

It must have been liberating for the thirty-six-year-old Elizabeth, who would usually spend about six weeks of the summer working at MacDowell, to control her daily routine again to some extent. No worrying about what her mother needed or expected her to do every day; instead, the environment and the energy of those around her daily affected her choices. If the night stars seemed closer here, so did the proximity to one's creative core.

Edward MacDowell's idea—that an artist should mix with those of other disciplines for greater creativity—was succeeding. Elizabeth mingled with poet DuBose Heyward and his playwright wife, Dorothy, who'd collaborate on *Porgy and Bess* at the colony; composer Aaron Copland; poet (and reputed man-magnet) Elinor Wylie; and writer Thornton Wilder, among others. The other artists fascinated her—not just the painters, but the writers, poets, and playwrights. Being a part of the world of MacDowell soon became tantamount with beginning the second half of her life.

Her daily schedule at the MacDowell Colony began in

the morning when the writers, painters, photographers, architects, and composers left one of the three "dorms" and sat together at the breakfast table at Colony Hall. Soon they each departed for their individual studios, none within sight of each other, to work—supervised only by the distant Mount Monadnock. In the evening, the colonists reconvened for dinner. If an artist wished to maintain the heat of creativity and avoid conversation at meals, he or she could sit at separate tables designated for quiet. (Remembered in a few memoirs for her lively conversation and witty quips, Elizabeth likely never cast her shadow on one of those areas.)

At one of these dinners during the summer of 1922, Elizabeth probably first caught sight of MacDowell's reigning "king," someone she would call both "a dangerous man, because of his charms" and the person with whom she felt more "alive" than any other time of her life. He would change her life in critical ways, and—in one particular area—the impact of their relationship altered everything that would come afterward. For Elizabeth had come to the MacDowell Colony to find something, and in his own way, Edwin Arlington Robinson would give it to her.

The nationally recognized poet Edwin Arlington Robinson had been personally invited by the colony's mistress, Marian MacDowell. Now in his early fifties, the Maine native had been coming to the colony for ten years, believing "the woods" to be his most productive environment. He had recently published another book of poetry, *Collected Poems*, in 1921; the collection exemplified his style of the dramatic

lyric, careful and structured form of stanza and meter, and concise diction.

From his two unlikely thrones of his studio rocking chair and his dinner seat (the only chair allowed to be reserved at the table in the main house), the long-limbed poet with his thin spectacles and thick mustache ruled the artist retreat with an eccentric charm born of shyness.

Robinson had known since he was a boy working his farm in Gardiner, Maine, that his life's passion would be language: writing and poetry. There was no other plan. And to this effect, he would say more than once that he literally didn't know what else he would have done in his life if he couldn't have been a poet.

But by the summer of 1922, his dream, albeit with a few stops and starts, had happened just as he'd imagined: first an apprenticeship at Harvard, publishing his first book of poems, then years spent writing poems, plays, and prose. He spent time in Boston and New York, and even exiled himself to a remote part of New Hampshire to write. For most of his life he'd survived by the kindness and generosity of his friends—an empty flat in Harlem in which to write one summer, spare rooms here and there—and even a job at the Custom House, headquarters of the United States Customs Service in the Port of New York, courtesy of a United States president.

President Theodore Roosevelt, who'd discovered Robinson's poetry through his son Kermit, was duly impressed by the different nature of Robinson's work. For unlike most poets of the day, his poems were not cheerful or pretty, but

depicted ordinary people—from butchers to prostitutes—in physical or emotional turmoil. The president even persuaded his own publisher to reissue a new volume of Robinson's work; then, in the early 1900s, he positioned Robinson in a sinecure at customs in New York so he would have time to work and also earn some income. Roosevelt also had offered the poet consular posts in Mexico or Canada, but Robinson chose to remain close to family he had in the surrounding areas. (When President Taft took office in 1909, Robinson quickly resigned from his post at the Custom House after learning he'd now have to wear a uniform and keep regular hours.)

Called simply by his initials, E.A., by most who knew him, the poet often referred to himself as a vagabond, though in truth he actually had a close-knit circle of friends. Many of them, writers themselves, also assisted Robinson by reading his early drafts and offering their opinions. For the poet's fiftieth birthday in December 1919, one friend, Percy MacKaye, even organized an appreciation of his work written by other poets in the *New York Times Book Review* and the same month wrote a tribute article, "E.A.—a Milestone for America" for the *North American Review.*

If Elizabeth regarded E.A. at first for his talent and achievements in poetry, her admiration soon became something deeper. Although sixteen years older than she with brooding dark looks that had begun to sag (from both reputed bouts with the bottle and time), E. A. Robinson still appealed to Elizabeth in a multitude of ways.

Not unlike her father or Morton Schamberg, E.A. had a

personality that exhibited an equally intense mix of prophet and artist. Elizabeth had always admired writers, and here was Robinson, with his soulful brown eyes and sensitive manner, quietly dominating every room he entered. Romantic hopes aside, he reportedly was a challenge simply to befriend.

From the outside, E.A. and Elizabeth were a study in contrasts: the poet 6 feet, 2 inches of restraint, occasionally elliptic of speech, who measured his every overture; and the painter about 5 feet, 4 inches, witty and candid, prone to squeal with laughter during conversations with friends.

But when the surfaced was penetrated, the two artists shared more than many would ever see, beginning with their singular and absolute devotion to their work. Though perhaps not experiencing the full measure of her artistic fervor the first summer they met, a letter to friend and fellow painter Marsden Hartley written in later years showcased her passion. She wrote, "I love to paint. There is absolutely nothing in life I find more satisfactory . . . There is nothing I could leave it for that would out-thrill the occupation of trying to realize form and place on the flat surface before me."

As for the poet Robinson, who committed himself to writing as a young boy, he was equally as fastidious about his work, once famously saying about how he spent his days writing: "And I will spend all my morning deciding whether to put a comma in, and then all afternoon deciding whether to take it out." *The Torrent and the Night Before*, a volume of poetry he self-published in 1896, also bore an inscription indicative of his boyish bravado: "This book is dedicated to

any man, woman, or critic who will cut the edges of it.—I have done the top."

By the time Robinson had published this first book, he'd already lost both of his parents—his father as a result of alcoholism and his mother from diphtheria. He had also endured the suicide of one brother and the slow death of another from tuberculosis. Not a terribly happy household, according to most accounts, the Robinsons of Gardiner, Maine, had not expected much from little "Win." His mother had wanted a girl and apparently was so disappointed when E.A. was born that he went unnamed for six months (until he was named by a passing visitor). His father, a rough-and-tumble sort, didn't consider writing poetry a valid career direction for a man.

Like E.A., Elizabeth understood the significance of dark influences on early life from the daily tight rope she balanced upon between two increasingly estranged and bickering parents. Her father, distant for years because of his depression, always remained somewhat absent from his children's lives even when "well"; being single-minded in devoting himself to his parishioners and intellectual pursuits often meant seeing his children only at the dinner hour. Her mother, insisting on both control and companionship, often didn't consider her at all.

A threat to their financial security also had plagued Elizabeth and E.A. throughout their lives; both had started life financially sound but were suddenly left struggling after deaths and mismanagement of funds. In another parallel of their similarities, each reacted to this in the same mildly defiant, and amusing, way. Far from making either a tightwad,

both poet and painter occasionally rewarded themselves with earnings from their work; E.A. savored the purchase of opera tickets, perhaps, and Elizabeth loved buying herself a new hat.

"Modernism," that ubiquitous tag now given to everything from sex to art to furniture, also yipped at both of their heels. Poetry was changing, and Robinson was not. Though his early poetry was traditional in form (meter and rhyme), his subject matter—bringing commonplace people and experience into poetry—was considered revolutionary. Nevertheless, his book-length narratives of Arthurian blank verse, his writing in tight-metered stanzas—more difficult for the ear to understand than light verse—had begun to now compete with poems written in the everyday language of poets like Robert Frost. The work of younger poets like T. S. Eliot and Ezra Pound also expanded expectations of what poetry could be.

Robinson certainly felt these small shifts, nearly undetectable to those of lesser talent, like Elizabeth had in the years before the Armory Show. But Robinson did not have a history of adjusting his way of writing to suit the public mood. "Dear Friends"—one of his earliest poems included in his first self-published work, *The Torrent and the Night Before*—extolled the virtues he considered in living life his way. It went in part:

> Dear Friends, reproach me not for what I do,
> Nor counsel me, nor pity me; nor say
> That I am wearing half my life away
> For bubble-work that only fools pursue.

> And if my bubbles be too small for you,
> Blow bigger then your own:—

Robinson's gift, its degree of difficulty not understood even by some of his contemporaries, was creating that impossible balance between word and meter. And whether he wrote about jealousies, prostitutes, business or personal failure, or the lure of alcohol, his poems engaged the reader to think about the motivations, impossibilities, and ironies of life. That he didn't make things easy for the reader was of no matter to him—reportedly he once finished a poem only to remark, "Well that will take them seven years to figure out!"—and this perfectly reflected the man.

Modernism for Elizabeth was not looming as it was for E.A. in the poetry world. It had been more than ten years since it had sailed in from Europe; styles had changed, along with the acceptance of the formerly finicky audience. Impressionistic paintings of children in the park no longer enthralled; portraits of ladies with upturned noses and open umbrellas were dull and passé; the new was the unexpected angle or presentation, the not-so-pretty picture, the surprising detail or palette. After such a long absence from her art, simply renegotiating her painting commitment and schedule with herself was a challenge. Now in the privacy of her Peterborough studio, she could experiment with color, style, place, and image.

As Elizabeth grew friendly with E.A., they may have watched other Jazz Age romantic and sexual dramas (and there were plenty) play out within the MacDowell Colony. But there was never a real question of the propriety of

their developing relationship. A former colonist, Margaret Widdemer, described them this way in her 1964 book, *Golden Friends I Had*: "For there was no question of any scandal. They had been middle-aged, remember, before the 1920s and were a lady and a gentleman by old-fashioned standards. She didn't hunt him; he didn't flee her."

With a touch less coyness and a bit of hyperbole, Elizabeth's niece Frances Kidder described the relationship this way: "They may have been the only two in the colony NOT having sex!" Although to be fair, Elizabeth wasn't the only one with whom Robinson *wasn't* having relations. In 1908, he famously spurned the advances of the dancer Isadora Duncan, who reportedly propositioned the poet.

From his late twenties, Robinson had referred to himself as a confirmed bachelor, an honorable station of the day that was not necessarily a cover for homosexuality. On the contrary, many Victorian-minded men actively declined to marry, or, in the vernacular of the day, to "take the veil." Following the nineteenth-century footsteps of Charles Dickens, E.A.'s excursions to prostitutes, written about in sonnets like "The Growth of Lorraine," hint at his early sexual experiences with women. In later years, E.A. would admit that he felt "pure artists" couldn't be married.

While other women fashioned their hair into the new short bob, Elizabeth's hair remained very long, hanging down her back in a thick brown blanket or worn up, braided in ropes and twisted behind her head in a knot. Sitting by the fire in

Colony Hall in the evening, she often regaled other colonists with her witty stories and anecdotes; the many about E. A. Robinson generally are remembered as pretty amusing. A favorite recalled by writer Chard Powers Smith involved Elizabeth's explanation about Robinson's tendency to stay in his studio for such lengths of time: "Well, he locked the door on the inside, threw the key out the window, and thereafter can't reach it to let himself out!"

Robinson—who once bought a portrait done of him by a colonist just for the pleasure of destroying it—apparently didn't mind Elizabeth's deft teasing. If he had, she undoubtedly would have found another subject.

At Elizabeth's studio, usually the small granite house nestled among the pine trees called Mixter, she worked under natural light from three pairs of long windows in the small room. Soon Elizabeth began delivering fruit baskets featuring Robinson's favorite apples to the step of his Veltin Studio door most mornings, and in a return gesture offered only to her, E.A. asked her to lunch with him privately once a week. Robinson biographer Chard Powers Smith conceded Elizabeth's growing importance in E.A.'s life by this gesture when he wrote, "She was the only one allowed to do so." Even when Mrs. MacDowell got wind of these lunches, she reportedly did what shocked some by doing nothing. For a woman who discouraged colony romances and made related adjustments (like prohibiting fires in the studios after 5:00 p.m. after she began to think certain men and women were getting too "warm" and cozy), the widow apparently only shrugged a shoulder at this blossoming friendship.

By many accounts, E.A. was proficient at dividing his friends into two camps, conveniently keeping his New York literary benefactors separate from his everyday contemporaries. This practice often "led to suspicion among them and earned him some whispers of hypocrisy," according again to biographer Smith. Elizabeth joined the elite of the latter group, an inner circle of his best friends, which included a writer, a poet, and a runaway lawyer.

Carty Ranck, a writer and aspiring playwright, had devoted himself to the idea of becoming E.A.'s biographer. Ranck was famous for his crudeness and eagerness to start a fight, and more than once Elizabeth joked that she feared to walk alone at night at MacDowell for fear Carty would come "snorting out of the bushes like a moose." But Elizabeth and Carty shared more than E.A.'s friendship. He had experienced a nervous breakdown in 1921 and entered an asylum for a short period—and, in a heavier blow not long afterward, his wife left him for one of his friends from the colony, taking their young daughter with her.

Another friend was Ridgely Torrence, a charming, elegant poet, who geared his works to the concerns of African Americans. Although E.A., who himself hated causes, believed Torrence also deserved a Pulitzer nod, Torrence had so far failed to receive much recognition for his poetry. But it was George Burnham, whom E.A. roomed with at Harvard, who was perhaps Elizabeth's favorite among E.A.'s friends. The lawyer had lost both his legs to frostbite after a bitterly cold night in the frontier of Wyoming. With his new wooden legs, he'd completed law school at Harvard, become a lawyer, and then chucked what he saw as the unethical demands

of the profession to become a ticket agent. Over the years, Elizabeth grew especially fond of Burnham, who would come and stay with her and her mother for weeks at a time during the off-season.

Elizabeth and E.A.'s relationship, which began in this "island in a sea of trees" (as Robinson called MacDowell in the poem "Hillcrest"), continued from one summer to the next. Eventually, Elizabeth would sometimes see him in the winter on stops to New York City. He nicknamed her "Sparhawk" and would refer to her that way in written correspondence to others.

Always forthright, Elizabeth hadn't taken long to declare E.A. "the love of my life" to anyone who would listen. It was the first time since Morton Schamberg that she'd talked about a man like that, and once again she'd apparently selected an "unavailable" one. While E.A. had the male luxury of declaring himself a bachelor for life, Elizabeth likely was dubbed a spinster or an old maid. If her time spent in the asylum was known, the labels may have been even less kind. But perhaps she *did* always choose the right man for her, and whether the barrier was faith, commitment, or sexual orientation, the relationships worked for her, because in the end, she had her painting.

Some may argue that the widest barrier for Elizabeth ever developing a committed love relationship was undoubtedly Harriet. How could she ever disappoint her mother now by leaving? Harriet's control of Elizabeth, whether guided by parental love, selfishness, or a combination of both, succeeded. Growing up without either parent conceivably left

Harriet with a fear of being alone and justified her refusal to encourage Elizabeth's independence. As family members remembered, Harriet wanted Elizabeth to be "her companion." Harriet probably believed it was she who was seeing the reality of her daughter's situation, one in which Elizabeth (who was, to Harriet, obviously living a guarded fantasy) would actually never marry because of her fragile mental health.

Not surprisingly, when Elizabeth shared her feelings about Robinson with her mother, Harriet decried Elizabeth's waste of affection on the poet, calling him a "neuter" of a man, a thinly disguised accusation of homosexuality.

The cruelty of Harriet's words didn't seem to bother Elizabeth enough to make her stop caring for E. A. Robinson; it did, however, bother Margaret. Now the mother of three young children, Margaret apparently saw the controlling nature of her mother more clearly than her sister, but she could do little.

If her mother was hanging onto her sister's life like an albatross, it was a dead weight Elizabeth had carried so long she didn't even know it was there.

Andrew Turnbull and Scottie Fitzgerald on the grounds of La Paix

CHAPTER 8
AGAINST A PHANTOM SKY

Years passed, and Elizabeth and E. A. Robinson still held their private demons close. The painter, like anyone who'd survived a breakdown, cautiously guarded her mental health and, following the wisdom of the day, saw strengthening one's physical and creative side as a viable antidote. The poet—flush from his second Pulitzer Prize in 1925 for *The Man Who Died Twice*, a work of poetry critics believed represented Robinson's preoccupation with personal ruin—tried to control his alcoholism.

Once Robinson had called his poetry the "grisly secret" he kept from his father. But drinking was the larger secret he hid from most. Even Prohibition didn't alter his habit. Writing in 1924 to longtime friend Laura Richards, Robinson theorized: "All human beings who are not made of putty are going to stimulate themselves in one way or another; and alcohol, in spite of its dangers, is the least harmful of all the more active demons. Everything is dangerous that is worth having." E.A. enjoyed the effects of the drink, he'd often say, not the taste. Like Elizabeth's lapses in her career because of depression, E.A. later shared with a friend how he'd also lost years by working with "nothing but the bottle."

With an alcoholic father and a brother whose behavior often became outrageous when under the influence, the quiet E.A. likely slipped under the radar with his own drinking, even perhaps convincing himself that *his* drinking was different. He reportedly was more like Dean, his older brother, who became quietly addicted to morphine until it killed him. The poet did mask his drinking—a weakness most considered moral—from most friends. (Mrs. MacDowell, however, could not be fooled; she eventually goaded his friends not to encourage his alcohol consumption.)

E.A. liked to drink and play pool with friends like Bill (William Rose) Benét, the poet, and sometimes with younger friends like the writer Chard Powers Smith, whose reverence to E.A. went so far as nicknaming Robinson "God." For other friends, accustomed to E.A.'s stinginess with words, the loosening of his tongue by a few whiskeys probably was a welcome occasion.

Despite always drinking three to four times the quantity of others, Robinson's high tolerance apparently gave him the illusion of sobriety; friends like Smith have written that often they didn't realize he was drunk until catching a hint of remorse from him the next day. (Holding true to the misguided understanding of alcoholism at the time, Smith even goes so far as to clarify firmly that Robinson was *not* "alcoholic.")

Regardless, E.A. knew his ability to fool others meant little. This was especially apparent with the publication of "The Dark House," a poem that most suspected to be about alcoholism.

> Where a faint light shines alone,
> Dwells a Demon I have known.
> Most of you had better say
> "The Dark House," and go your way.
>
> Do not wonder if I stay.
> For I know the Demon's eyes,
> And their lure that never dies.
> Banish all your fond alarms,
> For I know the foiling charms
> Of her eyes and of her arms, . . .

The alcoholic yearning would persist in E.A. as strongly as the lure of these "arms": a desire to be held versus one to be set free. It would be a lifelong struggle.

Chicago was always a lucky venue for Elizabeth, and in 1926 an exhibition at the Art Institute of Chicago offered the first sign that her stalled career could one day be resurrected. Awarding her the Kohnstamm Prize, the exhibition jury lauded her work, *Ladies at the Ribbon Counter*, for being the "most commendable painting in the show." An irrepressible, masterful nod to her earlier style of impressionism, the painting also possessed a strong undercurrent of urban realism similar to her earlier works, *Shoe Shop* and *Shop Girls*. The same year, Elizabeth also contributed her first painting in seven years to the Pennsylvania Academy of the Fine Art's annual exhibition.

Her depression seemed to be at bay, and though her work

speed remained sluggish compared with the years before her breakdown, the time she spent painting increased daily. Her new style ebbed and flowed, hinting at her inner turmoil. Like E. A. Robinson in many ways, she also was compartmentalizing her life, still separating the inner drama of her illness from the truth of the canvas.

Continuing to show at the Academy's annual exhibition each year, Elizabeth even received a personal visit to her studio from former teacher Hugh Breckenridge to help in selecting the best of her works. In 1928, for the first time since her breakdown, she accepted an offer from PAFA to sit on the Painter's Jury, a move that signaled their support for a resurrection of her professional career.

As committed to her mother as ever, Elizabeth still insisted on a private studio for herself in Philadelphia and on spending regular time at artist colonies. Although she preferred the MacDowell Colony, she also had visited Yaddo, a new artist colony in Saratoga Springs, New York. In sync with her professional life, her social life also gathered new energy. Her existing circle of friends widened from dear friends from the Academy days, including the likes of Alice Kent Stoddard, to new ones forged within MacDowell, such as her friendship with writer and poet Laura Benét (sibling of poets Stephen and William Rose). These relationships, an extended family in many real ways, were nourished through regular letters, calls, or visits. Elizabeth's loyalty, once earned, proved indelibly strong toward those she deemed "friends."

The test that men and women needed to pass before gaining such status was a remarkably simple one. Reportedly Elizabeth once advised her niece Eleanor on the most important criteria on which to choose friends, saying, "Always ask yourself: Are they interesting?"

Other factors, such as race, sex, sexual orientation, and social status, never played into the equation when Elizabeth decided who was *interesting*. She would promote the work of Horace Pippin, "a highly gifted folk artist" who was African American, long before the civil rights movement. With her friendship with painter Marsden Hartley in later years, she also proved her little regard for what others may have seen as valid reasons for distance, namely accusations about Hartley being anti-American and homosexual.

From the bores or "uninteresting" of the world, she tolerated little. Once, when attending a party in honor of the son of a famous writer, she found the young man so arrogant for "not giving another's point of view any room," she left the party feigning weariness.

Doubtless because she'd earned her own reputation for being interesting, smart, and entertaining, fascinating people also seemed to find her. Niece Frances Kidder recalled her aunt's charisma this way: "If there was a celebrity within 10 miles of Elizabeth, he'd find her." The actor Claude Rains (and two of his wives) would fall into this category and they became fast friends—even when Elizabeth bluntly questioned the *Casablanca* movie star's choice of becoming an actor when he could have done "anything."

With the depression of 1929, when the whole country seemed to have been on a buying binge only to wake up and have nothing, Elizabeth and Harriet moved again to a new address on Spruce Street. For once, financial losses, now en masse, didn't affect them personally. In the same year, for about $12 a week, they also found a boarding house in the Pennsylvania countryside in which to rent some rooms. Westtown Farmhouse, an environment that would feed both women's love for nature while being around other people, soon became one of their favorite places.

Since that first move from the parsonage nineteen years earlier to 1626 Chestnut Street after the death of Dr. Jones, they had never moved far (and reasons for the frequency can only be surmised). But the transience and the fact that she still lived with her mother no doubt affected Elizabeth. Never learning to drive a car, run a washing machine, or thread a needle, Elizabeth remained in many ways incredibly childlike. One niece remembered that Elizabeth simply "couldn't do anything practical" after living in mostly boarding houses or rentals with few amenities for so many years.

Her sister's estate in Maryland resembled the closest thing to "home" for Elizabeth over the years. Aptly named for being peaceful, the La Paix property fortunately had plenty of room for guests, as Elizabeth visited at least a few times a year and her mother more often. A generation earlier, they

would have been welcomed by the coleus and geranium that spelled out the name "La Paix" on the manicured lawns, but now that had given way to less time-consuming landscaping for the expansive acreage. Nonetheless, the Towson property still impressed with equal parts charm and grandeur.

Using his architectural talents, Bayard Turnbull had built the family a new large L-shaped Queen Anne–style frame house just around the bend from his parents' former home on the La Paix estate and named the home Trimbush. For the sake of achieving radiance, the walls and woodwork were painted with seven coats of paint; great care was also taken in the main drawing room, where he created detailed specifications for the cabinetmakers in their production of the intricate paneling.

Supported by a full-time maid, a full-time gardener, and a day worker who usually came about once a week, Margaret Turnbull had grown into her role as mistress of La Paix, society wife, and mother of three school-aged children. Soon, with the aid of a new famous tenant, she also would serve as an integral link and benefactress within the Baltimore literary community.

For the Christmas holidays of 1929, among other times, Elizabeth traveled with her mother to Towson to be with Margaret, Bayard, and the children. Frances, Andrew, and Eleanor, old enough now to appreciate all their land had to offer, rollicked through the crisp air of the winter season with their own skating pond and plenty of hills for sledding. Summertime at La Paix had its own smells: hay from the large barn where the children helped with the cows and lilac

flowers whose bushes encircled most of the shallow pond.

The children, each with their own developing personality, competed to be Elizabeth's favorite, and as they grew, so did their place in her life. When young, they looked forward to her visits (along with their more staid grandmother), especially because of her relaxed, merry temperament. She was recalled as "very dynamic, witty, very funny, and offbeat" by niece Frances Kidder, who loved how her aunt would "get excited and let out a little squeal." One person Elizabeth liked to tease was her brother-in-law Bayard, who was very conservative and puritan by nature. "To shock him, she would say outrageous things," niece Eleanor Pope recalled. Or do them. When Elizabeth bobbed her hair and wore lipstick in the mid-1930s, Bayard apparently disliked what he saw as the scandalous nature of this fashion so much he could barely contain himself.

Another entertaining aspect of Elizabeth's personality for the children was her notorious difficulty in keeping secrets; at one dinner, she blurted out an unkind comment her mother had made about a visitor who had just been bid a gracious goodbye from Margaret's home about twenty minutes before. The loud rebuke of "Gracious, Elizabeth!" from Harriet Jones and the ensuing laughter was remembered by those present for many years to come—along with Elizabeth's half-hearted apology and the requisite wink for the children.

A secret about herself, and debatably one she should have kept on reserve, related to her relationship with E. A. Robinson and what she saw as her rising status in his life. Their time together, because of Robinson's nature, consist-

ed of very little talking, but purportedly one day Elizabeth couldn't resist wondering what she meant to him; so at the end of one of their summer lunches, she finally asked E.A. how he felt about her. After a long pause, he looked at her and said, "The less I say, the more I feel." To Elizabeth, these few words expressed all she needed to feel assured that he cared about her—and all she needed to reinforce her love for him.

In later years she would write about Robinson, "A moment of sympathy with him drew one out of oneself onto the threshold of a mystic union." The depth of this union would alternately satisfy and torture Elizabeth for many years.

Into the mid-1930s, Elizabeth saw E.A. most summers at Peterborough and kept in touch with him during the off-season. When at MacDowell, the pair followed their usual routine of weekly private lunches and morning baskets from Elizabeth dropped at the door of his studio. Looking over her canvas at the woods outside the Mixter Studio, she worked and sought daily renewed inspiration. To the right of the inside doorway, she added her name alongside the many other artists who aspired within these walls.

Some of the colony evenings were filled by the ever-enterprising Marian MacDowell, who sometimes planned events to introduce potential contributors to the colony ways; Elizabeth wrote about a few such functions she'd attended and even enjoyed—unlike E. A. Robinson who by nature loathed such events. To his credit, he didn't let Mrs.

MacDowell down and repaid her for taking a chance on him by performing what was for him a difficult task—making polite conversation to prospective donors at the occasional gatherings at the colony.

At one event, E.A. reportedly exhibited his succinct style and underlying unease with talking about his work when a group of out-of-state women cornered the poet, who'd apparently slunk into a hiding spot near a stairway. "I just adore your poetry . . . in fact we all do," one woman said. "But it is so hard to understand. I wish you could tell us of some easy way."

"I don't know that there is any," he finally said in one long exhale, "except just to read it, one word after another."

Though his small lack of social graces may not have created long-term damage to Robinson's career, his lack of public relations savvy surely didn't help when compounded by petty jealousies by some of his fellow poets. "He was not handled so well by his younger contemporaries during his life, and he felt it keenly," Elizabeth wrote in later years, agreeing with a sympathetic article to this end about Robinson. Another New England poet, Robert Frost, reportedly contributed to weakening the reputation of Robinson by not participating with other poets in the 50th birthday tribute to him printed in the *New York Times Book Review* in 1919. In his book, *Where the Light Falls*, Chard Powers Smith recalled walking in on Robinson, looking shaken, holding a letter in his hand. When Smith asked about it, Robinson simply replied, "Frost is a jealous man." Today more is known about the complex relationship between the two poets, and professionally, each

greatly admired the other's talent. However the slight in 1919, which Frost later claimed was unintentional, only fostered the idea of a rivalry between the two men.

Back in Margaret's Baltimore, another soulful writer with an enormous presence entered the lives of the Turnbull family in the spring of 1932: Novelist F. Scott Fitzgerald rented the senior Turnbull's former home. Why would the same man who had lived his own posh, Gatsbyesque lifestyle want to inhabit the old eighteen-room Victorian gingerbread house with ugly brown paint and no modern plumbing? The question apparently boggled a few minds even then. But any idea that the writer didn't know what he was getting into disappeared when landlord Bayard reiterated to Scott, as Fitzgerald was known, about the plumbing situation. *New plumbing doesn't interest me,* he reportedly replied. And so, with his countless boxes of books, the writer and his daughter, Scottie, moved in.

"Fitzgerald came to La Paix as Tom Buchanan came East in *The Great Gatsby*—'in a fashion that took your breath away,'" recalled Andrew Turnbull in his biography, *Scott Fitzgerald*. "All one morning cars and vans swirled down our quiet lane and out of sight around the bend" to the rental property.

Fitzgerald lived and played hard, and, at thirty-six, his career was in a downslide (his books were nearly out of print) and his personal life in shambles as he battled alcoholism and mild tuberculosis. Then at work on *Tender Is the Night*, his first

novel since 1925, he chose La Paix for a myriad of reasons, the foremost of which was to be near his wife, Zelda Fitzgerald, who had suffered a breakdown in 1930 and sought treatment at Johns Hopkins Hospital in the city and at Sheppard Pratt sanitarium (across the street from La Paix). During Zelda's better times, she would come home to La Paix. The property also gave little Scottie a place to run around, climb trees, and have friends her age for play; she could swim, play tennis, and sled and skate in the winter. The two families would eventually carpool to school together.

Although Margaret, who was more familiar with Victorian-era writers like Charles Dickens and Henry James, hadn't known of Fitzgerald's work before the novelist came to La Paix, the two quickly bonded over books, ideas, and more; when Zelda's brother committed suicide in 1933, Scott reportedly came to tell Margaret so she would see that Zelda's poor mental health was not *his* "fault," but hereditary. Margaret never left a record of sharing her own family experiences with mental illness with Scott, but it's likely that whether or not she did, the truth only deepened the connection between the two.

During his eighteen months as La Paix, Fitzgerald left a mark on the Turnbull legacy. On his urging, Margaret reignited the Turnbull's traveling scholarship at Johns Hopkins University with visitors like poets T. S. Eliot, Archibald MacLeish, AE Russell, and Walter de la Mare coming to stay at La Paix for various lengths of time in the 1920s through the 1950s. Even Robinson's fair-weather friend, Robert Frost, came to stay.

The infectious enthusiasm of Fitzgerald also convinced Bayard to build a grass tennis court on the property. In one photograph from that year, Scottie, in half-tucked tennis whites, poses—lowered tennis racket in hand, one hip swung to the side impatiently—while Andrew, in shorts and knee socks, his chin lowered shyly, clutches a satchel of tennis balls. Fitzgerald also engaged the children in a range of other activities. He taught Andrew to box and shoot a pistol, and squired him to a Navy v. Princeton football game. He wrote and directed plays for all the children to please the family audience, especially encouraging what he saw in Eleanor as great acting potential.

When Elizabeth came to visit during 1932 and 1933, she and Fitzgerald apparently both were "fascinated" by the other, according to both nieces. So unlike her sister, Elizabeth shared the rollercoaster world of the artist with Fitzgerald, and they had this great intangible in common. The writer was drinking during this time and trying to hide it from others; likely this behavior stirred the familiar within Elizabeth as well.

A fire started by Zelda at La Paix in the summer of 1933, creating damage to the second story of the home, and her subsequent return to inpatient status at the sanitarium signaled the last days for Fitzgerald as a Turnbull tenant. He would, however, go on to have a lasting influence on Andrew's life and continue his friendship with Margaret. Years later at his burial, she would lay pine branches from the La Paix estate over the ground of his coffin.

Traveling in Europe in the spring of 1933, Elizabeth heard about the death of E. A. Robinson friend's Lilla Cabot Perry, likely making E.A. more on her mind than usual. So when she came across a small marble sculpture, she decided to buy it for him.

But when she finally presented it to E.A. in his Veltin Studio, the apparent depth of E.A.'s dislike of both the object and, worse, the fact that she had given him a gift at all was beyond anything Elizabeth had imagined. Though devastated by his negative reaction, Elizabeth forced a brave face and an appeasing manner before excusing herself for elsewhere. A few days later, she crept back into his studio when she knew he wasn't there and took the statue back. Finally, she dug a hole by her favorite pine tree and buried it.

But according to a letter that detailed the event from E.A.'s friend Parker Fillmore to Hermann Hagedorn, then E.A.'s biographer, the story didn't end there. When E.A. realized what Elizabeth had done, he apparently was tremendously upset and asked Elizabeth to "re-give" the sculpture to him.

And so the next morning, after digging up the marble sculpture and cleaning it off, she carried it again to the Veltin Studio for E.A. Upon receipt, he then acted very pleased by the gift and thanked her for her thoughtfulness.

Years later, in a letter to a friend, she would observe that "Mr. Robinson could do things with his feelings to people. His coldness was like nothing I have ever met within a human being. I have faced four people when he passed back of me and seen the intense effect his anger had on them when it

was not directed toward them." And yet in the same passage, she forgave him, for he was "a simple man, a very real man, never acting parts. A sensitive man who could feel eyes he did not see and cover his eyes from the look. He could punish and then suffer more than the punished."

The curious yet implicit nature of their relationship was exemplified further with the publication of a poem by E.A. widely rumored to be about Elizabeth. The painter knew that E.A. said things with his poems he couldn't say otherwise. So when he wrote *Tristram (the conclusion)*, it was a peculiar gift.

In Scott Donaldson's 2007 biography, *Edwin Arlington Robinson: A Poet's Life*, he described *Tristram*'s connotation this way: "As Sparhawk-Jones saw it, Robinson paid her tribute beyond measure in his portrayal of Isolt of Brittany in *Tristram*: not Tristram's great love Isolt of Ireland, but 'Isolt of the white hands' and grey eyes who was willing to love Tristram without reservation despite knowing that his heart belonged to another."

> In part, the poem read:
> Yet there she gazed
> Across the water, over the white waves,
> Upon a castle that she had never seen,
> And would not see, save as a phantom shape
> Against a phantom sky. He had been there,
> She thought, but not with her. He had died there,
> But not for her. He had not thought of her,
> Perhaps, and that was strange. He had been all,
> And would be always all there was for her,

> And he had not come back to her alive,
> Not even to go again. It was like that
> For women, sometimes, and might be too often
> For women like her.

Staying true to character, E.A. released volumes without having to speak. He created the image of Elizabeth searching for him, waiting, never to be appeased—seeking a comfort she'd never find from him.

Robinson the poet, who had always believed that women were the worst sufferers at Life's hands, had in the end become its accomplice.

Injustice, c. 1944, by Elizabeth Sparhawk-Jones, Watercolor on primed linen, mounted on masonite, 39 9/16 x 20 3/16, Courtesy of the Pennsylvania Academy of the Fine Arts, Philadelphia, John Lambert Fund.

CHAPTER 9
CARYATIDES

At Westtown Farmhouse in April 1935, Elizabeth got a call from Carty Ranck, and though stunned by his words, without hesitation left for New York. Ranck, who had received the news from Chard Powers Smith while in Kentucky, immediately headed north after calling Elizabeth and a few others. From Boston, George Burnham traveled to meet them in New York on East 68th Street at New York Hospital. Since January, the hospital had been caring for their friend E. A. Robinson, and now they were told he was dying.

For the past few years, Robinson's health had been slowly deteriorating; he'd lost weight along with his taste for food, and was often tired and in pain. (Ironically, after having stayed sober for many months, E.A. was now advised by his doctors to numb the pain with whiskey.) He apparently believed his digestive problems stemmed from an ulcer or colitis, but finally in January agreed to undergo testing and eventually exploratory surgery to discover the cause of his symptoms. During an abdominal operation, the surgeon found cancer of the pancreas that already had spread to his lungs, and the physicians made a terminal diagnosis. They did not tell Robinson the truth of his illness, but only that

he suffered from an inflammation of the pancreas and would need some time to recover from that and the surgery itself. It's suspected that Lewis and Edith Isaacs, longtime friends of Robinson's who oversaw his care at the hospital, may have recommended not "telling the poet the entire story." As Scott Donaldson writes in *Edwin Arlington Robinson: A Poet's Life*, "Whether he believed that diagnosis, and continued to believe it during the 10 weeks he stayed in New York Hospital, is not clear."

By the time Elizabeth arrived, many of Robinson's New York friends, who had known he was being treated over the last few months, had had the chance to see E.A. when he was feeling better. But now, in his rapidly diminishing state, the poet certainly understood that his death was near. Though E.A. was still working (with assistance) to meet a promised deadline for a long poem, he now had whittled his visitors down to a mere few as the cancer ravaged his efforts to move or speak. Carty Ranck and George Burnham, along with Ridgely Torrence, were among the last friends to see him alive.

But E.A. did not want to see Elizabeth, or perhaps he did not want her to see him. She was told that he didn't want to see any women friends, but this was not entirely true, as at least one friend visited accompanied by his wife. Robinson may have thought it would be too painful for her, as some have suggested, or that she might forever frame the wilted sight of him with her artist's eye. According to one friend, once E.A. had written to George Burnham after some friends lost their daughter, "I am never sorry for the dead, but I can be damnably sorry for the living." There would be no last

words between E.A. and Elizabeth.

Despite how grief-stricken or slighted she may have felt from this refusal to see her, Elizabeth wholeheartedly loved E.A., intact with all his idiosyncrasies, and in her own way, she probably understood his reasons. Contrary to how others at the time may have depicted her—as a spinster pining away for a mate—she never had any illusions or desires about a future with Robinson besides owning the fact that she loved him. She loved the lanky poet who gave her back herself, making her feel alive after years of a solitary struggle, and in his death, he would restore what she'd come to MacDowell to find: a renewed passion for her art. She would apologize, she reportedly told Chard Powers Smith many years later, to E.A.'s spirit for ever "having disturbed him with her love."

And so Elizabeth continued to keep guard with the others, taking turns spending nights in the hospital solarium near Robinson's room. The hospital nurses must have felt sympathy for Elizabeth's dedication to E.A., and one agreed to bring something in from her to the poet. When E.A. saw the rambler rose, which the nurse then hung at the head of his bed, he managed one word: "Pretty," he said of her gift. *Pretty.* (After his death, Elizabeth planted the rambler rose by her house in Westtown where it blossomed.)

Falling into a coma on a Wednesday, the same day he'd approved final edits on *King Jasper*, Robinson lingered for a few days in this unconscious state. On Saturday, April 6, after midnight, George and Carty left Elizabeth alone to continue the death watch. Since her illness, she'd become a night owl and surely heard a shift in activity surrounding E.A.'s room

about an hour after her companions left. At about 2:30 a.m., Edwin Arlington Robinson died, having never regained consciousness. The nurses then allowed Elizabeth to enter his room; the one not permitted to see him living was now the first to see him in death. Even friends who'd seen E.A. often had commented on the drastic decline of his appearance; for Elizabeth, the first sight of him must have been shocking. As she came to his bedside, she followed her heart—a heart belonging to the daughter of a minister—and fell to her knees, bent her head, and prayed.

It was nearly three o'clock in the morning, too early yet to do anything besides wait for the sun to rise. Then there would be telephone calls to be made, eulogies to be written, services to be arranged, and a king of poets to be buried.

Elizabeth survived the loss of Robinson in her life by working. Beginning in 1936, she decided which gallery would represent that work; the Rehn Galleries would become a critical step in assuring her future success. Owned by Frank K. M. Rehn, who had opened his first gallery in 1918, the Rehn Galleries operated from the Air France Building at 683 Fifth Avenue in New York. Rehn represented almost exclusively American painters—including Robert Henri, George Luks, George Bellows, Edward Hopper, and Reginald Marsh—and his gallery was regular stomping grounds for visiting museum curators, collectors, and the like. He also had long friendships with wealthy art collectors, such as Duncan Phillips and C. Vanderbilt Barton.

Rehn Galleries assistant John C. Clancy (who would eventually become the gallery director) handled much of the work involved with managing the Sparhawk-Jones entity and would do so for many of the next thirty years. For her premier Rehn Galleries' outing, Elizabeth steadily prepared for a one-woman show to be held for a few weeks in April 1937, and as much as she disliked the public relations and marketing aspects of being a painter, she let her new representatives do what they needed to do to tell her story.

It was a new generation of art aficionados, and her new dealer had no qualms about heavily promoting the event as Elizabeth's "first emergence into the public eye after an illness . . . where for 12 years she stopped painting." Her contributions, however small, made to the Academy's exhibitions since 1916 were apparently overlooked in favor of the more dramatic storyline. Elizabeth deferred to the gallery director's expertise: John Clancy knew how to attract the reviewers and collectors to his shows, and Elizabeth's intriguing history and triumphant return practically guaranteed the gallery a strong turnout.

Concentrating on content over style, Elizabeth created fantasy-inspired works unlike anything she'd ever done before. Far from the light, happy subjects of her earlier pieces, her new works dwelled on darkness and death and looked cynically at love, creating a theme that critics called one of "romantic disaster." A series of paintings representing phases of Edwin Arlington Robinson's life made Elizabeth especially proud. The four paintings, each of burial scenes with varying interpretations, shared an overall sense of impending disaster, exemplified in one work in which several old men, one

gaping over a dropped book, warily look heavenward to find only threatening clouds.

As John Clancy orchestrated, it was a jubilant return indeed. The powerful *New York Sun* reviewer Henry McBride, reputed to make or break artists' careers, wrote:

> Miss Sparhawk-Jones is an infrequent exhibitor, which may be one of the reasons explaining how she developed an unmolested character, for the artist who lives in the shop window has a poor chance to lead a mental life. [She] deals in strange matters: broods over death of poets, worries over such routine affairs as war-preparations . . .

Another New York reviewer chose a more sensational route (however spotty in fact-checking) to discuss the Sparhawk-Jones show. Under the guise of announcing the latest gallery offerings, he gleefully led his piece by describing her breakdown and disappearance from the art world: " . . . [I]llness interrupted a career begun with unusual promise . . . one brilliantly effective . . . and it was not until 1925 or 1926 that Miss Sparhawk-Jones took up her brush." He also noted the Robinson series, with its "keen and romantic color sense," writing, "The fantastic human drama unfolds beneath a sky that may at first remind one of Greco and that upon second thought seems oddly and with fresh play of fancy to re-invoke the witches that Ryder saw in Macbeth."

The exhibit also aroused the passions of Robinson loyalists like Parker Fillmore. After his visit to the Rehn Galleries, he could hardly contain himself long enough to dash off a letter to the writer Hermann Hagedorn, who was working on

a Robinson biography. Fillmore wrote in part:

> It is a notable exhibit for she is an artist of very great talent indeed. What seem to me the most important pictures in the exhibition are four which are dedicated to E.A. The first is called "Mourners" and the remaining three are variants of the same theme: "A Poet's Burial." All four are works of a powerful imagination, deep feeling, and a brilliant execution. And how E.A. would have loathed them! And how he would have resented her daring to attach his name to them. I'm sure Miss Sparhawk-Jones herself supposes and probably most art critics will suppose with her that in this show she is proving herself an ultramodern. Mebbe so. I dunno. However, the E.A. pictures at least are pure El Greco both in spiritual feeling and in actual execution. They have the same rent and tortured skies, painted in the same brilliant reds and blues, and the figures express the same single emotions, carried to the nth degree—here it is not ecstatic religious contemplation, but grief so overwhelming that it becomes ecstatic. They haven't any of the obvious decorative effects that El Greco delighted in, but in spite of that they have very lovely and very sure design, and exactly the kind of design that El Greco excelled in.
>
> They are a magnificent tribute to E.A. and I hope the execution of them has relieved the poor painter's heart of some of its hurt . . .

More notably, the showing attracted the favor of the pioneering modernist painter Marsden Hartley, who called

Elizabeth a "Painter of Romantic Incident" and "an original painter" for *American Artist* magazine. His opinion, which she valued highly as she considered his talent that of genius, would energize their budding friendship. Hartley, now sixty, had been—along with Georgia O'Keeffe, John Marin, and Arthur Dove—one of the key artists promoted in Alfred Stieglitz's illustrious gallery. In Hartley's review for *American Artist*, he wrote:

> There is a peculiar mental force in the kind of painting this unusual woman painter does. The absence of cult is preeminent in these pictures. It seems to be with something of a mental rapier that she conceives her subject matters—for these pictures border on the exceptionally forceful and they are different in thought as well as execution, from the work of most of the soft painters among men and women. She is a thinking painter with a rare sense of the drama of poetic and romantic incident.
>
> These particular pictures seem to be like a sort of painted sonnet—since they are so measured and controlled within their idea and the result of the search is pretty much enigma when the day's grasping is done.
>
> There is no question but that the spirit of her friend, the poet, Edwin Arlington Robinson, left a sharp mark upon Miss Sparhawk-Jones. It certainly must have sharpened her with the gift of penetration, deepened her sense of things, giving her force to see life in another and tenser degree: for it is in the representation of the tragic spirit that this painter is at

her best, and if these pictures are fused with a wistful irony, they are in no sense morbid, unless all great experience is born of neurotic condition. . . . Idea and thought are welded into one, and if this contributes originality, then, Elizabeth Sparhawk-Jones is an original painter.

In the unedited version of the review, which Hartley sent Elizabeth, he also included attributes of her personality that he found pleasing:

> Sparhawk-Jones is a very gay, cheery and pleasantly rotund person, of medium height, a mostly gayly feminine nature. . . . This lady is a lively companion with an ingratiating sense of humor, being completely alive to the comic interval in experience, yet with change of mood becoming a severe questioner of meanings and the underlying fate in experience.

Sometime after Robinson's death, Elizabeth decided to bob her hair, finally shedding the heavy length that hung down her back. The more contemporary style not only shocked the staid Bayard Turnbull when she visited at La Paix, but also sent tongues flapping around the colony gossip mill from those who thought the change reverberated from E.A.'s death: She had kept the hair long for him, and now that held no purpose. Whatever the reason for her new look, she accessorized it with a touch of lipstick, a new penchant for fashionable clothes, and, of course, her long-time weakness: new hats.

Sometime around 1934, she'd also become friendly with the lawyer Harry Weinberger, whom she most likely met

through his representation of playwright Eugene O'Neill. By Elizabeth's standards, Weinberger—a passionate, brilliant lion of a man who'd dedicated his life to the defense of anarchists—was nothing if not interesting. Believing that the persecution of someone for the expression of their opinion was dangerous, Weinberger spent the better part of his life arguing for "unpopular causes, but the attack on Pearl Harbor forced him to reassess his pacifist convictions," according to Richard Polenberg, who wrote about the defense lawyer in his 1987 book, *Fighting Faiths: The Abrams Case, the Supreme Court, and Free Speech*.

The Abrams case, which helped define Weinberger's career, came before the Supreme Court in 1918. The thirty-two-year-old Weinberger defended four radicals from the Soviet Union in what would become a landmark Supreme Court case, *Jacob Abrams et al. v. United States*. Weinberger lost the case, but it made history in the definition of free speech. The dissenting opinion, written by Justice Oliver Wendell Holmes (with Justice Louis Brandeis) regarding "clear and present danger" has become the standard for most subsequent first amendment litigation and theory. During his career, Weinberger also defended Emma Goldman, an influential anarchist who advocated free speech, birth control, women's equality, and union organization.

A Jewish immigrant from Budapest who grew up in an Irish neighborhood by the East River, Weinberger had gone nights to New York University law school, a popular option for many immigrants that allowed them to "skip college" and study for the bar. His temperament of being a "fighter" translated to his hard-working dedication to his clients and the law.

In a letter she wrote in 1938, Elizabeth also described him this way: "Harry Weinberger has been here also," she wrote after an apparent visit to see her in Westtown, and then, referring to a current case he was working on, "He is forceful—and a fighter in court." At 5 feet, 4½ inches, Weinberger was reportedly self-conscious about his height, though he was a strong runner and athlete; he had a pleasant face, a receding hairline, and an easy smile that showed a dimple in his chin.

Sharing a love of reading, he gave Elizabeth at least a few books as gifts during their relationship, including *Observations on the Mystery of Print and the Work of Johann Gutenberg*, inscribing it to "a lady of charm and graciousness." Eleanor Turnbull, Elizabeth's niece, recalled a lunch in New York with them at which Harry surprised her by leaning over during the meal and saying to her, "You know, I want to marry your aunt." But though Elizabeth cared for him very much, she apparently didn't take the idea of marriage very seriously and laughed if off as if he'd said this countless times before.

About a month after her successful 1937 show at the Rehn Galleries, Elizabeth sat up one midnight at the country house in Westtown. All the windows were open and a strong May breeze blew over plowed fields outside, an atmosphere she found especially "lovely," as she shared her deep sensual feelings for painting fellow artist Marsden Hartley. "Just paint for what it alone can do is always a joy to me," she wrote, "—and you can make things in paint that is alive with the dyes that are an expression of your spirit."

In June 1938, Elizabeth settled in at Peterborough for the summer with her fifteen-year-old niece Eleanor in tow. With blades of Maryland grass circling her ankle to ward off homesickness, Eleanor had traveled to New Hampshire with her aunt for a small role she'd won in a play with the Peterborough Players, a theater troupe in town. With rehearsals and the eight-night performance schedule, she was staying for about six weeks with her aunt. Elizabeth worried about her niece's taxing schedule and feared her nerve might give, but soon admitted that "it, as well as the grass, is holding."

Elizabeth treasured Eleanor's company but also excused her own half-hearted work effort on the additional distraction. Another diversion may have been the MacDowell Colony unveiling its tribute to Robinson, which stirred memories of their times together at the colony.

"I spent part of this evening in the house in which he lived when I was alive on the earth with him. I shall never be alive that way again," she confided to a friend in another letter, as usual written after midnight. "I met my lost self everywhere tonight, at the doors of that home, in the barn, on the porches, beside the chairs. I think it is because so little was spoken by either of us for fifteen years that the landscape of his spirit is so open for me, not a force anywhere as if all we had to do was to walk forward and forward. My life has been such a quiet one in many ways and yet [seems to follow] a strange pattern, and dissolution has no place in it."

When Grace Casanova, Sinclair Lewis's first wife, became a guest in the same rooming house as Elizabeth, life at MacDowell suddenly became a bit more fun. The former

Grace Megger Lewis, an attractive blonde now in her forties, had been divorced for about ten years from the renowned writer of such works as *Babbitt* and *Elmer Gantry*. Now remarried to a New York investment counselor, Madam Casanova, as Elizabeth called her, was the daughter of an art dealer who'd been working for *Vogue* when the aspiring writer Lewis spotted her across a tearoom in 1912. The repercussions of his eventual international fame, which she thought came too early, eventually torpedoed the marriage after fourteen years, but left her with a son, Wells, now twenty-one.

Casanova, a writer, at first struck Elizabeth as "somewhat affected, but a handsome woman . . . full of anecdotes and European flavor." But soon respect for the woman grew into fondness, and with her new friend knowing virtually no one in the Peterborough artist community, Elizabeth acted as town hostess, bringing her to meet Mrs. MacDowell; to dine with colonists, including new member Thorton Wilder; and to attend the many summer parties. Six weeks after meeting Casanova, Elizabeth's daily routine had gone from loose to sedentary. She wrote, "Madam Casanova and the first Mrs. Lawrence Tibbits have silenced us by the drama of their lives. I often sit on this narrow porch rocking with the old ladies, all of us poking the potted plants with our toes, and resting stupidly in the shade . . . "

Though hardly "old ladies"—with Casanova about ten years younger than she—Elizabeth apparently welcomed being with others who'd lost or been disappointed by those believed at one time to be great loves. (Even twenty years later, Grace Lewis Casanova would reminisce about her time with "Hal" Sinclair Lewis in a memoir she titled *With Love from Gracie*.)

Despite the band of entertaining friends and Eleanor's youthful presence, Elizabeth maintained a daily routine—kept since her illness—of sleeping late, lingering over lunch, and, whether she was painting or not, breaking for late-afternoon naps. But at night, she became a different person, filled with energy seemingly not found during daylight hours. Eleanor found the transformation remarkable and remembered her aunt's nighttime self to be "like a debutante, just scintillating, with everyone's eyes on her."

During that summer of 1938, Elizabeth also enjoyed spending time with George Burnham, who came to Peterborough for a week before continuing on to Head Tide in Maine.

In late September 1938, the most forceful hurricane to hit New England in 117 years barreled down on the six states, catching most of its natives by surprise. Elizabeth, lingering in Peterborough, didn't recognize the significance of the storm until it struck, despite storm signals being hoisted and weather advisories issued. Adding to the destructive force of the hurricane was a tidal wave, which together created a three-hour-long merciless rampage.

When the quiet came, the dead totaled 494; some had drowned in their homes, on the street, or at their workplace. The Peterborough community was hit especially hard. In Everett S. Allen's *A Wind To Shake The World: The Story of the 1938 Hurricane,* Allen described the scene. "Peterborough, New Hampshire, spent a night of horror combating a fire in the already flooded east side of the business district. The fire was said to have been started by a spontaneous combustion in grain bins of the Farmer's Grain Company. The

hurricane and the storm wave ravaged beaches and battered or destroyed thousands of permanent homes and summer cottages, damaged or destroyed many fishing and pleasure boats and equipment, ruined tremendous amount of other water front property and practically wiped out all means of communication in many sections."

Two days after the hurricane and storm wave tore through Peterborough, Elizabeth sent word of her survival, in language both dark and more than a touch macabre:

> I have been through flood, and hurricane, and fire (not near by) and there are now only discomforts. . . . We are all safe but uncomfortable, no heat, no hot water, no telephone, and there will be none of these things for a while. . . . The porch was filled with the sap of torn leaves,—the blood of green things, nature bleeding; an odor I had never known before,—delicious beyond compare, and prehistoric and a little terrible.

In December 1938, the Gardiner, Maine, library reacted to an unfavorable book by Hermann Hagedorn on its hometown son by reputedly banning the recently released biography on Edwin Arlington Robinson from its shelves. Elizabeth joined those protesting who felt E.A. had been maligned by a superficial profile, moreover by someone who didn't even know him. She was not only incensed but suspicious of Hagedorn's motives. Elizabeth vented her anguish to Marsden Hartley:

> I never thought Mr. Hagedorn could say anything about Robinson that would interest me. I know what I know. If there is any poison in Mr. Hagedorn's heart

toward his subject, why did he undertake this job? It seems he has left much for another biographer to do.

During the next few years and from the varying locales of New York, Florida, Pennsylvania, or New Hampshire, Elizabeth worked at the higher pace of her earlier days despite a setback after a fall that sent her to La Paix to recover for a few weeks. Curators slowly began to take notice of the new, vastly different "romantic disaster" style of Elizabeth Sparhawk-Jones, an approach she sometimes described as "painting on the pulse" or with her "inner eye."

In 1940, the Metropolitan Museum of Art in New York acquired the watercolor *Caryatides* by Elizabeth Sparhawk-Jones for its permanent collection; it was her first museum acquisition since 1912. The origins of the caryatid, a draped female usually presented carrying something on her head and used as support in neoclassical decorative arts, is still debated. It was first recorded by Vitruvius, an early Roman architect, as symbolizing the punishment of women condemned to slavery, and by others, more plausibly, as priestesses carrying sacred objects.

Like the split nature of the caryatid itself, Elizabeth's paintings now represented both the raw pain and pleasure of living through fifty-five years. Brushwork alone was no longer enough, and she would call it "merely the daily denizen of an acrobat." No more pretty dresses and shop windows for their own sake—her canvases now peered over the edge of darkness, finally merging with the drama of the painter's own life.

IV. APRIL 26, 1964
INTERVIEW of ELIZABETH SPARHAWK-JONES
Conducted by RUTH GURIN for the
Archives of American Art, Smithsonian Institution

For more than an hour, the painter and the curator had been talking, interrupted only once by a presumed hotel guest wishing to play the nearby piano; with a few words from Gurin, he was easily persuaded to delay his practice. One 7-inch tape, rich with anecdotes and personal history bound for the Smithsonian Archives of American Art, had just been replaced with fresh ribbon.

Now discussing American painter Charles Demuth, a Pennsylvania Academy of the Fine Arts contemporary who suffered from diabetes, Sparhawk-Jones recalled meeting him in New York's Washington Square one day and how "he looked so yellow and sick; he had a very heavy overcoat, very wide overcoat. He was just keeping alive for years."

Like the vivid description of her chance encounter with Demuth, Sparhawk-Jones conveyed her understanding of color and mood and shadows as easily with words as oils. Not only did she express the physical imagery but she also possessed an underlying certainty about what was said. Yet at rare times during the conversation, her memory appeared

clouded, especially when remembering less visual details.

Was she ever sentimental? No, she denied vehemently. How was Gurin to know of stacks of saved letters from various friendships or replanted rambler roses in the Pennsylvania countryside? In this vein, she denied ever keeping scrapbooks for herself and gave credit to those that existed to Grace Turnbull, her sister's relative. And yet the scrapbooks contain both personal notes to her and other writings in her own hand, close to impossible for anyone other than Sparhawk-Jones to possess—and they stop abruptly in 1913, the year of her breakdown. (They are small contradictions for a woman nearly eighty, but nonetheless necessary to mention.)

Sparhawk-Jones didn't care to talk about Demuth for very long; the accomplished painter and illustrator, though sickly, also had great family wealth that allowed him to indulge his avant-garde pursuits of cubism and precisionism at his whim. By bringing up another artist in the next breath, "one she knew well and admired more than any of them," she seemed to prefer the weight of a story about an artist who suffered—not simply from ill health, but also from poverty, social neglect, and insufficient professional recognition. That artist was Marsden Hartley, or, as he liked to call himself, "the painter from Maine."

Considering the more recent time line of her relationship with the pioneering American modernist, it's somewhat surprising that the narrative about him came so late in the interview. But Gurin preferred to go into these interviews cold and unearth the unexpected, and by her startled "Oh!" at hearing Hartley's name, it's apparent she had.

"Oh, yes, he was something."

"Tell me about him."

"Don't you know about him?" Sparhawk-Jones queried, one of the few times in the course of their discussion she seemed to test Gurin's expertise.

"Well, I know about his paintings, I've seen a number of them," Gurin qualified, "but I don't know what kind of person he was."

"The person that went with the paintings . . . " Sparhawk-Jones, apparently satisfied by the curator's explanation, now seemed to reflect gravely before answering. "He was naturally awkward, and they [his works] are; and very independent, the youngest of thirteen children. They were weavers who left England and came to Maine. And I don't know much more. He was a very interesting talker. He used to say to me, 'We should be together often, because we say such nice things when we're together.' He was very creative in his talk and made anybody creative who was with him. He used to not mince his words, not tiresome, flat words, but he used a good vocabulary and he wrote beautifully. There's an excerpt from an article he wrote on me in the catalogue that was made up and you'll see Marsden Hartley's name under it."

At one point in the discussion about Hartley, Gurin contributed her thoughts about the style of his paintings. "His work from the twenties is very abstract, and then later he went back to the figure."

"Yes, he went back to the figurative," Sparhawk-Jones agreed. "But very powerful. . . . He loved the Maine coast

and the sea, but he's quite different from Winslow Homer."

"Oh my goodness, yes. He's more abstract."

"I don't know. There's no . . . " Here Sparhawk-Jones paused, and then, "Everything is abstract. Velázquez [referring to a Spanish painter from the 1600s] is abstract."

"Painting is an abstraction, I suppose?" Gurin asked, ostensibly energized to be on the cusp of a larger principle.

"Always," Sparhawk-Jones replied without hesitation, "More or less exaggerated; more or less. And now it's more . . . "

Once she began reminiscing about Hartley, the older woman could barely refrain from praising him at every available turn in conversation. Whether the topic centered on new acquisitions of her work, her nephew Andrew Turnbull's biography-in-progress on Thomas Wolfe, or another artist of that time, she invariably brought the subject back to Hartley's story.

"Of all the people that I speak of, the one that was the most interesting was Marsden Hartley as a person."

"What made him more interesting?"

"Just because he was; because everything he touched was . . . " Sparhawk-Jones faltered here in trying to find adequate words to describe him and ended up repeating herself, "his conversation and his use of language."

Hartley's sudden death and the contributory factors of poverty and neglect prompted Gurin to mention other artists who suffered similar circumstances. But Sparhawk-Jones

quickly countered this opinion, which she seemed to consider a lessening of his stature.

"Yes [there were similarities]," Sparhawk-Jones allowed, "but he was a giant among them. He was the giant among them."

Years later, Gurin would wonder (even half-joking that she'd revere a therapist's opinion) if the empathetic loyalty Sparhawk-Jones extended toward her friends like Hartley was ever returned. In Hartley's case, the truth may be somewhat murky. For within the roots of their friendship—unbeknownst to Sparhawk-Jones—nestled a rivalry with another introverted Maine native, a certain poet long deceased. No doubt Sparhawk-Jones loved Hartley's intelligent conversation, his use of language, his unique talent—qualities suiting her lifelong fascination with "interesting people."

Hartley *was* an interesting man who also helped her career during a critical turning point; the question of whether he was trustworthy and honest, however, may always linger—unsatisfied and unrepentant—over it all.

Elizabeth in the 1940s

CHAPTER 10
THE MYSTERY OF MARSDEN

In a city that boasted some of the marvels of the modern era of transportation—two underwater tunnels for cars, a bridge of steel beams and cables that stretched almost a mile and a half from New Jersey to Manhattan, and a subway system with 130 miles of track—New York City's trolley car was definitely *not* the modern way to go. Yet on an afternoon in 1942, Elizabeth and Marsden Hartley, two "modern" artists, waited together for the (soon-to-be extinct) dinosaur of the NYC transportation system to take them to lunch.

Writing to each other consistently since 1937, the friends ever so often found a chance to see each other in person. By now they had exchanged at least forty letters, Elizabeth gradually disregarding the more formal salutations of "Mr. Hartley" in favor of "Dear Marsden"; from him, "Best Wishes, Marsden Hartley" became "Love, Marsden."

Today the streetcar would drop them at Madison Avenue, where they planned a celebratory lunch honoring Hartley. After unhappy alliances with previous dealers, Hartley had just changed representation to noted dealer Paul Rosenberg, who had his gallery on 57th Street. For an event that had been the subject of more than a few letters between them—

Hartley had written that he'd been "leery" of the change—he now set all modesty aside to enjoy this huge validation of his talent. Ever the supportive ally, Elizabeth had taken the train from Philadelphia to treat her friend to lunch and spend some time with him.

They must have made an intriguing pair. At fifty-six, Elizabeth kept her thick, curly hair loose to about chin length, and though there were a few creases and folds around her almond-shaped eyes now, they still accentuated her every facial expression from beneath thick brows; her fuller middle-aged figure usually sported an A-line patterned dress made of a free-flowing fabric that cinched at her waist and then fell away to a few inches below her knee. With hooded eyes and a large, pointed nose that overwhelmed his long face, Hartley's features, even in his younger days, resembled those of a nervous bird. Now balding and overweight, with a cigarette often dangling from his lips, he could carry off the part of distinguished gentleman, especially when donning his jacket, vest, and bow tie—and aided now perhaps by the flush of newfound confidence gained from his acceptance with the Rosenberg Gallery.

As they waited for the trolley, Hartley apparently couldn't get his thoughts away from something he'd seen in one of the shops and described to Elizabeth some rich blue cloth, which he dreamed of having made into a suit for himself. She clearly recalled the exchange years later. "It's such beautiful blue cloth," he told her. "You should see the color of it. Not quite like anything I've seen before . . . and the texture of it."

"Hartley," Elizabeth replied with a slight reprimand in

her voice, "don't hesitate. You want it. You've done very little for yourself ever. Just satisfy yourself and buy it."

For just a moment, he looked at her with imagination dancing in his blue eyes at the possibility. But for a man who'd grown up in poverty and had struggled for his current solvency as an artist for years, the idea of indulging such an extravagance was immediately shrugged away.

"Now's not the time for that," he answered her.

And then, she recalled, the trolley arrived, effectively ending the discussion; she slipped in two fares of 10 cents without a word, and the two headed uptown to eat.

When they first met, Hartley, in an unedited version of a review of her works that he gave her for a showing at the Rehn Galleries in 1937, described Elizabeth as "cheery" and "gaily feminine" with "an ingratiating sense of humor, being completely alive to the comic interval in experience, yet with change of mood becoming a severe questioner of meanings and the underlying fate in experience"—descriptions consistent with others' views on her personality. The timing of their friendship could have hampered their developing closeness; her show at the Rehn Galleries had gone well, whereas Hartley's at Stieglitz's gallery was met by not-so-wonderful reviews. Elizabeth even accompanied Marsden to the exhibit of his twenty-one paintings, and upon returning to Westtown from New York, she wrote one of her first letters to him prompted by nagging feelings of what she hadn't expressed to him in person.

Dear Mr. Hartley—

Now that I am back in the country once more with how much pleasure I remember my days in New York. I am thinking this evening most particularly of the afternoon I spent with you, and our visit to the rooms that hold your pictures; and just how you paused outside the door as any creator must,—and what a mature, and beautiful spread those walls supported when the door was opened. Delectable to me is the quality of your paint,—just paint for what it alone can do is always a joy to me . . . I feel your eye surrounds the object it looks at,—a crab,—a seashell,—a pasture. The poetry in these canvases is most personal. I like their blunt simplicity,—this confidence in the beauty of things. They are satisfying—they have hardly any place for fault-finding. They are little edifices, they hold, they do not break or break down. So there you are an artist. I wanted you to know all this the afternoon I speak of, when we were together.

I hope this month of May will be very good to you. It is lovely here at this minute. All the windows are up; and the breeze is wispy outside blowing over plowed fields. It is edging toward midnight.

Very sincerely yours,
Elizabeth Sparhawk-Jones

For an insecure man on the verge of a major shift in his career, her words undoubtedly buoyed his spirits and nurtured the budding friendship. It was fortunate, however, that Elizabeth met Marsden Hartley when she did, in the

late 1930s when he seemed to have mellowed, for she didn't seem to see the sides of Hartley that grated on the nerves of some others. Two factors apparently in her favor from Hartley's perspective: She understood modernism and was not conventional. In *Marsden Hartley: The Biography of an American Artist*, author Townsend Ludington describes such attributes sought by the shy, complicated painter during the period that Elizabeth was befriended by him: "And late in life, when he was weighed down with deafness and frail health, his bitterness and contempt surfaced. He made demands on people who sought to help him, and then either took them for granted or was gruff and ungracious in return." None of this attitude seemed to have been directed at Elizabeth, or if it was, she ignored it, for she remained steadfast in her devotion to him throughout their friendship.

Hartley until recently had been part of the stable of artists that included Georgia O'Keeffe, managed by gallery owner and photographer Alfred Stieglitz. Stieglitz, who had given Hartley his first New York show in 1909, had eventually tired of Hartley's manner along with his style of painting, one which he saw as less American than the others. So in 1937, Hartley had a bitter split with Stieglitz for these and other reasons.

Perhaps Elizabeth saw in the man she called "a giant" what Adelaide Kuntz, a longtime friend of Hartley, did when she wrote to a former dealer of Hartley to complain about what critics were saying after his death. Kuntz wrote:

> He loved flowers, insects, birds, minerals, children, as well as mountains and music, poetry and painting.

Marsden was a truly dignified man. He had a great respect therefore always for dignity in human relations. He was not really a talkative man—but he saw more with his blazing blue eyes than anyone I ever knew . . .

That Marsden Hartley was gay, or as Elizabeth put it, "loved men" mattered little to her and their friendship. Why should it? As always, talent and character, with a dash of personal struggle thrown in, superseded everything else to win her respect and attention. (In addition, her relationship with lawyer Harry Weinberger continued at a steady intensity; he was a friend whom she admired greatly and also someone who lavished male attention on her.) But biographer Ludington connects Hartley's sexuality to the core of his being when he writes that: "His loneliness, his peripatetic nature, his ideas, and the subjects of his paintings all stemmed from his homosexuality."

One aspect of Hartley's character that the biographer grapples with concerns his attachment to Sparhawk-Jones in the first place. Believing Hartley to be competitive with and jealous of Edwin Arlington Robinson, Ludington estimates Hartley's overtures may have been calculated. Winning over someone who worshipped Robinson may have been his intention, at least initially. (That the poet was dead did not seem to matter.)

The two introverted men from Maine did have many surface similarities: Both lived passionately for their art, held secrets close (alcohol for Robinson, homosexuality for Hartley), dealt with repressed sexuality, and knew poverty

firsthand. But the distance between them in personality was far greater. Unlike Hartley, Robinson's wide circle of friends was no accident; his loyalty, genuineness, and love and respect for them were simply repaid in kind. With regard to their home state of Maine, although Robinson traveled around the East Coast, his heart never strayed far from Gardiner, a bond that exists within the town today. For Hartley, years of bitter memories caused him to avoid Maine for about thirty years; he finally returned to the coast only in his last years.

Robinson's death in 1935 undoubtedly created a large void in Elizabeth's life, a space Hartley's friendship helped to fill. Finding someone who not only listened to her but actively sought discussions about E.A. probably meant the world to her. Hartley's unavailable status as a romantic partner also gave her the freedom to grieve over Robinson's death at length to him without restraint. Otherwise, she may have curtailed some of her more romantic imagery as when she wrote in one of her early letters to him of going through rooms she'd been in with the poet and fearing that "I shall never be alive that way again."

When Hartley responded a few days later, his words soothed like a salve.

Dear E. Sparhawk-Jones,
Such a lovely letter you sent me—I have never read [a] more precious sentence "the landscape of his spirit . . . in the house in which he lived when I was on earth with him" now—I have never seen or heard lovelier sentences. And after all, when two persons are really in communion is there very much to say—

He must have admired your natural vibrancy and gaiety and even your silent words must have been vivacious to him.

Hartley, not surprisingly perhaps, never seemed to tire hearing about Robinson and often coaxed Elizabeth into further conversation by small digs at the poet. In one letter, Hartley mused:

> I try so hard to read Robinson—but it is much the same as Emerson said of Thoreau—"I love Henry but I cannot like him." I find Robinson so difficult to read because of his adherence to classical imagery—yet I admire his strength as a poet.

Try as he might, Hartley never swayed Elizabeth from her perspective on Robinson's greatness as a poet. But he did succeed in fleshing out the poet's humanity, even having her concede a few faults of E.A.: "I have faced four people when he passed back of me and seen the intense effect his anger had on them," she wrote.

But in the long run, she defended Robinson and his memory.

> His was not a case of flighty temperament; his nature produced subtle dramas day by day with many who surrounded him. It must have been tiresome, but he was of a different kind and those who traveled the road along with him for a time, without jealousy, know what a man can be . . .

When she qualified those people "without jealousy" judging Robinson's legacy, perhaps she was subtly including

Hartley; nevertheless, there's no clear indication that the possibility of his being disingenuous ever dawned on her.

⌒

Although Hartley's reviews of her paintings undoubtedly helped Elizabeth professionally, his crippled career at the time still did not lessen her attachment toward him. As she did for Robinson, Elizabeth championed Hartley's work because she believed him to be vastly underrated, especially for his very powerful figurative work. One of his earlier masterpieces, *Portrait of a German Officer*, a tribute to his lover killed in battle during World War I, showed a brightly colored abstraction of an organized pattern of medals, flags, banners, and other military accessories. Unfortunately for Hartley, his Germany-inspired paintings left the American public cold, as they were seen as sympathetic to the enemy. Afterward, he traveled between New York, the Southwest, Massachusetts, and Canada, and then, finally in his last years, returned to his native Maine.

Now with his new representation at the Rosenberg Gallery, he'd finally achieved the recognition he'd been seeking throughout all those years of travel. Soon after their lunch in the city, Elizabeth reported to him about driving past the new gallery in October 1942. In part, she wrote:

> You are certainly bowling down 57th Street—lengthwise and crosswise. You are acknowledged to be an outstanding figure these days. I was in the city last Thursday to have lunch with Rehn. He was most amiable and generous and is for me an undoubted

blessing. I only had an hour in the city but as we drove down 57th Street, I saw your name in great letters. You are making such a name for yourself these days that you should seek exactly what you need and look after your health most carefully so you can continue to make pictures as long as possible. . . . I am distressed to learn that you have had a bruised leg and the making of pictures stalls a bit at the moment and very naturally because of long concentration. Where ever we are we seem to have too much of what this place provides whether it is solitude or company . . .

My love to you,
Elizabeth

The year 1942 also proved to be a pivotal one for her career. The Wichita Art Museum bought *The Generations*, a watercolor on silk for its collection, and the Rehn Galleries held a one-woman exhibition of her work. But the most prominent notice that year of the new Sparhawk-Jones style came when the Museum of Modern Art published the book *Romantic Painting in America*.

In his preface, Director Alfred H. Barr Jr. described the book, which showcased works by John Singer Sargent, Albert Pinkham Ryder, and John Sloan, among others, as "designed to present the movements, trends, or divisions in modern art." Two paintings of Elizabeth's were included in the book: *Lady Godiva* (1941) and *New Hampshire* (1938). In the book, Assistant Director James Thrall Soby calls *Lady Godiva*, which had been lent by collector Eloise Spaeth, "an engaging work which transcends dependence upon its stylis-

tic source" while paying tribute to Tiepolo.

⌒⌒

As her professional career began its ascent, one new private collector of her work added some Hollywood panache to her social life in the person of movie actor Claude Rains, whose name always topped the list of Elizabeth's private collectors in the catalogues of her exhibitions.

Rains, who'd been Oscar-nominated for his portrayal of a villainous senator in Frank Capra's Mr. *Smith Goes to Washington* a few years before, currently had a successful film, *Now, Voyager* with Bette Davis, at the theaters. In 1942, he was working with Humphrey Bogart in the film, *Casablanca*—which would win the Best Picture of 1943 and would give Rains his second Oscar nomination.

In late November, Rains and his wife, Frances, opened their home in Westtown to a few neighbors, including Elizabeth and her mother, to celebrate the American tradition of Thanksgiving. The British actor, who had begun collecting Elizabeth's work, and his fourth wife had a four-year-old daughter, Jennifer, and partly for her sake, had decided to stay in the country for the holiday this year.

Elizabeth had called Maryland that morning to say goodbye to her nephew Andrew Turnbull, who was leaving on a wartime destroyer from Norfolk, Virginia, possibly headed for Africa. Andrew had asked for a volume of Shakespeare's tragedies for his bag, and she most likely shared his story with Rains, who had his own war stories to tell. "I was in the trenches for about two years," Rains apparently told her, "I

weighed only about 145 pounds at the time, but I was tough, carrying cannonballs as big as a coalscuttle on my back . . . "

Sitting and talking most of the evening, they discussed everything from Rains's favorite Hollywood actor—Charles Laughton—to more about his time spent in the British Army with the Scottish Regiment during War World I. Elizabeth wasn't unimpressed by Rains's movie career, but she believed that he'd have made his mark in any calling. She wrote Hartley about Rains: "He is so intelligent. He might have made a statesman, but he started as [Ellen] Terry's 'call boy' and grew up in the theatre."

Elizabeth apparently felt the "delightful strain from a few of the noses of other women being out of joint a fraction" by her spending so much time talking with their host. But she didn't care in the least. Rains's company and conversation gave her an effervescence that she, at fifty-seven, fully enjoyed.

Over the hot chocolate drink, Frances Rains poured a wide band of ice cold cream from a pitcher. When Elizabeth put the rim of the cup to her lips, she felt "transported" by its chill and warmth and flavor. "I had a lovely Thanksgiving," she wrote to Hartley in early December, "the best day since I last wrote you."

It would be one of the last saved letters she'd write to Marsden Hartley. In September of the next year, her favorite "giant" artist died as a result of complications from a bruised leg and weak heart while in Corea, Maine. His wish of cre-

mation had been fulfilled with his ashes scattered on Maine's Androscoggin River. He'd also ordered no stone or marker to be placed for him. Apparently even Marsden hadn't realized the extent of his illness and infection until the last. Few friends had warning.

In one of Hartley's last letters to Elizabeth, he had written about the new Metropolitan show, about someone from the Bauhaus that he'd seen again, and declining an invitation, he'd explained, "I need few social affairs now—feel as if I must get away from people." But upon one particular passage in which her often-fussy friend practically shouts his happiness, she may have lingered:

> I am most thrilled at praise Paul Rosenberg gave to me in talking to Hudson Walker. He said I am the "greatest American painter produced so far because I am thoroughly American and at the same time universal"—could anything be better than that?

> And he signed the letter, "Devotedly, Marsden."

Leda and the Swan, c. 1944, by Elizabeth Sparhawk-Jones, Watercolor, 27 ½ x 20 in., Courtesy of the Estate of Harold B. Deshowitz; Maura, Rob, and Lily Geils current owners. *Leda* was once owned by Juliana Force of the Whitney Museum of Art.

CHAPTER 11
"A PHENOMENON IN THE WORLD OF PAINT"

It had been a warm November so far, no snow and little rain. Not terribly unusual for Maryland, but a gift nonetheless, softening the days against the burden of deep sorrow. For weeks now, the world for Elizabeth had moved inside the heavily lacquered walls of her sister's Baltimore home.

Outside the windows and doors of Trimbush on the grounds of Margaret and Bayard's La Paix estate, remnants of the season that hadn't been gathered in barrels or bags flew in free-form dance around the property. Any time of year became spectacular here, but autumn perhaps strutted most, flouting its landscape of orange and crimson foliage against the expansive green grounds. The Queen Anne–style home in which the Turnbulls lived, however painstakingly crafted by Bayard, had been built to suit the land on which it stood, and no one would suggest otherwise. La Paix created an illusion of rural privacy within its walls of trees and 26 country acres; but in 1946 the estate lay in the midst of the ever-growing suburb of Towson, with relatively close access to all the benefits of city living, including excellent medical care. La Paix certainly offered the best possible environment

in which to retreat, especially for one who was dying.

In one of Margaret's guest rooms, Harriet Sterett Winchester Jones lay, her two daughters taking turns by her side. For these weeks, Elizabeth and her sister lived on the emotional edge as they prepared to lose their mother. Seeing death up close was nothing new for either woman by now; Elizabeth was sixty-one and Margaret fifty-nine. It had been thirty-six years since their father's sudden death had shocked (and subsequently uprooted) them. But that loss was lifetimes ago. Elizabeth had lost her friend Marsden Hartley only a few years ago; just months later, the death of her companion Harry Weinberger had sent her into a tailspin of mourning that produced *Injustice*, a large oil of an angel-like figure shot through the heart with a bow and arrow. Bought by the Pennsylvania Academy for its permanent collection, a reviewer described the canvas as "a striking contrast of chromatic notes—glowing red relieved only by a flash of plangent blue."

But this was her mother, for whom she'd been a lifelong companion and from whose influence she'd never quite escaped. The power Harriet had over her daughter apparently was difficult for her to relinquish, for even as she contemplated her impending death, she did not foster her middle-aged daughter's independence. Rather, she assured Elizabeth, who sat distraught by her mother's bedside one day, that "I will hold you in my arms forever." For years afterward, Elizabeth would chide herself for her inability to make her mother happy. If only Elizabeth could have been happier, she'd obsess, then perhaps her mother would have been as well. She con-

veyed to a friend, "How I wish I could turn the clock back 10 years—and live them over with greater joy and calm, so that I might have been a blessing . . . the best thing I could have done for her was to be happy."

Elizabeth expresses such painful laments despite having had an upward surge in her professional career nearly equal to that of her early fame and having the steady companionship of a wide family of friends. At no time does she suggest that perhaps her mother could have done them both a service by finding happiness elsewhere. (Only in the narrative of Margaret's children is the suggestion made that Harriet's overbearing nature perhaps snuffed out some of Elizabeth's drive to become fully adult.)

Waiting for the signs that someone beloved was about to die was draining. At times during these warm fall days, it likely induced varying cases of claustrophobia. Every nuance of body, every communication was naturally magnified: the pressure on the dying as well as the living to say something meaningful before it's too late, all the while knowing that no words could ever suffice. There were no longer subtleties or asides or "by the ways"—even laughter hung like an anchor around the heart. With the dying Harriet, every moment gained the prefix "the last," so the idea of living to celebrate the Thanksgiving holiday on November 28 likely gathered momentum as the month went on.

In mid-November, Elizabeth had a scare, believing her mother's heart had stopped. Clasping her mother's hand in hers over the cotton sheet, she had an out-of-body experience as she looked down at their entwined hands, feeling

that neither belonged to them—but to others. She wrote to her friend Edie Brecht, a writer of children's books, about the sensation: "Well, there are no words for some things one sees. I had to shut my eyes. I could not stand it. How does God stand it?"

When Thanksgiving Day arrived, Harriet sat up by her window in the guest room and looked out over the La Paix estate at the autumn trees and the hill beyond them, which had at its foot a lily pond. The temperatures lingered in the mid-50s, and as she gazed out of her room, she seemed greatly affected by what she saw. Perhaps childhood memories of the rolling acres of Clynmalira mixed with her present scenery as she let tears run freely down her cheek and mourned, "How much I have loved this old earth." Elizabeth always thought her mother's "wild" love for nature differed from most, describing it as a "love of the creatures for this star called the earth—she was not so divorced from it as many humans are."

The next day, as the sun ducked in and out of the clouds and a slight southwest breeze stirred the warm air outside Trimbush, Harriet died within its solid walls. Despite the preparations, her mother's death devastated Elizabeth. In a letter to Edie Brecht, she described the void: "I am broken, and it is not the tears from behind the eyes but the cry of my whole being, that I utter when alone, that relaxes me; but I shall be as brave as I know how to be."

That night Margaret and Elizabeth planned for a simple

memorial to be held at Trimbush. Describing the service to Brecht, Elizabeth wrote:

> My sister has a very beautiful room downstairs and it is from there we buried her. We only asked the family by telephone so no one should be there who had not a long running with her. The room was a poem, all the big sprays of flowers lifted up on the walls, they were like frozen fountains of foam and a long cross of white carnations hung in the big window against the afternoon light. Over the casket was a pail of ivy and ferns that looked like the shore of fairyland and on top if it set among the flowers there was a small colored picture I have of her as a girl open in its velvet case. The last words that were read before the benediction were Carlyle's—
> "Know of a truth that only this time—shadows have perished or are perishable; that the real Being of whatever was, or what ever is and whatever will be, is now and forever."

Within days of the memorial, a polar air mass swept into Baltimore, and the temperature plummeted into 30s. Although Margaret implored her to stay through Christmas, Elizabeth prepared for her December return to Westtown, alone for the first time in sixty-one years.

Outside, it had finally snowed, laying a fresh powder of white across the grounds of La Paix.

What likely wasn't said when Elizabeth left her sister's house that day in December 1946, except perhaps in the most roundabout way, was anything about Elizabeth's mental health. Worries that her depression would return as she dealt with her mother's death would not have been out of the question; she now would be living by herself, making decisions for and about herself without her mother's approval or knowledge. Margaret would have to concern herself with the return of her sister's mental instability at a future date, but not yet. For now, Elizabeth chose a route she knew best to deaden the pain of acute loss: painting.

"I escape every day out of the present in my painting—and the familiar life goes on here day by day as it always has," she wrote to Edie Brecht, "The pattern is richer, as T. S. Eliot says, for the dead and the living together make it so."

Her younger friend privately believed Elizabeth's solitude was not healthy, and Brecht would one day grieve over Elizabeth's "sad and lonely" life. Although Elizabeth had expressed to Brecht her regrets about not making her mother happier by being happy herself, it's not clear what path she would have changed to have made it so. Romantically, Elizabeth received little if any encouragement from Harriet to pursue love or a family life. If she had, the result would have been Elizabeth leaving her role as her mother's companion, and Harriet had a history (from Schamberg to Robinson and Weinberger) of warding off these kinds of threats.

If Harriet had wanted to see as "content" the flush of renewed career success in her daughter's face, it had been there for at least the last few years. Beginning with her inclu-

sion in the 1943 publication of *Romantic Painting in America* and aided by several new important relationships, Elizabeth now had regained respect and a professional footing in the art world. Her second life as an artist had begun.

Preferring to scribble sketches on note paper rather than make preliminary sketches on the canvas, she drew and painted at the same time. She chose a canvas larger than what the finished picture would be so the arrangement could change as she worked. "After a while, painting a picture is like a conversation with someone in trouble, only you must listen with the eye and try to help the picture out of its difficulties," she explained in a later interview. And rather than drawing from models or objects in front of her, she used her sense of recall. "The eye holds innumerable memories. Mine can recognize, after a fashion, when a thing is right and when it is wrong, and where."

One of her most ardent supporters and patrons during this time was the indomitable Juliana Force, the director of the Whitney Museum of American Art in New York. *Time* magazine, in a review of a memorial exhibit to her, described Force as "hardworking" and "fast-talking," but that may have been an understatement. A dynamo advocating for modern American artists, Force had been making things happen at the Whitney since 1931. As the legendary story goes, in 1929, the Metropolitan Museum of Art had refused Gertrude Vanderbilt Whitney's offer to donate her personal collection of contemporary art, thus paving the way for the birth of the Whitney Museum.

A major influence in American art, the Whitney pio-

neered shows, lectures, and exhibitions of contemporary, historical, or folk art that other museums were unwilling to feature. While the museums uptown concentrated on collecting the old masters and French impressionists, Force encouraged American artists like George Luks and Everett Shinn and naturalist painters like William Glackens to show at the Whitney on West 8th Street. Force's career also had included being manager of the Whitney Studio, an association of artists and friends organized to showcase modern artists. Friends of Whitney and Force's in this original group included John Sloan, Arthur B. Davies, and PAFA alum Robert Henri. Whitney had died in 1942 leaving $2.5 million to keep the museum going, to which Force continued providing the oversight and drive.

Now nearing seventy, Force's iconic influence still could sway the direction of an artist's career. Fortunately for Elizabeth, this favor likely assisted in the ascent of her career with its new modern style and introduced her to a widening audience. Another influential patron, Eloise Spaeth, wife of Dayton Tool and Die Co. founder Otto Spaeth, owned Elizabeth's *Lady Godiva* (written about in *Romantic Painting in America*), among other works. Credited with helping to persuade the Smithsonian Institution to establish a bureau for the Archives of American Art, Spaeth accumulated an extensive collection of American and European art that covered the period between the two world wars.

It may have been a nudge by Force or Spaeth that brought the attention of Editors Ernest W. Watson and Arthur L. Guptill from *American Artist* magazine to feature Sparhawk-Jones in the September 1944 issue. The 4-page article,

"A PHENOMENON IN THE WORLD OF PAINT"

which included reproductions of *Injustice, Godiva, A Letter to One Beloved*, and *Leda* opened with the simple statement, "Elizabeth Sparhawk-Jones is something of a phenomenon in the world of paint."

The writer [unidentified but reportedly Watson did the majority of the writing] bridged the world of her golden past with the idiosyncratic present. He told of the young girl whose "work was [once] in greater demand than her brush could supply" and who years later, after she survived ill health, "finally resumed creative work, [but] her interests and her philosophy had changed" to a "vision of the inner eye."

> She is revealed as a remarkably original, not to say eccentric, painter and person. She says she "paints on her pulse" an idiom that more aptly describes her creative process than a thousand proper adjectives. For she is first of all an emotional painter. Her art is spiritual; her brush answers inner urges, it is a subconscious voice, a yearning voice that strives to translate deep meanings into the language of paint.
>
> Few of her pictures reflect the world as seen by worldly eyes. . . .
>
> In her best work now, she holds the mirror not up to nature but to a realm of fantasy. Sometimes it is a light-hearted fantasy, more often it is somber, frequently macabre; always it wells up from the caverns of the subconscious. [Her technique] is as original as her conceptions and it has excited quite a bit of comment. She will tell you it is simply pure water color applied to a fine-grained canvas, with sable brushes. But no one quite believes her; some say she must mix

a paste with her colors, others think that canvas must first be coated with a gelatinous ground, still others maintain that her technical effects could only be secured with brittle brushes. All agree her pictures are beautifully painted . . .

In May 1947, Elizabeth participated in a Carnegie Institute exhibit as part of their show titled "Painting in the United States, 1947," showing *Europa*. Preparing for this and other exhibitions, she feared her mother's absence in her life would negatively affect her creativity. In a letter to Carl Sprinchhorn, a friend of Marsden Hartley's whom she wrote to on occasion, she voiced her concerns:

> I am working to get a little collection of my work together for the Rehn in March. My mother, who was the center of all my life, died in November 1946 and I fear my pictures are not as good as they should be because of this pain of soul I was through last year.
>
> How I miss Marsden also! I number him among the benefits of time to me—there are but 2 or 3 on that list of human beings.

Later in the year, Elizabeth returned to Baltimore for a family wedding: Her niece Eleanor, the young woman who'd once tied Maryland grass to her ankle to ward off homesickness one summer visit to her aunt at the MacDowell Colony, was getting married to a man named Frederick Pope. Frances, now thirty, had already been married eight years to Jerome Kidder, and Andrew, the little boy who'd played tennis with Scottie Fitzgerald and shot guns with her father, had graduated from Princeton in 1942 and served as a lieutenant in

the United States Navy during World War II. He still had aspirations to be a writer.

⌒

Sometime during the rise of her professional success in the mid-1940s, Elizabeth became enamored of another artist, one whose talent she feared might be overlooked or diminished because of what to her would be a stupid reason: the color of his skin. With a pointed note during this period to Joseph Fraser, the director of the Academy, Elizabeth wrote about her hopes that Horace Pippin, "the negro artist," would be invited to exhibit at PAFA with her at an upcoming show.

The story of Pippin, a self-taught African American painter, likely impressed Elizabeth as much as his talent. The Pennsylvania native, among the first African American soldiers to fight overseas for the United States, was a corporal in the 369th Colored Infantry Regiment, with whom he fought on the front lines of World War I under French command. Shot by a German sniper, he suffered a shattered right shoulder and lost the ability to raise his right hand above shoulder level. After the war, Pippin began painting as therapy for his arm (he used his left hand to support his weak right hand) and also to battle his depression.

In the letter to Fraser, Elizabeth strongly suggested he consider Pippin and offered locations where his paintings may be found for him to review:

> I am wondering if the Academy has invited Horace Pippin, the Negro artist who lives in West Chester, Pennsylvania, to send a painting to the forthcoming

> Annual Exhibition. For me, he is one of the few real artists in our country when he is at his best. . . . It is with the thought of adding to the value and beauty of the annual exhibition that I am writing of Pippin, and of course you may have invited him already.

In the spring of 1948, on the heels of her second one-woman show at the Rehn Galleries, the Pennsylvania Academy of the Fine Arts prepared to run their own one-woman show of Elizabeth's work. Writing Fraser again to iron out some details of the show, she also asked for a new favor, this one perhaps more complicated: She wanted to replace *Two*, a painting that the Academy had purchased in 1926, for another work more representative of her style. In the twenty years since she'd painted *Two*, she always felt it to be vastly inferior, especially because she thought the painting was created before she'd fully healed from the wounds of her "ill health."

From Paris, she wrote to Fraser of her wish and offered him his choice of a replacement painting for the Academy's collection.

> I wish you had seen my recent exhibition at the Rehn Gallery. I showed there my most mature work. Alfred Barr of the Modern Museum came in and stayed a long time Mr. Clancy told me . . . I told John Clancy if you stopped in to offer you a choice of one of these for the Academy's collection, a gift of course.

Months later, Fraser wrote to Frank Rehn confirming the exchange of paintings.

"A PHENOMENON IN THE WORLD OF PAINT" 199

Dear Frank:

This is just a note to say that after all this time we have finally had an exchange of letters and proposal and now acceptance of "Injustice" by Elizabeth Sparhawk-Jones for the older picture entitled "Two" . . .

She doubtless has told you that this matter was pending, but I am writing her today of the official action of our Committee on Exhibition and I thought you ought to know also. I am, of course, delighted that she is now represented in our collection by something very worthy, and she tells me that she plans to destroy the old picture when I return it to her . . .

Injustice, the large watercolor the Academy chose as the replacement for *Two* and the work dedicated to her great friend Harry Weinberger, featured a winged angel in mid-flight with an arrow shot through its chest. At the bottom of the painting is a large bow already set with another arrow ready to trigger.

By the early 1950s, Elizabeth had accumulated a wealth of artistic honors for her comeback style. New acquisitions by the Metropolitan Museum of Art, Wichita Art Museum, Toledo Museum of Art, and Addison Gallery of American Art complemented appearances at exhibitions at the Whitney Museum of American Art, Brooklyn Museum of Art, the Art Institute of Chicago, the Carnegie Institute, and others.

In the spring of 1952, Elizabeth had a show at the Rehn from March 31 through April 19. She described her satisfaction in a letter to Edie Brecht: "I believe these to be my

best—in spite of all the darkness of the hours in which they were made."

Leslie Katz, art critic and collector (and soon to become publisher of *Arts* magazine) agreed. In an art feature titled "Elizabeth Sparhawk-Jones: Notes of the Paintings," he wrote about some her works, including *Lady Godiva, Between Several,* and *On an Enchanted Shore.* By now, most reviewers had deemed her new style one of romantic love, or injustice, and Katz was no exception. However, he suggested that "in all the paintings . . . the central figures are anonymous spectators as well as personal participants in their own actions and emotions, and are often shown observing their own fate while engaged in fulfilling it. This incidentally, might serve as a definition of the role the artist plays." His conclusion went even further with praise:

> The art of Sparhawk-Jones is imbued with a frontier independence, which may account for the ability to place the self personally in the situation of the myths she depicts (as Mark Twain's Connecticut Yankee is placed in King Arthur's court). . . . One might go so far as to say that the enchantment in these paintings is an enchantment of experience rather than innocence—an experience that is candidly human.

For the next three summers, Elizabeth stayed at Yaddo, the artist colony in Saratoga Springs, New York, and in the off-season, she returned to Westtown.

In the winter of 1954, Margaret lost her husband of more than forty years when Bayard passed away. Dividing her time between La Paix in Baltimore and her summer home in Chilmark on Martha's Vineyard, off the coast of Massachusetts, Margaret busied herself with community and church involvement, gardening, and time spent with her growing family of children and grandchildren.

In late spring of 1956, Frank Rehn died. Ever since he had taken the chance on promoting her at his gallery after her breakdown, Elizabeth had been equally loyal to him and his gallery. But though she remained committed to her friend John Clancy, who'd run the Rehn Galleries for now, she knew there might be other choices for her to consider.

With these things in mind, she left for Europe and spent the summer season in Paris. But a funny thing happened, she liked to say, when August rolled around. She didn't leave. Unfettered at seventy-one, she did what she had the freedom to do now—something the young winner of the Cresson scholarship had been denied, something she'd yearned to do those many years ago.

She stayed.

The Enchanted Shore, Oil on canvasboard, 18x24, Courtesy of Private Collector.

CHAPTER 12
PARIS

Hotel Saint Romain, a small hotel off the rue de Rivoli, where Elizabeth at times took up residence over the next few years, appealed to her pragmatically (for its prime location) and for artistic reasons that, among other things, took into account the longevity of natural light in the bathroom. Close to the Grand Louvre Museum, the Jardin des Tuileries, and the Place de la Concorde, the half-century-old Parisian hotel stood just six stories high and had thirty-four rooms, a manageable navigation for a woman in her midseventies—one who also liked to enmesh herself in the lives of the other guests, perhaps accustomed to the colony way of life, regardless of setting.

Balancing her canvas against the rim of the bathtub, Elizabeth created a studio for herself within the bath of her hotel room, finding just the right light in which to paint. Since her mother's death, she had learned to go on with her life, increasing time spent abroad and such, but she also had to endure a new kind of loneliness. "It's not easy what I do, quite alone," she wrote to Edie Brecht from the French steamship *Liberté* en route to Europe in the spring of 1956. "Isolation is continually my problem, I wonder if it is yours?

After work I lack the energy [that I find at work], and with the hours it takes to go down into myself, I find housekeeping a bit too much."

She'd just completed an exhibition at the Rehn Galleries, the highlight of which was a reportedly long and admirable stay by Alfred Barr of the Museum of Modern Art. The reviews were "something to shrug the shoulders at," she explained away to others, while also partially blaming the Rehn itself for being "something not quite alive these days." Only a month since Frank Rehn's death, her comment still signaled a dissatisfaction with the gallery and its representation that would continue to grow over the next few years. Around this time, a painting she'd sold through the Rehn in the mid-1930s was donated from the Margaretta Hinchman Collection to the Pennsylvania Academy of the Fine Arts. The 18 3/16x15-inch oil on canvas, *Woman with Fish*, became the third and final addition of Elizabeth Sparhawk-Jones's work to PAFA for its permanent collection. Her last contribution to their annual exhibition was still a few years away; in 1966, Elizabeth, who couldn't decide which painting to submit for the longest time, finally chose a recent favorite, a work she'd named *A Tree in My Memory*.

⌒⌒

On this trip in April 1956, she was headed to Paris for two weeks, and then would meet her friend Fanny Colby, daughter of former Secretary of State Bainbridge Colby, in Rome. Fanny had lived in Greece for the past year and was bringing her poodle, "a big drawback" according to Elizabeth, to which she drolly added, "Our fate is in his paws." Following

Italy, the next month's schedule "was a blank," she wrote, allowing her the freedom to *not* plan an entire season when there was no reason to do so. But being separated by continents didn't mean Elizabeth emotionally detached from her family (Margaret and the children). Especially proud of her nephew, Andrew Turnbull, at this moment, she raved to Edie about his recent article about his childhood friendship with F. Scott Fitzgerald in the *New Yorker*: "They paid him $642 for it—a fine recompense for an unknown creature. I trust he will be able to keep it up but this time he had an almost surefire subject—so much depends on subject and moment."

Elizabeth needn't have worried about Andrew's literary success. In 1962 he would publish the critically acclaimed biography, *Scott Fitzgerald*, still in publication today. In June 2008, Jonathan Yardley, Pulitzer Prize–winning book critic from the *Washington Post*, would write: "Turnbull's book comes close to being an ideal literary biography. To be sure it isn't perfect. . . . but in the areas that matter most—empathy for and understanding of his subject, a keen but clearheaded appreciation of his work, a prose style of genuine elegance and grace—he has no rivals in the Fitzgerald camp and precious few outside of it."

For the next few years, Elizabeth lived a relatively quiet life, spending parts of the year in both Paris and her rental room in Westtown, Pennsylvania, and summering at Yaddo, the artist colony in Saratoga Springs, New York. Early in 1957, she contributed works to "The Twenty-Fifth Biennial Exhibition of Contemporary American Oil Paintings" at the Corcoran

Art Gallery in Washington, D.C., but other than the PAFA shows, her exhibitions slowed from the frequency of the mid-1940s.

From Paris in the fall of 1959, she wrote to her "beloved" niece Frances about her life living and painting there. Expecting a visit from Andrew soon, and then later in the month one from her sister Margaret, who would stay with her at the Saint Romain for a week, she sounded buoyant and playful. Recently spending time with gallery owner John Graham, on whom she had a small crush, likely helped her mood as well. Although here she claims to savor her time in solitude, in other letters, she admits to falling victim to loneliness and depression. Whatever the truth (and likely it varied by day, mood, and letter recipient), the subject of dealing with being alone was never far from her mind.

> My life has no great excitements in it but pleasant moments every day with good emotions all about me, warm European ones from which I learn their point of view about many things. In fact I seem to be one of the few people who is completely content alone. I and the little American biologist working in a laboratory here and who walks down the street as straight and thin as a needle. Perhaps she will bend and study the stems of things growing in a window box . . . then she will stand long in contemplation but with a human being seldom will she get involved.

The "little marine biologist" was just one of the people Elizabeth studied in form and trait, appreciating every nuance of her character whether she was aware of it or not.

Then there was the newborn Bernard Bouche:

> He is a thin and ugly baby but he has drawn his parents together and the father had wanted to divorce his mother early in the year and took no interest in his birth because he likes his mother so little. . . . I take an interest in this child. I cannot tell you why. He is touching . . .

There was Madam du Pac who "swept downstairs this morning all in a cream-colored dress with big ivory beads about her neck looking terribly clean." A Lech Yejeski also caught her eye, who was "an old acquaintance of mine, a Pole with a habit of castles."

Not yet her official new gallery representative (and perhaps simply because of this), John Graham allowed himself plenty of time to spend with Elizabeth on his recent visit. Persuading her to join him at a Russian church for service and lunch afterward, Elizabeth enjoyed herself immensely, especially the church service. The Russian deacon's bass voice was glorious, she felt, giving just the right note to the tense and devoted hour.

"The service impressed me," she wrote to Frances. "We stood of course all the time. Little children . . . making the sign of the cross frequently and looking straight ahead at the priest. . . . It was certainly the most devout service I have attended ever.

But after the bustle of visitors and activities had subsided, she faced many bad days as well; days when living alone on the other side of the Atlantic from family didn't serve her well. During one episode, perhaps with the flu, she spent a few days so sick that she had to crawl around on her hands and knees, fearing that she would fall if she stood. During times like these she felt that she became "a stranger to myself." When her bad spell finally lifted enough for her to visit a doctor, he gave her some sort of injection that brought back her vigor. Not unlike Edwin Arlington Robinson, who felt he could do "nothing but write poetry," Elizabeth always found herself again through painting. She wrote to a friend named Mary about such a recovery:

> You see I always paint some, I need to do this but that holds me back no doubt, but it is necessary for the spirit. It is how religion possesses itself in me. It is worship for me and very continual.

While living in Europe, her view of American politics soured, and her tone became harsher and less accepting of others and their behavior than usual. This could have been simply a sign of less tolerance with age, but also possibly a sign of her depression returning. Sounding harsh and caustic in a 1960 letter to Frances, Elizabeth expressed her cynicism at the way things were unfolding politically at home. A Democrat, she favored Stevenson, fearing Kennedy's ambition and superficial appeal to the masses.

> Only Eisenhower has a honeysweet time—quite coddled—no matter his easy going technique in finance and around the world, all relations have been

allowed to slip, too much has slipped but he holds up his hands like a baby in a coach and the USA is satisfied. Where is a strong man? Stevenson is the best, Eleanor has come to think this way. He made a big impression on her on television the other day she told me, such a gentle man and so very intelligent—and keen she said, but he has not a chance against Kennedy who wants to be President too damned much. One should not so need to be in the White House just now speaking like Kennedy with his pretty fashion model wife at his side—to appeal to a certain American woman who will say wouldn't she be cute in the White House. All is trash.—It is a time for fasting and prayer . . . great men like de Gaulle, they are dyed unto their resolutions.

Politicians and voters weren't the only ones with whom her patience was wearing thin. One morning, Agi Rains, the fifth wife of actor Claude Rains, called in tears to talk about her fear that her husband was going to return to his ex-wife Frances. Elizabeth apparently comforted the young woman with what words she knew were true, telling her what a lovely, perfect, and gifted lady she was. She hinted at her concerns that perhaps Agi loved Claude too much, that she suffocated him with her love. Offering her "all the advice in my heart," Elizabeth warned Agi not to talk of her fears or suffering to any of his friends or her daughter, and if Claude's confession was true, then she advised her to give him his freedom if he had been in fact too impulsive with his decision to marry her.

But her frustration with Agi Rains (or perhaps with the source: husband Claude) she saved for a letter to her niece Frances:

> Goodness what messes I see people make for themselves because the one thing they cannot do is stay alone—even at 80 years of age they dream of embracing a stranger like John Graham. There is more madness about than my senses detected before and especially over here. I hope there is gravity enough to keep the world going about the sun.

Although her attraction for John Graham may have been confusing for Elizabeth, there's no doubt her decision to leave Rehn Galleries for the Graham Gallery was a good one, energizing her career and broadening her exposure. In April 1964, a new one-woman show of Elizabeth's work opened at the Graham Gallery. *Art News* highlighted the "poetic nature" of her subjects in its review and discussed the gradual style change of the artist,

> ... [one] marked at all times by a romantic disposition, but showing increasing freedom in the handling of form and color. The earliest works in the show, the series of Lady Godiva preparing for her ride, are a spoof of romantic subject matter handled with a safe hazy atmosphere. Since then there has been an increase of importance both in color which is built up in heavy rich layers of paint, and in brushwork, which in places becomes turbulent and expressionistic.

When abstract-surreal American artist Clifford Wright, part of a younger, edgy crop of modern artists, wrote a paper

he titled "Elizabeth Sparhawk-Jones: A Painter of Romantic Incident," crediting Marsden Hartley with the title for Sparhawk-Jones, she definitely received high praise from a new generation. He wrote in part:

> Considering the works of Elizabeth Sparhawk-Jones, one is reminded of the motto which you can read in golden letters above the state of the Royal Theater in Coppenhagen, NOT ONLY FOR PLEASURE. For while enjoying the elegant, the virtuoso, the refined elements in the inspired pictures in this mature and compassionate artist's works, the spectator is reminded that art is not only refinement of the senses but more than that—a temple of humanity: Elizabeth Sparhawk-Jones is undoubtedly the best American woman painter since Mary Cassatt with whom she has no more in common than a certain element of timelessness.

Coinciding with the well-received Graham show, the Smithsonian asked Elizabeth to sit for an interview as part of its Archives of American Art series with one of its curators. Currently with New York University and relatively new to the Smithsonian, Ruth Gurin possessed intelligence, curiosity, and charm—a rare mix in this field (and traits that would serve her well). They would meet at the Allerton House in New York in April.

In the quiet of the Jardin des Tuileries, only steps from Hotel Saint Romain, Elizabeth sat with her notepaper in her lap

finishing another letter to Frances. Sparrows danced among the begonias beside her seat, and she watched the birds balancing themselves on the leaves, pressing their tails against the stems.

The sun brightened the flowers as it shone through them, reminding Elizabeth of stained glass in a church window. A minister's daughter, after all, she was accustomed to nonentities triggering a religious association, a connection to the spiritual. She found God whenever she painted, she would say, and what more could one ask?

The vibrancy of the garden's many shades and hues transfixed her, and for a moment she likely rested her pen. Then, *Love to Jerry and the kids but above all to yourself*, she wrote in parting, *Aunt Elizabeth*.

Elizabeth Sparhawk-Jones relaxed in the Jardin des Tuileries, enjoying the play of the birds. The autumn sun warmed her, and for a time she was illuminated by gold.

V. APRIL 26, 1964
INTERVIEW of ELIZABETH SPARHAWK-JONES
Conducted by RUTH GURIN for the
Archives of American Art, Smithsonian Institution

The tape recorder set between them on the lobby floor of the Hotel Allerton had been spinning now for an hour and a half. When curator Ruth Gurin shared the length of time they'd been talking, subject Elizabeth Sparhawk-Jones seemed incredulous.

"Oh, my! Mercy!" Sparhawk-Jones said, and then, "Well, it's all been very agreeable."

"Well, it's been lovely for me and I'm sure Robert Graham will be thrilled when he knows that we have gotten together because he was very eager to have us talk."

The mention of Robert Graham's name got Sparhawk-Jones's attention, and she mused, "Those Grahams are interesting men," and then, as she received no response, she became more specific. "Those two Graham brothers. Quite different, aren't they?"

Gurin agreed that the men, of whom Sparhawk-Jones added were "Yale graduates," did have a more "enlightened" social attitude than most dealers. Thoughts of Graham's vis-

its to her in Paris likely were not far from the artist's mind, and she probably would have elaborated if given a nudge by Gurin. But time was up.

"I think what I'll have to do is follow you to Paris and do some more recording there," Gurin jested, and then she became earnest. "No, I really am most grateful to you for sitting there like this, you know, on a Sunday when you probably had lots of other things to do."

Sparhawk-Jones did not respond verbally, though she gave every indication of satisfaction with the way she'd spent the last two hours. In addition to the "agreeable" nature of the interview, she likely enjoyed the wide breadth and scope of the conversation with Gurin. The interview, soon to be in the care of the Smithsonian Archives of American Art, had covered more than sixty years.

But even if Elizabeth Sparhawk-Jones, at nearly eighty, forgot all about this April day in New York City and these hours spent being so engaged by this charming young curator, it wouldn't matter now; her words and memories were safe. They weren't merely left in cardboard boxes at La Paix in the attic of Trimbush for decades, hoping to one day be saved.

EPILOGUE

On December 26, 1968, Elizabeth Sparhawk-Jones died in a hospital family members believe was in Connecticut. Her body was then returned to Maryland to be buried alongside her parents in the hilltop cemetery of the Immanuel Episcopal Church in Glencoe. Her name, carved underneath her mother's, reads: ELIZABETH SPARHAWK JONES, THEIR DAUGHTER, and the dates of her birth and death. And then, SING, HEART, AGAIN IN THE DEW OF MORN.

A base of granite lifts and frames the simple stone Elizabeth shares with her mother, which is at the foot of Dr. John Sparhawk Jones's large, rectangular tomb with its raised crucifix. His pastoral resume etched upon his grave includes both churches he led: MINISTER OF THE BROWN MEMORIAL CHURCH IN THE CITY OF BALTIMORE AND OF CALVARY CHURCH IN THE CITY OF PHILADELPHIA. Not long after Elizabeth's death, Margaret received a letter from lifelong family friend Edie Brecht, who wrote expressing her grief: "When I think of Elizabeth's long, sad [life], I shake my fist in the wind."

In the condolence letter, Edie also included a copy of a poem by Elizabeth's MacDowell Colony friend and colleague Leonora Speyer. It read in part:

> And let my wing be strong,
> And my last note the first
> Of another's singing,
> See to it, then.

Remanding Elizabeth into the care of a Connecticut hospital, sometime in late 1967 or early 1968, was not an easy decision for Margaret, and she did so only after long consideration. Elderly herself and having sold the La Paix estate in 1963 to a hospital, Margaret knew that her sister needed professional caretakers. Age had not turned her older sister into a docile, malleable creature—in fact, quite the contrary: Her wit had become tinged with acid, her once bountiful attitude toward life had deflated and showed possible signs of depression, and her relaxed nature had turned unpredictable. Even her beloved nieces, Frances and Eleanor, agreed with their mother that Aunt Elizabeth needed more care than they could give.

But up until this period, Margaret regularly sought time in her sister's company, often now at the Turnbull residence on Martha's Vineyard. The Chilmark property, which Margaret bought after her Bayard's passing, included a modest house with a pre-raised roof and a large barn (inhabited mainly by swallows) but offered a stunning ocean view. A rural community on the western end of the island with rolling farmlands, stone walls often housing sheep or cows, and a center that had a one-room schoolhouse from 1850, Chilmark offered both quiet and a network of volunteer opportunities. An active member of the Garden Club and the West Tisbury Congregational Church, Margaret wholly embraced the life and pace of the island for many years.

When she died in 1981 in Baltimore, she left behind six grandchildren and two great-grandchildren, but she had suffered the loss of son Andrew by his own hand in 1970. Sometime in the years following Andrew's death, Margaret also suffered what her alum surveyor from Bryn Mawr recorded in 1974 as "an incapacitating heart attack." But, like her sister, she was a survivor and would live until the age of ninety-four. An obituary from the *Vineyard Gazette*, one which Margaret would have liked, recalled her as someone who along with her many academic achievements also had "opened her home to the literary world."

When the Turnbull property on Martha's Vineyard sold in 2006, three paintings Elizabeth had likely sent from Paris that were hanging in the home and barn were sold by the family to their broker. As she'd likely done before at her Baltimore home, Margaret apparently offered to store some of her sister's things, and this time perhaps her sister needed an address in the States near her New York gallery. (It's not clear whether Elizabeth ever actually painted in the barn during her visits or just stored her things there.) The real estate broker immediately fell in love with the works despite not knowing anything about their creator. (Coincidentally, in 2006, some of Elizabeth's earlier works, those from the Manoogian Collection, were hanging at the Vero Beach Museum of Art in Florida as part of the *Masters of Light* exhibition alongside John Singer Sargent and Mary Cassatt.) The realtor subsequently bought all three of the paintings with the idea that they remain on the island.

The Turnbull relative, who agreed to the sale, liked the suggestion of the works—one of which depicted a woman/fish emerging triumphant from the sea—remaining close to the water. It just seemed right.

ACKNOWLEDGEMENTS

Beginning with the discovery that led me to the life and story of Elizabeth Sparhawk-Jones, I first must thank the extended Turnbull family for letting me copy the scrapbook material and providing additional letters and photographs. Frances Kidder and Eleanor Pope, two gracious nieces who shared family stories and gave insight into their Aunt Elizabeth, played an integral part in my research over the years. Mrs. Pope, thank you for the art history lessons in your living room, and Mrs. Kidder, I'll always have fond memories of sitting and talking with you in the garden behind your stone home. For those Turnbull family relatives who don't wish to be publicly acknowledged, thank you anyway. Your support reignited my inspiration on many days when the spark ran pretty darn low.

To my family and friends who have encouraged this project through its various phases, thank you for being wonderful: My entrepreneurial husband, Chris, taught by example that doing what you love is always worth the effort and the risk. For giving me a loving foundation where I knew I always could fall softly, my mother, Jeanette Lehman, from whom I inherited a passion of words, my late father, George Bradley Lehman, whose faxes of research notes about the Hurricane of 1938 I will always treasure, and for their editing and ad-

vice, my lovely sisters, Janet Danker, Phyllis Kennedy, Mary DeFelice, and Laura Stevens. Thanks also to my brother-in-law Gene DeFelice for sharing his legal expertise. My longtime friends, Trish Boyden Francescon, Patricia Powers, and Denise Knobloch, you each amaze me with your ability to shrug away the negative with a smile and a "why not?" Thanks also to Cheryl Levine Schainsfeld, Mary Beth Regan, Pat O'Brien, Lori Vidil, Mary Anne Fisher, Laurie Tasselmyer, and Tom Tasselmyer for his help with weather research.

I am deeply indebted to Scott Donaldson who— whether he wanted to or not— became one of my most generous mentors during the course of this book. As one of the country's best literary biographers, especially my favorite on Edwin Arlington Robinson, Scott helped point the way for me on countless occasions. For kick-starting this project, I'd like to thank my graduate school professor and renowned biographer Rob Kanigel for not following through on his flattering threat to "steal" the story. To *Pennsylvania Heritage* magazine and its incredible staff, thank you for being the first to publish my work on Sparhawk-Jones and recognize the "talent, tragedy, and triumph" of her story.

And then there is Ruth Gurin Bowman, whose enthusiasm for life and art out dazzles anyone within a New York City block. Ruth literally changed the structure of the book after our first meeting—along with my perception of the inner workings of the art world, both of which I'm so grateful. Many thanks to Catherine S. Gaines, E. Jane Connell, Sarah Cash, Juliann McDonough, James Cooke, Jonathan Boos, Richard Rossello, Deborah Chapin, Pam Flanders, Carlie Sigel, Barbra Stoddard, Ed Ogul, Russell Maloney, Jim

ACKNOWLEDGEMENTS 223

Harbison, Matthew Innis, Maura and Rob Geils, Townsend Ludington, and Richard Polenberg for generously sharing various insights and information along the way.

At the Pennsylvania Academy of the Fine Arts, former archivist Cheryl Liebold deserves the lion's share of the credit for her invaluable assistance. Somehow Cheryl knew the location of every possible research element—a shred of paper, a related file, an out-of-print review, or a personal source—about Sparhawk-Jones, without consulting one index card or computer field. Thanks, Cheryl. I'm also indebted to Judith Thomas and Barbara Katus for their help in the final stages of the book. At the Art Institute of Chicago, I'd like to thank Aimee Marshall for kindly not blocking my email address and instead answering my many questions with genuine interest and also hastening the approval process to help me meet deadlines.

In Baltimore and Philadelphia, thank you to the people who helped me piece together the story of Dr. Jones's religious life at Brown Memorial Presbyterian, First Presbyterian Church, and the Calvary Presbyterian Church: Mary McLanahan, James Quinn, Ken Ross, and Jane Swope. For other background on Maryland and the Carroll family, I'm grateful to the Baltimore County Historical Society.

To the people of Gardiner, Maine, thank you for keeping the love alive for your poet son. At a three-day festival in Edwin Arlington Robinson's honor, I witnessed firsthand the pride felt by Gardiner natives toward their three-time, Pulitzer–Prize-winning son. Thanks especially to Elsie S. Whidden, Jody D. Clark, Harriet Mofsher, Nancy Reinhardt,

and Michele Marcantonio.

To the MacDowell Colony, a unique oasis that I had the pleasure to visit during one August open house, much gratitude for your continued support of the arts and for your help with my research on Elizabeth's many summers spent in Peterborough. Many thanks especially to Robin Rausch for her illuminating assistance (and whose upcoming biography on Marian MacDowell I eagerly await).

To the team who helped make this project move from concept to reality, thanks for your vital collaboration: Joe McCourt for creating the book's web site, elizabethsparhawkjones.com, and book jacket design, Kathleen Achor for her copyediting wizardry, and Greg Ferguson for his marketing and technology expertise. A final note of gratitude to the benefactors whose support allowed the Sparhawk-Jones story to be told, and I employ one of Elizabeth's highest compliments by saying, you are truly *interesting* people!

Ruth Gurin Bowman in the 1960s.

THE PAINTINGS OF ELIZABETH SPARHAWK-JONES

Although much of Sparhawk-Jones's work is held in private collections, here is a sampling of paintings that are available for public viewing. You may check for the latest information and showings at elizabethsparhawkjones.com, the book's web site.

The Market, 1905. Oil on canvas, 35 x 133 in. Pennsylvania Academy of the Fine Arts, Philadelphia. Commissioned by the Pennsylvania Academy.

Woman with Fish, 1936 or 1937. Oil on canvas, 18 3/16 x 15 in. Pennsylvania Academy of the Fine Arts, Philadelphia. Gift of Mrs. Thomas E. Drake (The Margaretta S. Hinchman Collection)

Injustice, Pennsylvania Academy of the Fine Arts, Philadelphia.

Shop Girls, c. 1912. Oil on canvas, 38 x 48 in. The Art Institute of Chicago, Friends of American Art Collection, 1912.1677.

Shoe Shop, c. 1911. Oil on canvas, 39 x 33 ¼ in. The

Art Institute of Chicago, William Owen and Erna Sawyer Goodman Collection, 1939.393.

The following are paintings that are part of a museum's collection but may not be currently on public view.

Caryatides, 1940. Watercolor. Metropolitan Museum of Art, New York.

The Generations, Watercolor on silk, 16 ¾ x 24. Wichita Art Museum, Kansas.

A Startled Woman, 1956. Museum of Modern Art, New York.

Soldiers Bathing, Oil on canvas. Addison Gallery of American Art, Phillips Academy, Andover, Massachusetts.

BIBLIOGRAPHY

Catalogues

Rehn Gallery, various catalogues and letters on Elizabeth Sparhawk-Jones circa 1930-1963, Archives of American Art, Smithsonian Institution.

1964 Graham Gallery catalogue on Elizabeth Sparhawk-Jones, courtesy of James Graham & Sons, New York, 2010.

Pennsylvania Academy of the Fine Arts, catalogue copy, 1948, courtesy of PAFA.

Letters and Poetry

Edwin Arlington Robinson's Letters to Edith Brower. Ed. Richard Cary. Cambridge, Mass.: Harvard University Press, 1968.

Letters from Elizabeth Sparhawk-Jones to Edie Brecht and to various members of the Turnbull family. Permission granted courtesy of the Turnbull family.

Letters from Elizabeth Sparhawk-Jones to Pennsylvania Academy of the Fine Arts, care of Mr. Fraser and Elizabeth V. Swenson, and catalogue copy 1948. Archives of Pennsylvania Academy of the Fine Arts.

Letters from Marsden Hartley to Elizabeth Sparhawk-Jones and letters from Sparhawk-Jones to Marsden Hartley. Permission granted to use materials from the Archives of American Art and the Yale Collection of American Literature, Beinecke Rare Book and Manuscript Library, Yale University.

Selected Letters of Edwin Arlington Robinson. Intro. Ridgely Torrence. New York: Macmillan, 1940.

Edwin Arlington Robinson's poetry material non-exclusive use granted by David S. Nivison, heir and representative of Robinson's heirs.

Letter from Adelaide S. Kuntz to Hudson Walker, October 1944. Archives of American Art, Smithsonian Institution, Elizabeth McCausland Papers, Reel 268.

SELECTED BIBLIOGRAPHY

Agee, William C. *Morton Livingston Schamberg*. New York: Salander-O-Reilly Galleries, Inc., 1983. (Text from Exhibition Catalogue)

Bernstein, Amy. *Baltimore 1797-19997: Bringing Our Heritage into the 21st Century*. United States of America: Cherbo Publishing Group, Inc., 1997.

Brecht, Edie. Notes. Sent to Margaret Turnbull, 1968. Permission granted courtesy of the Turnbull family.

Brown, Milton W. *American Paintings from the Armory Show to the Depression*. Princeton: Princeton University Press, 1955.

Chilvers, Ian. *A Dictionary of Twentieth-Century Art*. New York: Oxford University Press, 1999.

Donaldson, Scott. *Edwin Arlington Robinson: A Poet's Life*. New York: Columbia University Press, 2007.

Fee, Elizabeth, Linda Shopes, and Linda Zeidman. *The Baltimore Book*. Philadelphia: Temple University Press, 1991.

Fillmore, Parker. Notes. Sent to Herman Hagedorn, 1936-37. Library of Congress.

Grob, Gerald. *Mental Illness and American Society, 1875-1940.* New Jersey: Princeton University Press, 1983.

Gurin, Ruth. Interview with Elizabeth Sparhawk-Jones. 26 April 1964. Archives of American Art, Smithsonian Institution.

Hall, Donald. *The Essential Robinson.* New Jersey: The Ecco Press, 1994

Hathaway, William. "Grim Reaper comes later and slower." *Hartford Courant* for *The Sun*, May 19, 2002: 9

Henri, Robert. *The Art Spirit.* Philadelphia: J.B. Lippincott Company, 1923.

Ludington, Townsend. *Marsden Hartley: The Biography of an American Artist.* Boston: Little, Brown and Company. 1992.

Olsen, Sherry H. *Baltimore: The Building of an American City.* Baltimore and London, Johns Hopkins University Press, 1997.

Pierce, Patricia Jobe. *The Ten.* New Hampshire: Rumford Press, 1976.

Polenberg, Richard. *Fighting Faiths: The Abrams Case, the Supreme Court, and Free Speech.* New York: Cornell University Press, 1987.

Prieto, Laura R. *At Home in the Studio: The Professionalization of Women Artists in America.* Boston: Harvard University Press, 2001.

Rausch, Robin. "The MacDowells and Their Legacy". *A Place for the Arts: MacDowell Colony 1907-2007.* New Hampshire:

The MacDowell Colony, 2006.

Rosenburg, Charles E. *The Care of Strangers: The Rise of America's Hospital System*. New York: Basic Books, Inc., 1987.

Sewell, Jane Eliot. *Medicine in Maryland: The Practice and the Profession, 1799-1999*. Baltimore: Johns Hopkins University Press, 1999.

Solby, James Thrall, and Dorothy C. Miller. *Romantic Painting in America*. New York: Museum of Modern Art, 1943.

Smith, Chard Powers. *Where the Light Falls: A Portrait of Edwin Arlington Robinson*. New York: Macmillan, 1965.

Turnbull, Andrew. *Scott Fitzgerald*. New York: Charles Scribner's Sons, 1962.

Watson, Ernest W., and Arthur L. Guptill. "She paints on her pulse." *American Artist*, September 1944: 10-34

Weigley, Russell Frank, and Nicholas B. Wainwright. *Philadelphia: A 300-Year History*. New York: W.W. Norton & Company, Inc., 1982.

Widdemer, Margaret. *Golden Friends I Had: Unrevised Memories of Margaret Widdemer*. New York: Doubleday & Company, Inc., 1964.

INDEX

Addison Gallery of American Art, 199
Albright Gallery, 78
Alexander Brown and Sons, 14
Allerton House (see also Hotel Allerton), 3, 211, 213
American Artist magazine, xiv, 158, 194
American Salon (see Carnegie Institute, International Art Exhibit)
Anshutz, Thomas, 4, 42, 48
Archives of American Art, Smithsonian Institution, 1-2, 41-44, 111, 167, 194, 211, 213-214
Armory Show, 69, 90, 97-99, 124
Art Fellowship Association, 56
Art Institute of Chicago, xiii, 73, 135, 199
 Friends of American Art, 88
 Kohnstamm Prize, 135
Art News, 1, 210
Art Students League of New York, 3
Ashcan School, 69, 89
Auden, W. H., ix

Backus, Reverend John C., D.D., 13, 20, 26
Baltimore & Ohio Railroad, 9, 14
Balzac, Honoré de, 72

Barr, Alfred H. Jr., 182, 204
Barton, C. Vanderbilt, 154
Beaux, Cecilia, xi, 48-49, 86-88, 98
Beers, Clifford, 104
Bellows, George, 154
Benét, Bill (William Rose), 134, 136
Benét, Laura, 136
Bishop, Emily Clayton, 58, 71, 84, 86
Bowman, Ruth Gurin, xiii, 1-4, 41-44, 111-115, 167-171, 211, 213-214
Brecht, Edie, 190-192, 199, 203, 205, 215
Breckenridge, Hugh, 48, 136
Brooklyn Museum of Art, 199
Brown Memorial Presbyterian Church, 7-8, 10, 13, 15, 17, 19-21, 24-25, 81, 100
Brown, Alexander, 14
Brown, Arnesby, 74
Brown, George, 7, 14
Brown, George Stewart, 15
Brown, Isabella McLanahan, 7, 14-15, 17
Bryn Mawr College, 66, 90, 217
Buffalo Fine Arts Academy, 78
Burnham, George, 128-129, 151-153, 164

Calvary Presbyterian Church, 31, 37, 79-80
Canton Junction, xi
Capra, Frank, 183
Carnegie Institute, International Art Exhibit at, 68, 71, 87-88, 111, 196, 199
Carroll, Charles, 14, 22
Carroll, Henry Hill, 22

Casanova, Grace (Grace Megger Lewis), 162-163
Cassatt, Mary, xi, 48, 74, 87-88, 98, 211, 217
Cézanne, [Paul], 70
Charles Toppan Prize, 57, 77
Chase School of Art, 70
Chase, William Merritt, xii, 1, 3, 42, 48-50, 54-55, 63-64, 70, 74, 78, 85-86, 88-89, 97, 99, 105-106
Clancy, John C., 155-156, 198, 201
Clynmalira (Carroll's Manor), 22-24, 81
Colby, Bainbridge, 204
Colby, Fanny, 204
Copland, Aaron, 118
Corcoran Gallery of Art, 55, 83, 111, 205
Corson, Alice V., 77
Crane, Bruce, 72
Cresson, (William Emlen) Memorial Traveling Scholarship, 58-61, 63-64, 106, 201

Davies, Arthur B., 194
Degas, [Edgar], 89
de la Mare, Walter, ix, 144
della Francesca, Piero, 108
Demuth, Charles, 167-168
Dickens, Charles, 126, 144
diphtheria, 29, 123
Donaldson, Scott, 147, 152
Dove, Arthur, 158
Duchamp, Marcel, 98
Duncan, Isadora, 126

Eakins, Thomas, 3-4, 48

Eliot, T. S., 124, 144
Elizabeth Sparhawk-Jones (Alice Kent Stoddard), 53, 84
Evening Bulletin, 34, 79

Fillmore, Parker, 146, 156
First Presbyterian Church, 13
Fitzgerald, F. Scott, ix, xi-xii, 143-145, 205
Fitzgerald, Frances Scott ("Scottie"), 143, 145, 196
Fitzgerald, Zelda, 144-145
Force, Juliana, 193-194
Franklin, Benjamin, 101
Fraser, Joseph, 197-198
French, William Henry, 68
Frost, Robert, ix, 124, 142, 144
Funk, Wilhelm, 86

Gardner, John H. Jr., D.D., 14
Girard College, 16
Glackens, William, 69, 194
Goldman, Emma, 160
Graham Gallery, James, 1, 112, 210-211
Graham, John, 206-207, 210
Graham, Robert, 213
Gurin, Ruth (see Ruth Gurin Bowman)

Hagedorn, Hermann, 146, 156, 165
Hals, Frans, 51
Harper's Bazaar, 99
Harper's Weekly, 72
Hartley, Marsden, xii, 106, 112, 122, 137, 157-159, 165, 168-171, 173-181, 184-185, 188, 196, 211

Hassam, Childe, 74, 87
Henri, Robert, 69-70, 87-89, 97, 154, 194
Heyward, Dorothy, 118
Heyward, DuBose, 118
Homer, Winslow, 68
Hopper, Edward, 154
Hotel Allerton (see also Allerton House), 3, 211, 213

Immanuel Episcopal Church, 81-82, 215
Inquirer, 72
Isaacs, Edith, 152
Isaacs, Lewis, 152

James, Henry, 144
Johns Hopkins Hospital, 144
Johns Hopkins lectureship/traveling scholarship, ix, 94
Johns Hopkins University, 93-94
Jones, Elizabeth Huntington (see Elizabeth Sparhawk-Jones)
Jones, Harriet Sterett Winchester,
 background, 21-24
 death, 187-190
 marriage and motherhood, 24, 26-27, 29, 33-36, 38-39, 50, 59-60, 94-96, 100, 104, 129-130, 138, 140, 190
 personality of, 23, 26, 36-37, 39, 82
Jones, Joel, 16
Jones, Joseph, 16
Jones, the Reverend John Sparhawk, D.D.,
 appeal as preacher, 12, 34-35, 79-80
 Brown Memorial Presbyterian Church, 9-15, 17-18, 21, 24-26

Calvary Presbyterian Church, 31-37
death, 79-82, 215
depression/illness, 17-20, 24-27, 32, 36, 80
marriage of, 35, 38-39, 59-60,
portrait of (by William Merritt Chase), 3-4, 50
writings, 12, 80
Jones, Margaret Carroll (see Margaret Carroll Jones Turnbull)

Katz, Leslie, 200
Kidder, Frances Turnbull, 93, 126, 137, 139-140, 196, 206, 208, 212, 216
Kidder, Jerome, 196
Kirkbride, Dr. Thomas Story, 101
Kuntz, Adelaide, 177

La Paix, x, 93-94, 105, 138-139, 144-145, 159, 166, 187, 190, 201, 214
Laughton, Charles, 184
Lewis, Sinclair, 162
Locust Point (Baltimore), 10
Locust Street (Philadelphia), 31
Ludington, Townsend, 177-178
Luks, George, 69, 154, 194

Macbeth Gallery, 69
MacDowell Colony, xii, 113-114, 117-118, 125, 136, 141, 153, 162, 196
MacDowell, Edward, 114, 117
MacDowell, Marian, 114, 117-119, 127, 134, 141, 163
MacKaye, Percy, 121

MacLeish, Archibald, ix, 144
Manoogian Collection, xiv, 74, 217
Marin, John, 158
Marsh, Reginald, 154
Martha's Vineyard, Chilmark, MA, 201, 216-217
 Vineyard Gazette, 217
Matisse, [Henri], 70, 98
McBride, Henry, 156
McCullough, 23, 81-82, 84
Metropolitan Museum of Art, 166, 193, 199
Miss Irwin's School, 83
Mixter Studio, 127, 141
Monet, Claude, 88
Morris, Harrison S., 48
Morse, Samuel, 14
Mount Monadnock, xiii, 119
Museum of Modern Art, 182, 204

New York Sun, 85, 156
New York Times, 65-66, 99, 121, 142
New York University, 2, 211
New Yorker, 205

O'Keeffe, Georgia, 158, 177
O'Neill, Eugene, 159
Otto, Eliza, 84

Pennsylvania Academy of the Fine Arts (PAFA), xii, 1, 41,
 43-44, 47-49, 52, 54, 67, 77, 105, 112, 188
 exhibitions/expositions, 65, 67, 78, 84, 96-97, 135, 198
 Margaretta Hinchman Collection, 204

Pennsylvania Hospital for the Insane, 33, 101-102
Perry, Lilla Cabot, 146
Phillips, Duncan, 154
Picabia, Francis, 107
Picasso, Pablo, 98
Pippin, Horace, 106, 137, 197
Pittsburg Bulletin, 74
Polenberg, Richard, 160
Pope, Eleanor Turnbull, 20, 137, 139-140, 161-162, 164, 196, 216,
Pope, Frederick, 196
Pound, Ezra, 124
Presbyterian Pulpit, 12
Princeton Theological Seminary, 15-17
Public Ledger, 57, 59, 86

Rains, Agi, 209-210
Rains, Claude, xii, 137, 183-184, 209-210
Rains, Frances, 183-184, 209-210
Ranck, Carty, 128, 151-153
Rehn, Frank K. M., 154, 198, 201, 204
Rehn Galleries, 154-156, 161, 175, 182, 196, 198-199, 201, 204, 210
Richards, Laura, 133
Robinson, Dean, 134
Robinson, Edwin Arlington, xii, xiii, 114, 119, 122-130, 133-135, 140-142, 146-148, 151, 154-155, 165, 178-180
Rodin, [Auguste], 70
Roosevelt, Kermit, 120
Roosevelt, Theodore, 49, 98, 120-121
Rosenberg Gallery, 181

Rosenberg, Paul, 173, 185
Rush, Benjamin, 101
Russell, AE [George William], 144

Saint Louis Art Museum, 78
Sargent, John Singer, 48, 74, 217
Sauter, George, 72, 74
Schamberg, Morton Livingston, xii, 41-44, 47, 54-57, 61, 64, 70-71, 89, 97, 106, 108, 111, 113, 129
Sheeler, Charles, 54-56, 61, 64, 74, 108, 111
Shinn, Everett, 194
Sloan, John, 69, 194
Smith, Chard Powers, 127-128, 134, 142, 151, 153,
Soby, James Thrall, 182
Spaeth, Eloise, 182, 194
Spaeth, Otto, 194
Spanish flu pandemic of 1918, 107
Sparhawk-Jones, Elizabeth
 appearance, 30, 36, 78, 122, 126, 159, 174
 breakdown/depression, 90, 99-103, 105, 117, 133, 135, 192
 Chase, William Merritt, xii, 1, 3, 42, 48-50, 54-55, 63-64, 70, 74, 78, 85-86, 88-89, 97, 99, 105-106
 childhood, 29-32, 123
 church and faith, 37, 207-208, 212
 death, 215-216
 father, 35, 38-39, 59-60, 123
 friends, 53, 58, 78, 136-137, 178-180, 183-184
 Hartley, Marsden, xii, 106, 112, 122, 137, 157-159, 165, 168-171, 173-81, 184-185, 188, 196, 211
 letters written by, 119, 122, 141-142, 146-147, 161-163,

165, 176, 180-181, 184, 189-192, 196-197, 199, 203-209

mother, 35, 38-39, 59-60, 83, 94-96, 129, 138, 140, 188, 187-190, 192,

name change, 66

personality and character, 52-53, 74-75, 97, 118, 124, 126, 137-138, 140, 152-153, 161, 164, 189, 216

Robinson, Edwin Arlington, xii, xiii, 114, 119, 122-130, 133-135, 140-142, 146-148, 151, 154-155, 165, 178-180

Schamberg, Morton, xii, 41-44, 47, 54-57, 61, 64, 70-71, 89, 97, 106, 108, 111, 113, 129

sister, 36, 70-71, 79, 86, 94-96, 105, 130, 138, 143-145, 187, 190-192, 201, 216

vacations, 70, 79, 84, 204

Sparhawk-Jones, Elizabeth, art of, xiii, xiv, 51, 57, 64-67, 125, 127, 155, 166, 193, 203

A Letter to One Beloved, 195

A Tree in My Memory, 204

At the Zoo, 78

awards, 57-61, 64, 72, 77, 84, 135

Baby Coaches, 71

Between Several, 200

By the Fountain, 97-98

Caryatides, 166

Comrades, 83

early interest, 36-38

early sketches, 37

Europa, 196

galleries/shows, 96-97, 182, 199

Home Life, 57

Housewives on Holiday, xiii

In a City Square, 68-69
　　In Apron Strings, 84
　　In Rittenhouse Square, 71-74, 78-79
　　In the Spring, 85, 90
　　Injustice, 188, 195, 199
　　Lady Godiva, 182, 194-195, 200
　　Leda and the Swan, 195
　　interview with Ruth Gurin, 1-4, 41-44, 111-115, 167-171
　　New Hampshire, 182
　　Nursemaids, 67
　　On an Enchanted Shore, 200
　　Passing, 78, 79
　　reviews, 57, 60, 65, 67-69, 72-73, 85, 87-88, 155-158, 195, 200, 211
　　Roller Skates, 67
　　scrapbook inspiration, 59, 72, 74, 87, 89
　　Shoe Shop, xiii, 135
　　Shop Girls, xiii, 87-89, 97, 135
　　The Generations, 182
　　The Market, 51
　　The Porch, 65-66
　　The Sketchers, 97
　　The Veil Counter, 71, 73
　　Turning Home, 84
　　Two, 198
　　Woman with Fish, 204
Spectator, 87
Speyer, Leonora, 215
Sprinchhorn, Carl, 196
Stieglitz, Alfred, 70, 175, 177

Stoddard, Alice Kent, xiii, 53, 58, 64, 77, 84, 136

Tarbell, Edmund, 72, 74, 88
Tender is the Night, x, 143
Terry, Ellen, 184
"The Eight," 69
The Craftsman, 73
The Studio, 73
Tiffany, Louis Comfort, 7
Toledo Museum of Art, 199
Torrence, Ridgely, 128, 152
Trimbush, ix, x, 187, 191, 214
Turnbull, Andrew, xiii, 139, 143, 145, 170, 183, 196, 205-206, 217
Turnbull, Bayard, ix, 93-95, 99, 139-140, 145, 159, 187, 201, 216
Turnbull, Eleanor (see Eleanor Turnbull Pope)
Turnbull, Frances (see Frances Turnbull Kidder)
Turnbull, Grace, 94, 168
Turnbull, Lawrence, 93
Turnbull, Margaret Carroll Jones, ix, x, 36, 70-71, 79, 84, 86, 94-96, 99, 105, 138-139, 143-145, 187, 190-192, 201, 216
Turnbull, Percy Graeme, 94

urban realists/realism, 69-70, 89, 135

Velázquez, [Diego], 170
Veltin Studio, 127, 146
Vero Beach Museum of Art, 217

Walker, Hudson, 185
Washington Post, 205
Watson, Ernest W., 194-195
Weinberger, Harry, 159-161, 178, 188
Westtown Farmhouse, 138, 151, 153, 175, 191, 200, 205
Whistler, [James Abbott McNeill], 3
Whitman, Walt, 59, 74
Whitney, Gertrude Vanderbilt, 193
Whitney Museum of American Art, 193-194, 199
Wichita Art Museum, 182, 199
Widdemer, Margaret, 126
Wilder, Thornton, 118, 163
Williams, Adele Fay, 87-88
Winchester, Alexander, 22, 81
Winchester, Betty, 23-24
Winchester, Fanny, 23-24
Winchester, Harriet Sterett (see Harriet Sterett Winchester Jones)
Winchester, Henry, 23
Winchester, Samuel, 23
Winchester, Sarah Carroll, 22
Worcester Art Museum, 83, 90
Worley, Michael Preston, 89
Wright, Clifford, 210
Wylie, Elinor, 118
Yaddo, 113, 136, 200, 205
Yardley, Jonathan, 205

Zorn, Anders L., 69

Ted 4x8 case 0019577

Hotel Galvez
2024 Seawall Blvd
Galveston, TX 77550
409-765-7721